life drawing

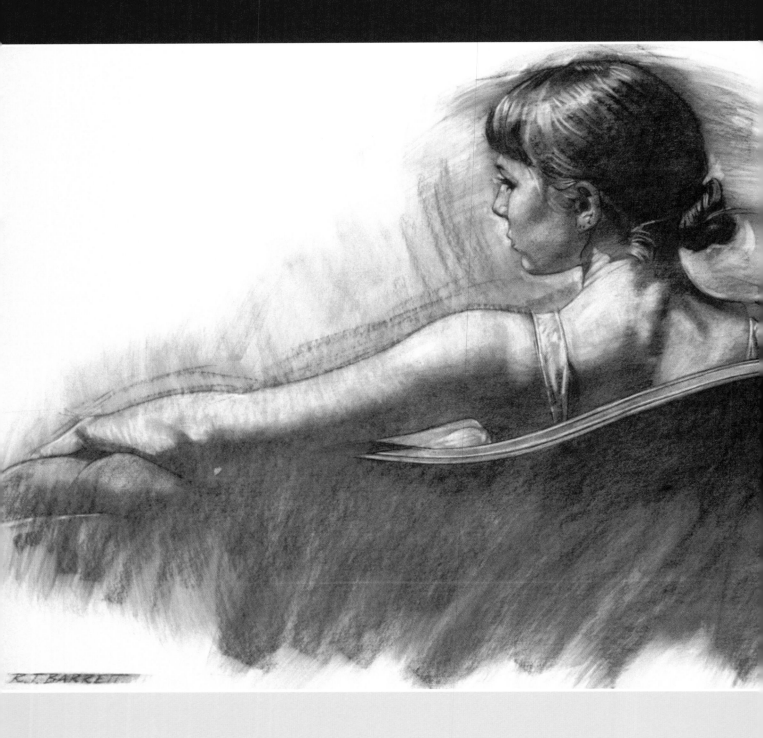

Life Drawing

how to portray the figure with **accuracy** and **expression**

robert **barrett**

NORTH LIGHT BOOKS
CINCINNATI, OHIO
www.artistsnetwork.com

Life Drawing: How to Portray the Figure with Accuracy and Expression. Copyright © 2008 by Robert Barrett. Manufactured in China. All rights reserved. No part of this book may be reproduced in any form or by any electronic or mechanical means including information storage and retrieval systems without permission in writing from the publisher, except by a reviewer who may quote brief passages in a review. Published by North Light Books, an imprint of F+W Publications, Inc., 4700 East Galbraith Road, Cincinnati, Ohio, 45236. (800) 289-0963. First Edition.

fw
F+W PUBLICATIONS, INC.

Other fine North Light Books are available from your local bookstore, art supply store or visit our website at www.fwpublications.com.

12 11 10 09 08 5 4 3 2 1

DISTRIBUTED IN CANADA BY FRASER DIRECT
100 Armstrong Avenue
Georgetown, ON, Canada L7G 5S4
Tel: (905) 877-4411

DISTRIBUTED IN THE U.K. AND EUROPE
BY DAVID & CHARLES
Brunel House, Newton Abbot, Devon,
TQ12 4PU, England
Tel: (+44) 1626 323200, Fax: (+44) 1626 323319
E-mail: postmaster@davidandcharles.co.uk

DISTRIBUTED IN AUSTRALIA BY CAPRICORN LINK
P.O. Box 704, S. Windsor NSW, 2756 Australia
Tel: (02) 4577-3555

**Library of Congress
Cataloging-in-Publication Data**

Barrett, Robert.
 Life drawing : how to portray the figure with accuracy and expression / Robert Barrett. -- 1st ed.
 p. cm.
 Includes index.
 ISBN-13: 978-1-58180-979-4 (hardcover : alk. paper)
 1. Figure drawing--Technique. I. Title.
NC765.B195 2008
743.4--dc22 2008000298

Edited by Kelly C. Messerly
Designed by Wendy Dunning
Production coordinated by Matt Wagner

ABOUT THE AUTHOR

In addition to being an accomplished painter, muralist, and illustrator, Robert Barrett is also a professor in the Department of Visual Arts at Brigham Young University in Provo, Utah. He has exhibited his work in many art shows including those at the Society of Illustrators in New York, the Director's Guild of America, N.Y., the National Arts Club, N.Y., and the Annual Utah Illustrator's Exhibitions. He has had a number of one-man shows including those at the Society of Illustrators, Springville Art Museum, the St. George Art Museum, the Kimball Art Center, Repartee Gallery, and the Busam Gallerie in Berlin, Germany.

Robert studied painting in Europe as the recipient of a German Academic Exchange Grant and was an artist in residence at the Kimball Art Center as the recipient of a joint grant from The National Endowment for the Arts and the Utah Arts Council. His work has been featured in *International Artist, Southwest Art, The Artist's Magazine* and *American Artist*. He has also had work published in *Society of Illustrator's Annuals, Communication Arts Magazine*, and *Print Magazine*.

His clientele includes many imprints of Viking USA and *Outdoor Life, American History, Boy's Life*, and *McCalls Magazine*. Robert has completed limited edition collectors' plates for the Bradford Exchange and prints for Millpond Press. He recently completed a children's book entitled *The Real Story of the Creation* for Concordia Publishing House.

Robert received a BFA in painting from the University of Utah and an MA and MFA in painting from the University of Iowa. In 1995 he was awarded the Karl G. Maeser Award for Teaching Excellence at BYU and in 2004 he was awarded the Karl G. Maeser Research and Creative Arts Award.

He is a member of the Society of Illustrators, the Pastel Society of America, the Portrait Society of America and the Salmagundi Club.

Cover art:

DEAN
Nupastel on paper
30 " × 22" (76cm × 56cm)
Collection of the artist

Art on page 2:

REPOSE
Nupastel on paper
22" × 30" (56cm × 76cm)
Collection of Brian and Ruth Arnst

METRIC CONVERSION CHART

To convert	to	multiply by
Inches	Centimeters	2.54
Centimeters	Inches	0.4
Feet	Centimeters	30.5
Centimeters	Feet	0.03
Yards	Meters	0.9
Meters	Yards	1.1

ACKNOWLEDGMENTS

When I began my education at the University of Utah in the late 1960s, I was able to study drawing and painting with a gifted draftsman and portrait painter named Alvin Gittins. He hailed from England and maintained his pronounced British accent, which, to me, added an air of authority to what he said. He was committed to teaching and became a mentor to many of us.

Among other things, Alvin felt that the idea for a drawing or painting was always vulnerable to failure if the artist lacked the technical skill to give it authority. He remained convinced that art that was different for the sake of difference failed ultimately to hide its mediocrity. If drawing truly is an act of discrimination, as Alvin felt it was, then the process of refining one's skill can teach the artist discernment as a way of thinking and a way of life.

Several years of teaching experience have convinced me that there is no curriculum content compelling enough to make up for the deficiencies or miscasting of the teacher. The best teachers are those who love learning and know how to help it happen. They are specialists in nurturing and guiding talent both conceptually and technically. They understand that talent without skills, inspiration without knowledge, and creativity without technique count for little but lost potential.

During the course of my career, I have been fortunate to come under the tutelage of excellent teachers. I have also been fortunate to be proximate to teachers who have shared my views, enthusiasms, and experiences. To them I wish to express acknowledgment for their influence and support. I wish to thank Ralph Barksdale for his devotion and commitment to life drawing and the many discussions we have had over the years in that regard. To my colleagues Richard Hull and Bethanne Andersen I wish to express my gratitude for their encouragement to the enterprise of drawing and for their commitment to the process of teaching and mentoring students at Brigham Young University. I have learned much from my association with them. I also wish to express my thanks to my good friend Burt Silverman whose work I continue to admire and whose devotion to the process of drawing is both remarkable and transformational. Burt has been willing to exhibit his work at BYU on more than one occasion and has made several trips to Utah to lecture and perform workshops. In addition, he has been willing to take several of our students under his wing as interns in New York City.

To artists Sherrie McGraw, Anthony Ryder, Bob Dacey, Murray Tinkelman, Thomas Blackshear, John Collier, C. Michael Dudash, Walter Rane, Bunny Carter, Jeff Hein, Ron Dias, William Maughan, and so many more who have been willing to travel to BYU to lecture, demonstrate, and freely share your personality and perspectives, I express appreciation. I feel I have often benefited from their composite knowledge more than my students. To William Whitaker who has lectured and demonstrated on campus and been willing to mentor students in his studio as well I express appreciation.

To the many students I have instructed over the years I express gratitude. In my role as teacher, it has been a privilege to associate with students of the highest caliber and potential. Although students come with different backgrounds and levels of ability, I am convinced that all have talents that are unique only to them. One of my great rewards is to experience the development of those talents and observe the transfer from natural ability to professional competence. An additional reward comes from the student who takes ownership for their education, learns how to learn, and is able to relate their internal values to their personal, organizational, and aesthetic priorities.

To Stephen Jones, Dean of the College of Fine Arts and Communications, I express appreciation for his support and friendship over the years and for the Department of Visual Arts I express my thanks. My further thanks go to the editors at North Light, Vanessa Lyman and especially Kelly Messerly for their patience and aid in the long process of bringing this book to reality.

Lastly, I wish to express appreciation to my family for their love and support along the way: To my mom and dad who always encouraged their children in their creative and educational pursuits. I was fortunate to grow up in a home where both parents drew and painted and where the smell of oil paint was a frequent experience. Thanks to my children who have all modeled for me at various times and for their commitment to their own families and careers. And to my wife, Vicki, who has been by my side always offering her love and encouragement. Without her support, this book could not have happened.

DEDICATION

To all students both past and present and to all who are devoted to learning the discipline of life drawing.

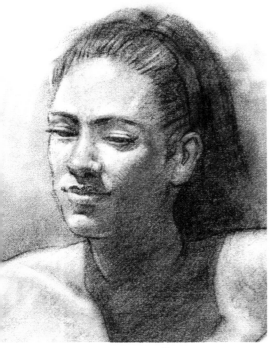

Table of Contents

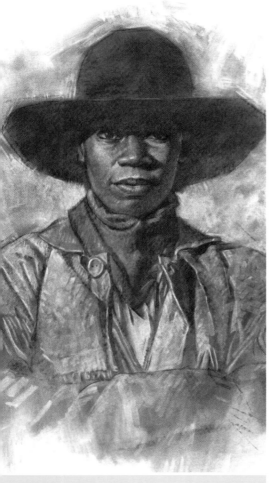

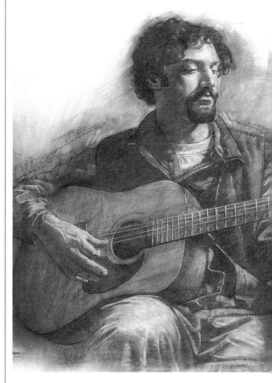

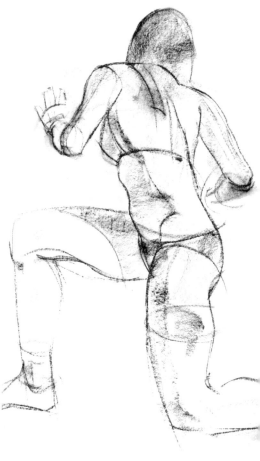

Foreword

Over the years, as my career in illustration wound down in tandem with the decline of magazine and print art, I found the illustration program at Brigham Young University to be a refuge from the loss of these arts. Even as my work shifted to painting for myself (a nicer phrase being Fine Art) this support seemed undiminished, and, in fact, seemed to grow. I had been invited to many places—both to university and independent art schools and museums, to either lecture or to conduct workshops, but none seemed to have the special warmth, affection and appreciation that characterized my visits to Provo, Utah. I think in large part this was due to the quiet and undiminished support of the man who was at the heart of the illustration and arts programs at BYU. As I got to know Bob Barrett I realized that his demeanor—reserved, balanced and low key—masked a fierce determination to make art, and that the road to do this was through the vehicle of drawing.

But though I had seen some of Bob's historical illustrations, I was not to discover his extraordinary draftsmanship until recently, so modest was he about his substantial body of work in this arena. In recent years he has been active in the annual conferences of the Portrait Society of America where he has begun to conduct mini workshops in drawing. It was there, too, that I became aware of the compelling quality of his teaching skills that complemented the work itself so completely.

Bob Barrett's drawings are about real people, and are viewed through the prism of his serene humanism. They are often of the young people among whom he toils as a teacher in the craft of drawing. His available models (students mostly) all provide a wide spectrum of character, gender and mood. This is revealed in such works as *Camille* (page 156), *Even* (page 105), and *Repose* (pages 2 and 151). The last is most revelatory of Bob's perceptual skills in that he has given us a subtle emotional insight about this young woman with the most minimal of portrait "information." We get only a glimpse of the woman's face, yet a strong sense of her contemplative mood. Conspiring with this intuitive skill is how he conveys the drama of character through the intense use of light and dark values in the rendering of the form. Bob also knows how to use materials to alter the mood with equal subtlety, switching the color of his pastel or Conté chalks from sepia to umber to Venetian red.

This combination of visually appealing images and instructional efficiency (through step by step images) is a wonderful platform to engage and instruct the student, the fledgling artist and even the interested art lover. Drawings can provide much of what we normally demand in painting—a feeling of participating in the life of a human being—if only as a sort of voyeur. Absent only is our unabated passion for color; Edgar Degas is reported to have lamented that he would have much preferred only to draw, but the times demanded color.

There are a good many more such pleasures in his work and this book brings them to full view. It is possible to savor the drawings of Bob Barrett for their inviting humanist images and their incipient painterly qualities and to forget that he is also a wonderful instructor. The savvy reader will absorb both.

Burton Silverman, N.A.

ABOUT BURTON SILVERMAN

Burt Silverman has exhibited in galleries and museums since 1956. He has had thirty-two solo shows in New York, Boston, Philadelphia, Washington, D.C. and in international venues such as the Mexico City Museum of Art and the Royal Academy of Art in London. In 2002 he received an Honorary Doctorate from the Academy of Art University in San Francisco and in 2004 was awarded the Gold Medal Award from the National Portrait Society for distinguished accomplishments in the arts. In 2005 he received a lifetime Achievement Award from the Newington-Cropsey Foundation. His paintings are represented in more than two dozen public collections. A retrospective of drawings titled The Intimate Eye was exhibited in 2006 at the Brigham Young Museum of Art.

Silverman is represented by the Total Arts Gallery in Taos, NM; Gallery 1261 in Denver, CO; and Gallery Henoch in New York, NY.

JAMISON
Nupastel on paper
20" × 16" (51cm × 41cm)
Collection of Blake and Cora Barrett

Introduction

The idea for this book began several years ago when, at the insistence of a number of my students, I mounted an exhibition of my life drawings in the gallery at Brigham Young University. That was followed by exhibitions at the Springville Museum of Art and at the St. George Museum of Art, and several articles on my work in national magazines. The enthusiasm with which my work was received convinced me of the interest that currently exists for the activity of traditional drawing. Interest in drawing the human figure and in learning the logical procedures and methods to do so has seemed to take on new relevance in recent years. Part of that interest may have been generated through the market demands for figurative artists created by the entertainment industry in the last two decades. Other factors may relate to the change in aesthetics in postmodern societies, the cyclical nature of the art world generally, or an attempt to recover that which was lost along the way.

During much of the twentieth century, a de-emphasis on drawing became more pervasive in art and design schools. In the art programs of the 1960s, curricula were modified to allow students more freedom to explore self-learning. Motor skills were replaced by explorations into the emotions and instructors influenced by Dada tended either to drop drawing classes altogether or to modify the discipline. In my experience, the term "drawing" was not removed from the course offerings, rather its meaning was expanded to include discussions of social consciousness, politics, race and the environment.

In fine arts programs the process of learning to draw became less concerned with preparing a student for a professional career or for improving the student's ability to see and think in visual terms. Illustration programs, on the other hand, continued to teach formal skills preserving principles of traditional drawing and did much to keep the figurative tradition alive.

I have come to the conclusion that learning to draw the human figure can be an end in and of itself or it may be the means to other ends. From the beginning, however, it has also been the measure of an artist's skills. The human form is a marvel of creation capable of exhibiting form, structure, proportion, contrast, action and emotion. When coupled with drapery and costume it is also capable of communicating narrative content as well. For centuries, some of history's greatest minds have devoted themselves to its understanding and the tools and procedures for drawing it convincingly.

The ancient Greeks may have been the first to establish canons of proportion and beauty for the human figure based on the perfection of physical development. They recognized that the human structure is a perpetual embodiment of design and ideal organization. They also recognized the indivisibility of the mind, body, and spirit. To study the work of the masters is to learn that artistic accomplishment combines both highly developed visual sensibilities and articulate practical skills. In most forms of human endeavor, in fact, there appears to be no substitute for shaping natural abilities through discipline. To draw the figure well requires a particularly high degree of focus as well as the ability to orchestrate a number of principles.

The artist James McNeill Whistler made an association between the keys of a piano and "notes" that belong to the visual artist. He observed that some artists were content to sit on the keyboard in their attempts to "make music," others were content to learn to play with a few keys, and still others not content until they learned to play with many keys. Though using many keys will not necessarily create good drawings, an understanding of tools and processes will allow an artist the opportunity

to make choices—to simplify, to clarify, to strengthen, and to add conviction in their work. Learning and internalizing correct principles may also be about unlearning some things that were incorrectly learned or, perhaps, understood in the wrong way.

When properly understood, the discipline of drawing can give an artist the ability to communicate visual ideas with conviction while simultaneously developing an inherent sense of confidence in both craft and vision. It is my observation that ability supports both concept and imagination and offers a pathway to lifelong learning.

The development of understanding, in fact, appears to be more liberating than restrictive. Learning the processes associated with traditional drawing not only helps the artist see the external world more efficiently and translate it more personally but also acts as a catalyst to stimulate the release of imagination into the realms of creativity. Structural knowledge and emotional content are not mutually exclusive. Learning to draw well takes effort but it is effort well expended and the process can be both engaging and a lot of fun as well. It is hoped that the principles communicated in this book will help you on your journey.

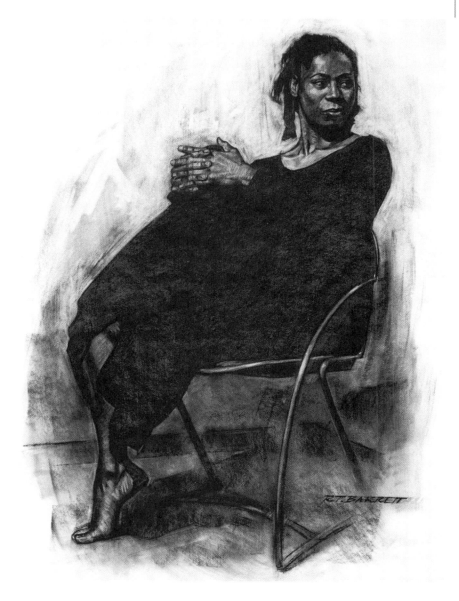

SEATED FEMALE FIGURE
Nupastel and charcoal on paper
30" × 22" (76cm × 56cm)
Collection of the artist

Studio Lighting and Materials

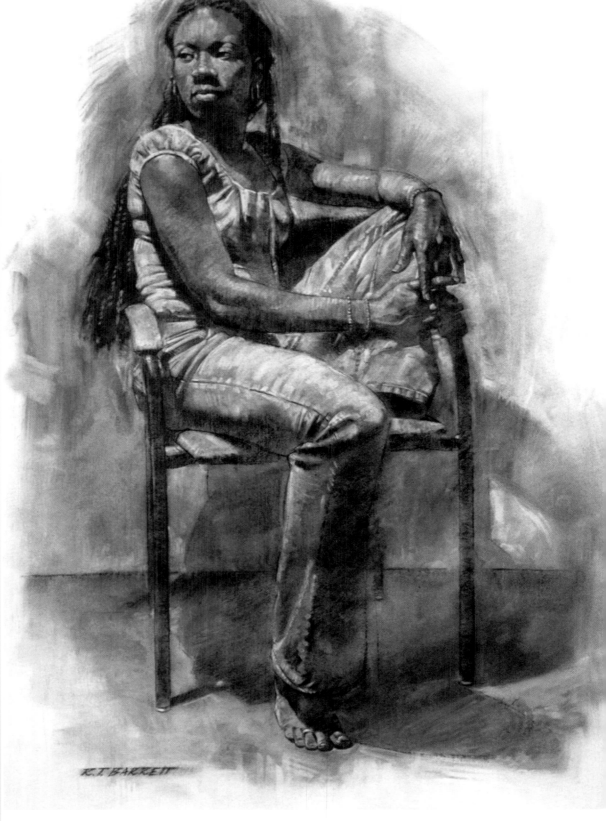

Proper Lighting Is an Essential Drawing Tool

This drawing of a former student was set up in the studio and drawn under a light angled at 45 degrees, coming from the upper left. Notice how the light defines both horizontal and vertical planes.

CAMILLE III
Charcoal on paper
28" × 22" (71cm × 56cm)
Collection of the artist

It's best to work in an area that's conducive to drawing the human form. This usually means a space with high ceilings and light coming from above at about a 45-degree angle. Artists through the years have found that this controlled lighting allows them to perceive and define the nature of lights and darks on the human figure more clearly. In many ways, this is because we live in a world lit generally from above and occasionally from the side but rarely from below. This fact is responsible for the way we perceive forms in the tangible world. This 45-degree angle of light also reveals the structure of both vertical and horizontal planes simultaneously and defines two types of shadow—the form shadow and the cast shadow (see page 55).

Lighting

North Light

Light from the north is softer, cooler and more constant in the northern hemisphere than it is in the southern hemisphere. The sun rises in the east and sets in the west. In the winter, it travels to its farthest point south. The light from the north sky is soft and indirect and has a subtle quality. I've always been enthralled with the beauty and simplicity of natural light, as there is something almost spiritual about it.

Single-Source Light

In traditional drawing, it's always best to have a controlled single-point light source rather than a double- or triple-point one. You'll find that the lightest lights on the model will be on those surfaces that are perpendicular or almost at right angles to the light source. You must train yourself to "see" the light. A lot of drawing is a combination of what you see and what you know.

Artificial Light

From time to time, I use artificial light coming from above. Artificial light is usually much warmer and harsher—meaning that the shadows are more defined and darker. In addition, the cast shadows are more hard-edged than those created by natural light.

LIGHTING THE STUDIO

The lighting in my studio comes from the north, entering at approximately a 45-degree angle. This type of lighting is quiet and subtle and beautifully illuminates the human form.

Studio Materials

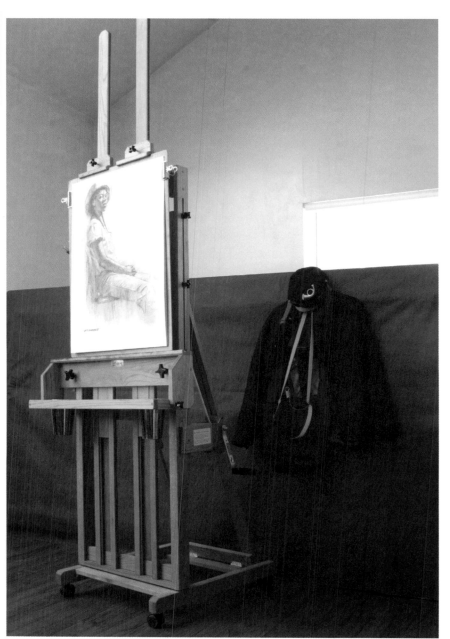

The Drawing Donkey ▲

I also use a drawing donkey, which is nice for drawing the figure at a lower perspective. The donkey allows me to see the model directly above my drawing board as well as from either side.

Drawing Board and Paper ▶

Here the drawing board sits horizontally on a drawing donkey. The board is braced against one of the ridges on the donkey, and the paper is held in place by two metal clips. It's important to create a situation where your hands and arms can remain free while you draw.

Selecting an Easel ▲

If you're going to buy an easel, select one that allows you lots of flexibility. It should be able to tilt back and forth and have a crank for raising and lowering your drawing board. It's also nice to have a shelf where you can rest your drawing tools.

I've drawn using many different mediums but I'm currently working with either Nupastel or charcoal on Strathmore 400 Series bristol two-ply vellum or smooth-finish drawing papers. I use sanding blocks, to create various tips, and a variety of drawing stumps, paper towels, erasers and, occasionally, paintbrushes to achieve my results. I prefer to work from life, but have done illustration for long enough to be able to work from photos when necessary. Using the right tools and the best ones you can afford makes the work easier, quicker, and ultimately more effective.

Drawing Materials

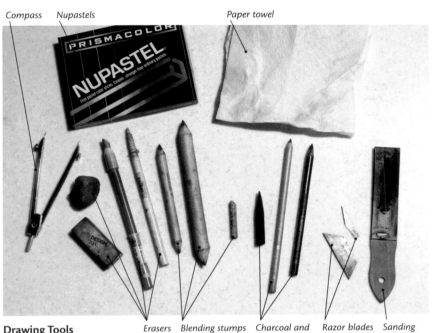

Compass Nupastels Paper towel

Drawing Tools
A variety of tools I use in drawing.

Erasers Blending stumps Charcoal and carbon pencils Razor blades Sanding block

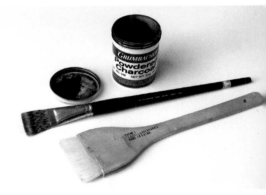

Charcoal Powder
Use charcoal powder or powdered pastel with different brushes to apply the powder much as you would a watercolor wash. You can then lift out lighter values with an eraser and add darker ones with a stick of charcoal or Nupastel.

Nupastel ▶
In this photo, you can see a variety of Nupastel sticks. On the side of the box is the number and color of the specific pastel in the box. If you purchase a whole box of the same pastel, you can keep different lengths and tips of the same color in the same box. Or you can use a pastel holder to facilitate control. Notice that each Nupastel stick has a number printed on it designating its name and color. Use this information when restocking your supplies.

Mark Making ▲
These marks represent different ways you can use a stick of Nupastel. When used on its side, you can create broad lines, and when used on its tip, the marks are thin. The amount of pressure you use when drawing also influences how light or dark the line appears. Remember, light marks are easier to adjust than heavy marks.

Sharpening Nupastel ▶
In addition to the sanding block, I also find a razor blade is a helpful tool. Be sure to point the blade away from your body as you sharpen the Nupastel stick.

15

Materials List

Pastels and Charcoals

Nupastel sticks by Prismacolor. The earth tones work best for figure drawing. You can buy these by the box and keep track of the number for future reference. Sticks can be used unbroken, but broken sticks can be sharpened to your specifications, then sanded or shaped.

Charcoal. You can use vine, compressed charcoal or charcoal pencils. Try combining them.

Charcoal or pastel powder. Use this with a paintbrush and apply it like a wash.

White pastel or white charcoal. This is helpful for heightening the highlights on toned paper.

Holders, Sharpeners and Erasers

Pastel holders. Use these for ease in handling and for creating more detail. They're inexpensive and there are several varieties available.

Sanding blocks. These are inexpensive, so keep several on hand to use with different colors.

Razor blades. You can use both utility knife and craft knife blades (with or without the handle) to sharpen charcoal pencils and pastel sticks.

Erasers. Look for kneaded, plastic and ink erasers that come in pencil form. Having a kneaded eraser is like having several paintbrushes in one tool. It can be stretched and molded into different shapes and points.

Blenders

Blending stumps. Use these for softening small, intricate areas.

Paper towels. Use these for blending large or broad areas and for evening out tones. (You can also use the back of your hand and your fingers for blending.)

Papers

Newsprint pads, 18" × 24" (46cm × 61cm) or 24" × 36" (61cm × 91cm). These are great for gesture or warm-up drawings.

Canson Biggie Sketch Pad, 18" × 24" (46cm × 61cm). An acid-free paper that's great for intermediate-level drawings.

Strathmore 400 Series two-ply drawing papers, 22" × 28" (56cm × 71cm). Use either a vellum or smooth finish for more developed drawings.

Stonehenge printmaking paper. A good surface for charcoal drawings.

Canson papers. Use this paper when working on a toned surface. Neutral or earth-tone colors are best.

Other Tools

Compass. This can be used for measuring comparative distances.

Compact mirror. A helpful device for seeing things in reverse, for correcting drawing mistakes, and for maintaining objectivity.

Wooden box. An easy way to transport your drawing materials and supplies.

Drawing board. Use a simple drawing board made from Masonite or hardboard. Those made from rigid Gator board are especially light and easy to transport.

Metal clips. There are different types and sizes available. Useful for clipping your paper in place while you draw.

To grow as an artist, you need to know how to use your tools effectively and efficiently. Tools make most tasks easier and the right ones help accomplish the work more efficiently. As you draw, it's important to realize that there are actual tools as well as tools that are conceptual and procedural. We'll focus on the latter two in this section.

Conviction

It is not only the materials you use but also the skill and rapport you develop with them that determines the level of conviction you communicate in your finished drawings. Self-expression should not be your central concern, but rather a by-product of the skillful use of tools.

Dexterity

A goal of drawing is to develop dexterity. The greater the ease with which you can move your arm, wrist and hand, the less limited you'll be in your ability to express your visual ideas. It may be helpful to consider the energy and time expended by dancers and musicians in practicing and perfecting their performance skills.

Logic

As with most traditional art forms, drawing is a logical and procedural endeavor—it moves from one step to the next. Learning the correct order of steps in completing a particular drawing will be a critical conceptual tool to master as you develop your abilities.

The Illusion

In the visual arts, there are three types of space: the "real" space of an architect or sculptor; the "flat" or "pictorial" space of a stained-glass artist and the "illusionistic" space of a traditional painter or draftsman. Working with illusionistic space can be the most challenging, as you are confronted with the problem of making images appear three-dimensional on a two-dimensional surface. The way you use tools and the way you will learn to draw is intended to maximize the illusionistic aspects of the human form.

Intangible Materials

Gesture Drawing

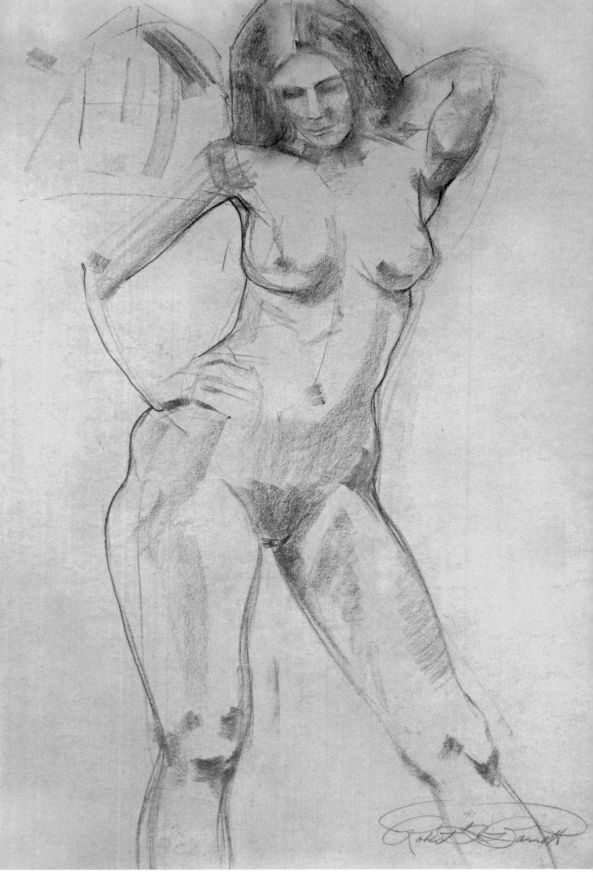

Essence and Energy

I drew this charcoal image of a female figure very directly to attempt to discover the essence and energy of the model's pose.

FEMALE FIGURE
Charcoal on paper
30" × 24" (76cm × 61cm)
Collection of the artist

Portrait artist Nelson Shanks said, "Great paintings do not happen in the finish but in the beginning." On a similar note, twentieth-century illustrator Robert Fawcett stated: "A drawing started tentatively rarely gains vitality later, while the bold statement, however preposterous, possesses both conviction and flavor."

The best way I've found to make such bold statements and to get my drawings off to a good start is to do lots of *gesture drawing*. Also called rhythm drawing, action or motion drawing, rapid contour drawing or gestalt drawing, a gesture drawing is simply a quick study of the model in its entirety. Gesture drawings serve as great warm-ups before doing more serious or sustained drawings. They also build confidence and allow you to move beyond your initial tendency to be timid or stiff in your approach. Seeing the whole form at once and "blocking in" the large shapes the way a sculptor might helps you analyze the way the overall relationships work together.

Developing Confidence

HAVE PAPER ON HAND

Buy several sheets of paper at the same time. It's less expensive and you'll always have something on hand with which to practice gesture drawing.

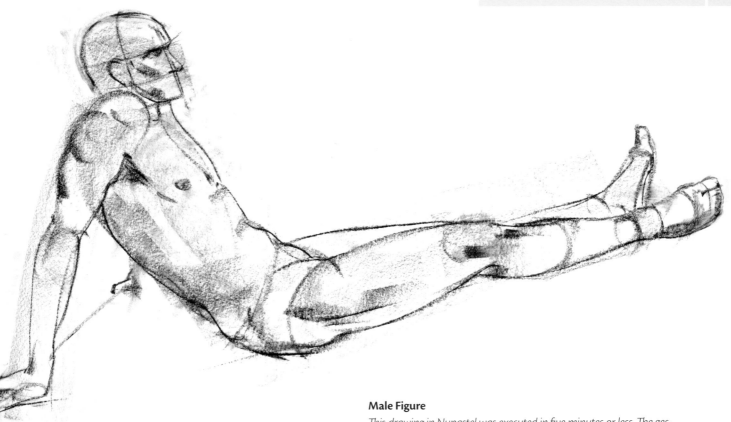

Male Figure
This drawing in Nupastel was executed in five minutes or less. The gesture of the figure is indicated quickly but deliberately. Weight and depth are suggested by the varying thickness and thinness of the contour lines.

Providing the Framework

Gesture drawings can be an end in themselves, or a way to begin more ambitious drawings. Try to state the important rhythms and overall design of the figure with the initial strokes of your charcoal or pastel. In a more comprehensive drawing, the gesture, silhouette or "ghosting in" of the subject also provides a framework for subsequent work. This initial lay in helps to stage the entire drawing and provides an opportunity to assess proportional relationships and compositional considerations.

THE MODEL

It's fascinating to note how each model you draw moves his big shapes in ways that are unique to him. You may have experienced seeing someone you know well moving toward you from a great distance, and being able to recognize them as your friend or family member by the characteristic way they move the big shapes of their body. In gesture drawing, you need to be tuned in to how your model moves the big forms of his anatomy. Pay attention to things like age and gender. Notice the size and proportion of the model and what they usually do as they move the masses of their body—how they carry their weight, what they do with their arms and hands and how they stand.

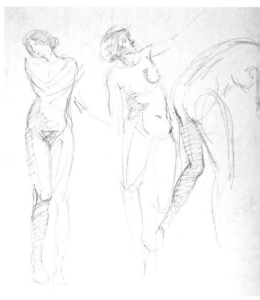

Establishing the Rhythm
The drawings on this page were done with a pencil in my sketchbook. Although they're small, there's a sense of rhythm and movement in them.

20

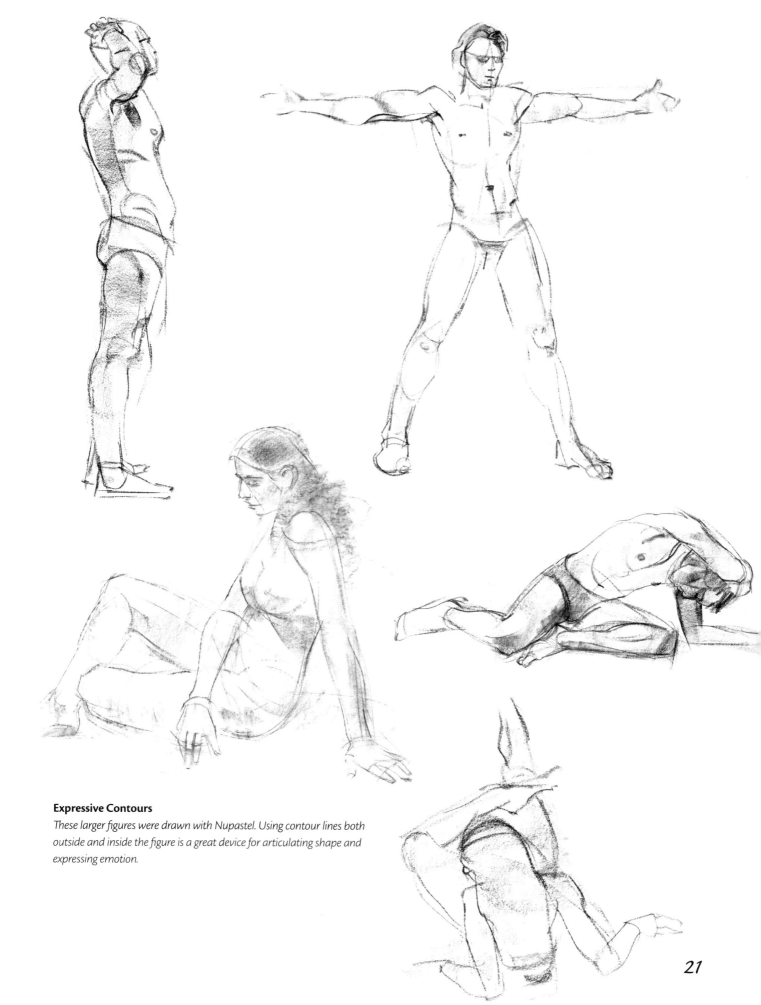

Expressive Contours

These larger figures were drawn with Nupastel. Using contour lines both outside and inside the figure is a great device for articulating shape and expressing emotion.

21

The Beginning

Start with your Nupastel or charcoal on its side to put down the biggest and broadest marks possible. Locate the head and use it as a unit for proportion, laying in the rest of the figure in relation to it. You can also start from the big masses in the middle and work outward, taking care to relate each part to everything else.

Another approach is to begin your gesture drawing with a single line that seems to capture the rhythm or essence of the model in a particular pose. In a compact pose, you can start with a series of overlapping ovals. The pose will generally dictate how you should start the drawing.

The Silhouette

The first step in a gesture drawing is to indicate the big shape, or gestalt, of the figure. To do this, lay the Nupastel on its side and lightly fill in the whole silhouette of the figure.

The Structure

In the next step, use contour lines to indicate more specific structure. At this point, tip the Nupastel on its end for a more controlled line.

Building on the silhouette

MATERIALS LIST

Charcoal or pastel

Kneaded eraser

Sketch paper

This approach to drawing can be characterized as procedural, or moving from one step to the next. It requires a flexible medium and the discipline to develop the whole drawing at the same time. Avoid the tendency to complete one part of the drawing at the expense of another. Try to move through the entire drawing several times, refining, strengthening and clarifying each individual section. It's important to see the individual parts in relationship to other parts, and the individual parts in relation to the whole. With this approach, it's possible to stop drawing at any point and still have your drawing communicate a sense of overall completeness.

1 Block in the Figure
Stage or set up your drawing by simply "blocking in" or "ghosting in" the entire figure.

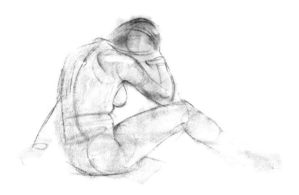

2 Define Specific Forms
From the silhouette, or big shape, indicate and define more specific forms so the specific structure of the figure becomes increasingly clear.

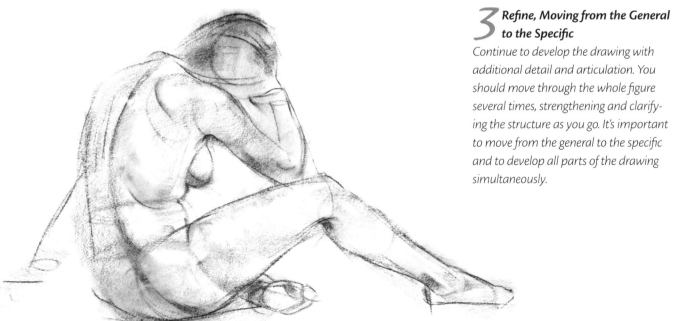

3 Refine, Moving from the General to the Specific
Continue to develop the drawing with additional detail and articulation. You should move through the whole figure several times, strengthening and clarifying the structure as you go. It's important to move from the general to the specific and to develop all parts of the drawing simultaneously.

Relating Parts to the Whole

An important concept to grasp through gesture drawing, whether you're using it as a warm-up or as a foundation for more complex drawings, is that drawing is very much a thinking process. You must understand how one form evolves from another and how all forms relate to the whole. The sum, or gestalt, of the figure must always be more important than the individual parts. The process of moving from big to small and simple to complex allows the initial energy to remain evident in more finished and sustained drawings as well. Develop your drawings as a whole so that at any given point along the way, each drawing is a complete, self-contained statement. All good drawing is a combination of what you know and what you see.

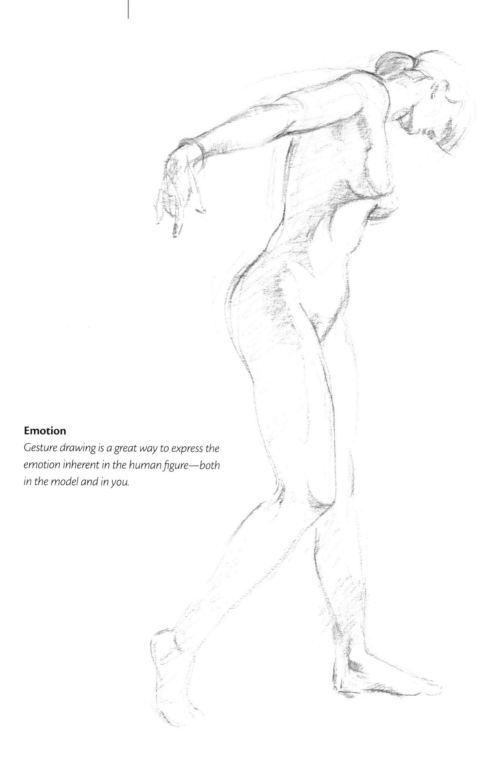

Emotion

Gesture drawing is a great way to express the emotion inherent in the human figure—both in the model and in you.

On a recent trip to New York City I visited the Metropolitan Museum of Art, where I viewed an exhibition of Leonardo da Vinci's drawings. I found it interesting how he strengthened and clarified his ideas through a series of related drawings. He often enhanced the energy of his work by allowing parts of his preliminary drawing to show through in his finished works. The same idea is present today in animation, when an artist develops both individual characters and the sequence of action for those characters, and leaves initial strokes or "blue lines" evident under the more complete, finished drawings.

Strengthening and Clarifying

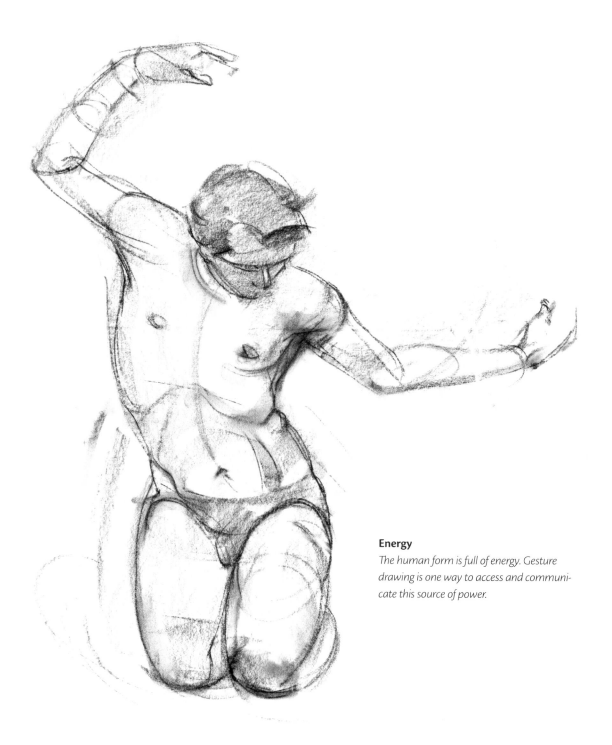

Energy

The human form is full of energy. Gesture drawing is one way to access and communicate this source of power.

The Importance of Exaggeration

As you work through your gesture drawings, try to exaggerate what you're seeing or experiencing. Not only does exaggeration often come closer to the truth than understating the facts, it will also help you carry your enthusiasm for your subject through to the end. So if you see something is curved, make it more curved than it is, or if it's relatively straight, make it straighter. In a foreshortened pose, make the parts of the figure coming toward the viewer bigger than they actually are. This process involves editing and simplification to strengthen and enhance the model's pose and the concept of the drawing.

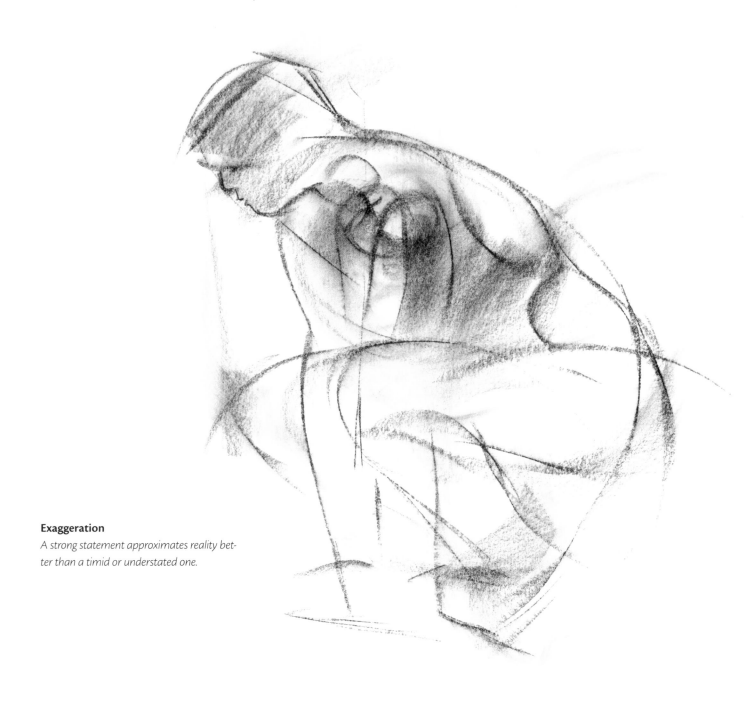

Exaggeration
A strong statement approximates reality better than a timid or understated one.

The process of gesture drawing is like a dress rehearsal, where you establish the initial rhythm, energy, flow, setup and best use of space. As you practice gesture drawing, you will develop your ability to establish the essence of the model's pose from the very beginning—without a major investment in energy or time. The better your beginning is, the better your finished drawing will be.

Success Is a Result of a Strong Beginning

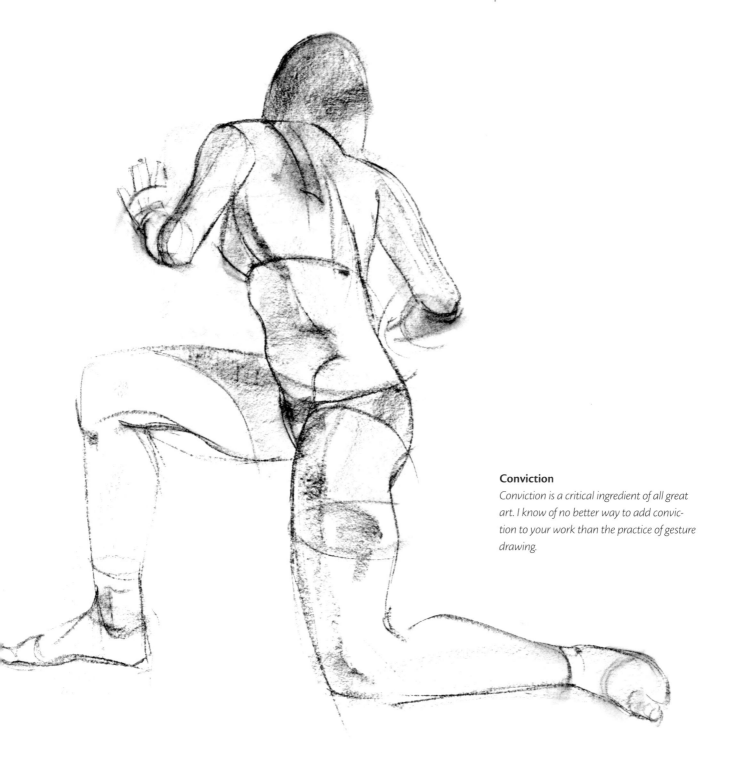

Conviction
Conviction is a critical ingredient of all great art. I know of no better way to add conviction to your work than the practice of gesture drawing.

Constructing the Figure

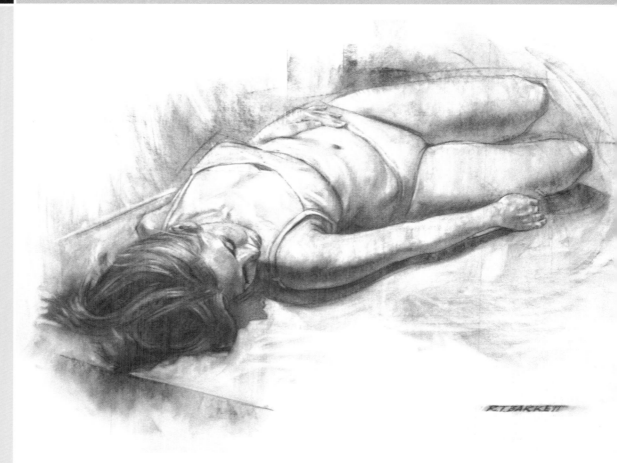

R.T. BARRETT

The Figure in Perspective

Historically, artists have been challenged with the problem of showing the figure in extreme proportion. When the figure is foreshortened, many forms appear only a fraction of the length they actually are.

RECLINING FIGURE
Nupastel on paper
22" × 28" (56cm × 71cm)
Private collection

The most effective way to simplify drawing the human figure is to reduce its complex forms to fundamental ones. The figure is primarily a three-dimensional object that has volume and occupies space. It's important to think of the human figure in terms of major or fundamental forms, since it's these forms that create the major masses that affect both the inside gesture and the outside shape of things. The smaller pieces are important, but should be subordinated to the larger ones. When you break the fundamental units into increasingly smaller ones, basic structures become essential forms from which you can develop and refine more specific forms.

Start with the Basic Structures

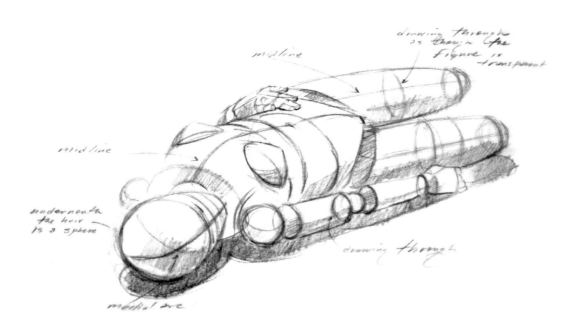

What the Sketch Shows

By reducing the figure to geometric shapes you create convincing fore-shortening. This approach also helps you understand the big forms and how one builds on top of another. In this sketch of the finished drawing on page 28, you can find examples of geometric shapes, midlines, and the principle of "drawing through," which you'll explore on page 36.

Build on a Framework

As with any drawing, construct the figure by roughing in the gesture. A loose gesture sketch will help you capture the overall essence of the figure. Continue to "flesh out" the figure by adding mass and weight via geometric forms. It's important to keep the figure fluid and gestural; otherwise, you may forget the action of the figure and make it too stiff or tight. Try to feel the action of the pose as you develop the solidity of the forms. Remember, the figure is dimensional—it has height, width and depth.

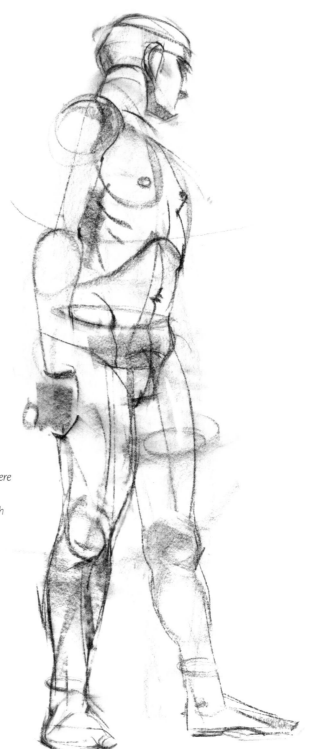

Gesture and Structure Come Together

This drawing is an orchestration of sorts, where gesture and structure come together at the same time to build a framework upon which you'll develop the figure.

Shapes like spheres, cubes, cylinders and cones can help you understand the complicated structures of the figure because you can draw them easily. When you understand a known quantity, such as a cube, you can more easily understand and estimate an unknown quantity, such as the pelvis.

To construct a modified form of the figure, sketch the legs, arms and torso basically as cylinders and reduce the head to a sphere, and suggest the hands and feet with wedge or cube forms.

Move from the Known to the Unknown

Building on the Forms Below the Surface
As you become more observant, your structural imagination (the ability to imagine the body's different structures) will help you understand where basic forms are located both on and below the surface.

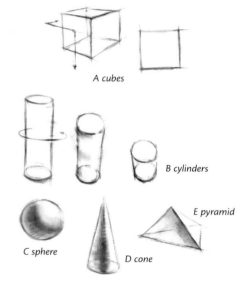

A cubes

B cylinders

E pyramid

C sphere

D cone

Geometric Forms
It is critical that you understand basic geometric shapes. The human form is more easily understood when reduced to simple forms.

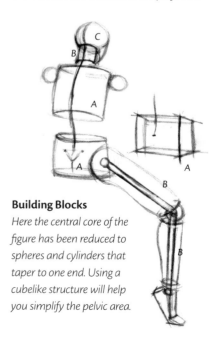

Building Blocks
Here the central core of the figure has been reduced to spheres and cylinders that taper to one end. Using a cubelike structure will help you simplify the pelvic area.

Understanding the Design of the Structures

The process of seeing complex structures as simple shapes is critical in understanding the design of both simple and complex anatomy. As you become involved in the process of breaking down complicated structures into simpler ones, you will find that your understanding of the design of the structures will increase dramatically.

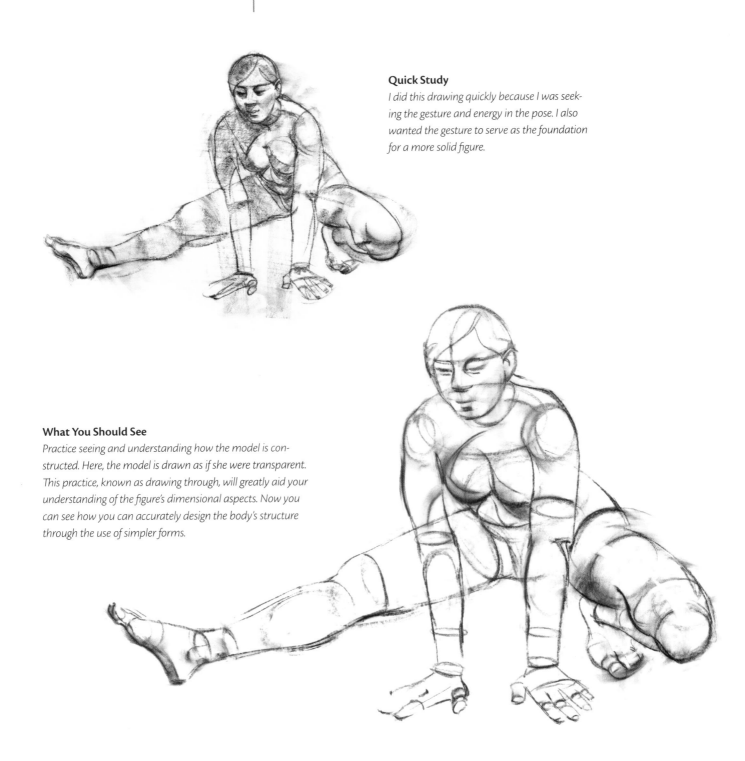

Quick Study
I did this drawing quickly because I was seeking the gesture and energy in the pose. I also wanted the gesture to serve as the foundation for a more solid figure.

What You Should See
Practice seeing and understanding how the model is constructed. Here, the model is drawn as if she were transparent. This practice, known as drawing through, will greatly aid your understanding of the figure's dimensional aspects. Now you can see how you can accurately design the body's structure through the use of simpler forms.

As the drawing progresses from the initial gesture sketch, refine the head into a sphere and the torso into basic cylinders. Modify the arms and legs from symmetrical cylinders into tapered cylinders. Add a straight line, or shaft, down the center of an arm or leg to help define and refine the outer—and more subtle—contours of each respective appendage.

Refine, Define and Modify

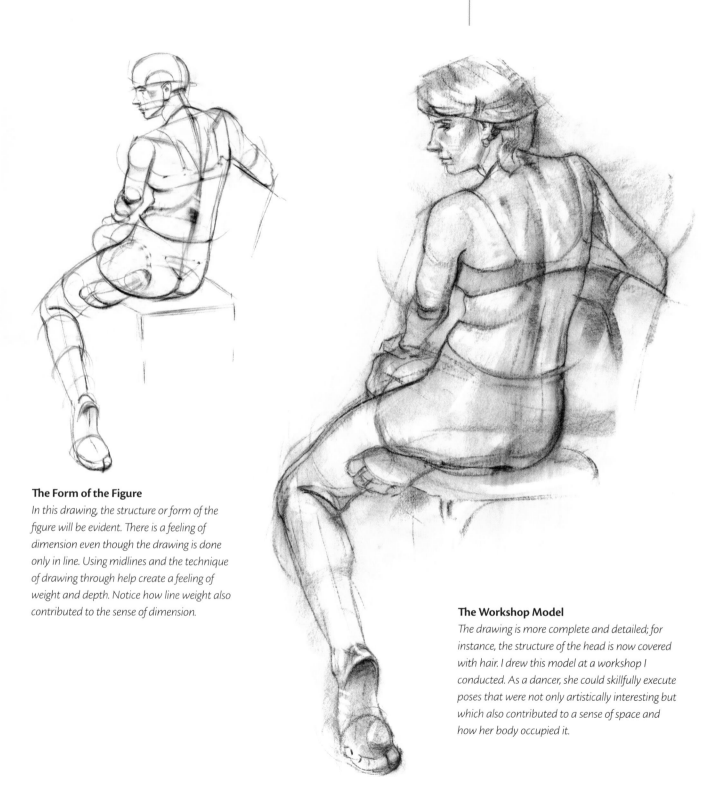

The Form of the Figure
In this drawing, the structure or form of the figure will be evident. There is a feeling of dimension even though the drawing is done only in line. Using midlines and the technique of drawing through help create a feeling of weight and depth. Notice how line weight also contributed to the sense of dimension.

The Workshop Model
The drawing is more complete and detailed; for instance, the structure of the head is now covered with hair. I drew this model at a workshop I conducted. As a dancer, she could skillfully execute poses that were not only artistically interesting but which also contributed to a sense of space and how her body occupied it.

Keep the Forms Related

As you practice constructing the figure, you'll understand the importance of each separate form being properly proportioned, or related to, the other forms. Appreciating the comparative sizes of, for example, the head to the foot and the foot to the forearm, helps you see how each individual form relates to other forms, so when they're put together, they relate to the whole figure.

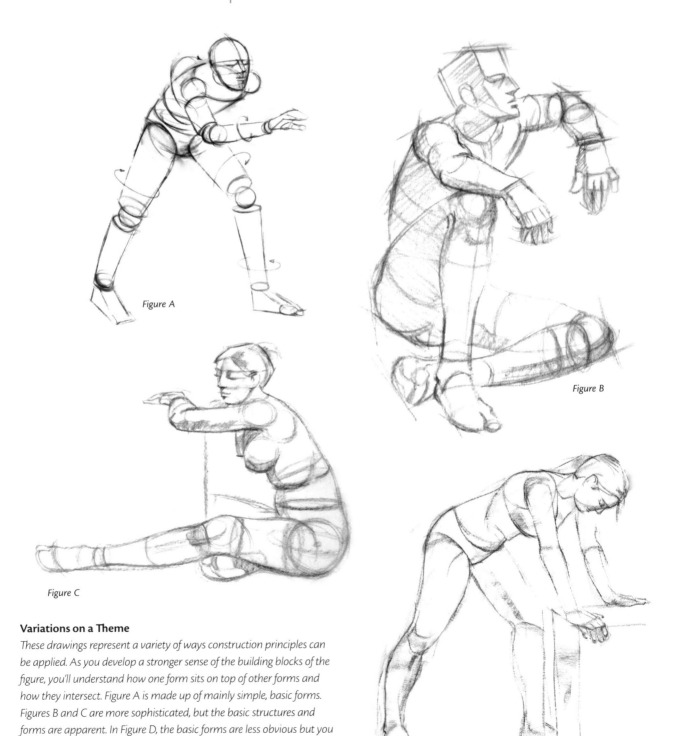

Figure A

Figure B

Figure C

Figure D

Variations on a Theme

These drawings represent a variety of ways construction principles can be applied. As you develop a stronger sense of the building blocks of the figure, you'll understand how one form sits on top of other forms and how they intersect. Figure A is made up of mainly simple, basic forms. Figures B and C are more sophisticated, but the basic structures and forms are apparent. In Figure D, the basic forms are less obvious but you can imagine that they are there.

A useful device is a shaft or *midline*, which is a line drawn through the middle of a human form to see how it is supported. A midline acts like the armature underneath a piece of sculpture because it approximates the skeleton. As such it helps you understand movement and direction. It also simplifies the process of seeing and indicating the angles of specific forms.

Use Midlines

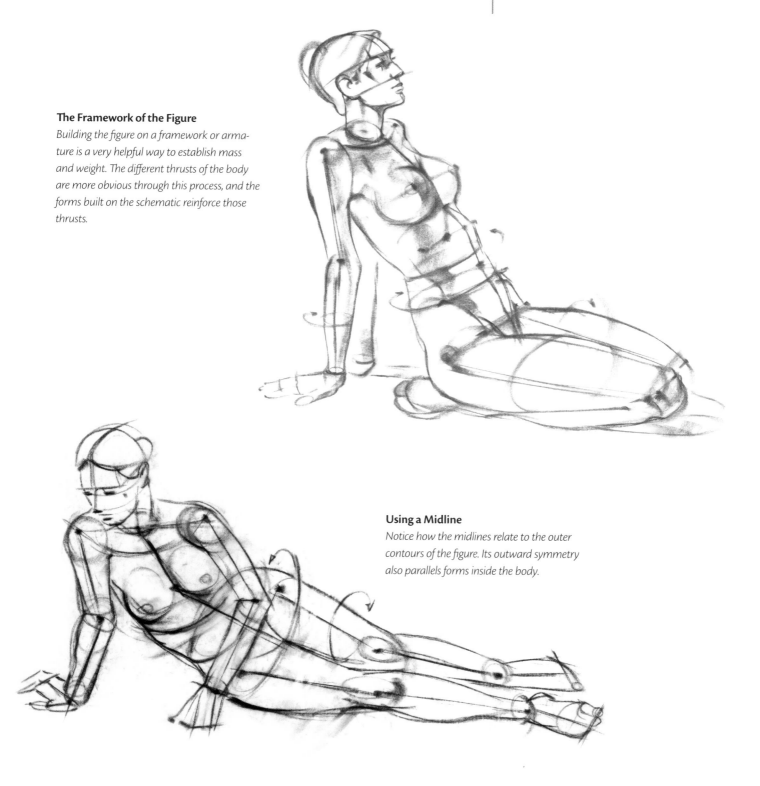

The Framework of the Figure

Building the figure on a framework or armature is a very helpful way to establish mass and weight. The different thrusts of the body are more obvious through this process, and the forms built on the schematic reinforce those thrusts.

Using a Midline

Notice how the midlines relate to the outer contours of the figure. Its outward symmetry also parallels forms inside the body.

Draw Through

Simply put, to "draw through" means to render geometric shapes as if they were transparent. This becomes a way to communicate the sense of volume, as well as orientation, to the form and its specific construction. The cylinder, for example, is essentially a simple form, but using it effectively enables the artist to quickly describe deep space. Using it perceptively can also help you overcome the challenges associated with drawing the figure in a foreshortened view. By drawing through each shape as you build the forms on top of one another, you create a structure that's clear-cut and more easy to understand.

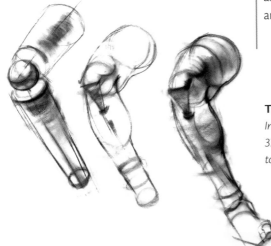

Three Studies
In these studies of the leg of the figure on page 37, you can see its development from a simple to a more complex structure.

Keeping Things Simple
The human body is complex, so in order to draw it, you need to translate the complicated forms into more simple ones. Simplifying the figure into basic forms makes them more understandable and easier to manipulate.

Learning to construct the human figure is critical to drawing it convincingly. Understanding its basic geometry is fundamental to communicating a sense of dimension to its structure. A drawing that's constructed well has depth, as well as height and width.

Communicate Depth

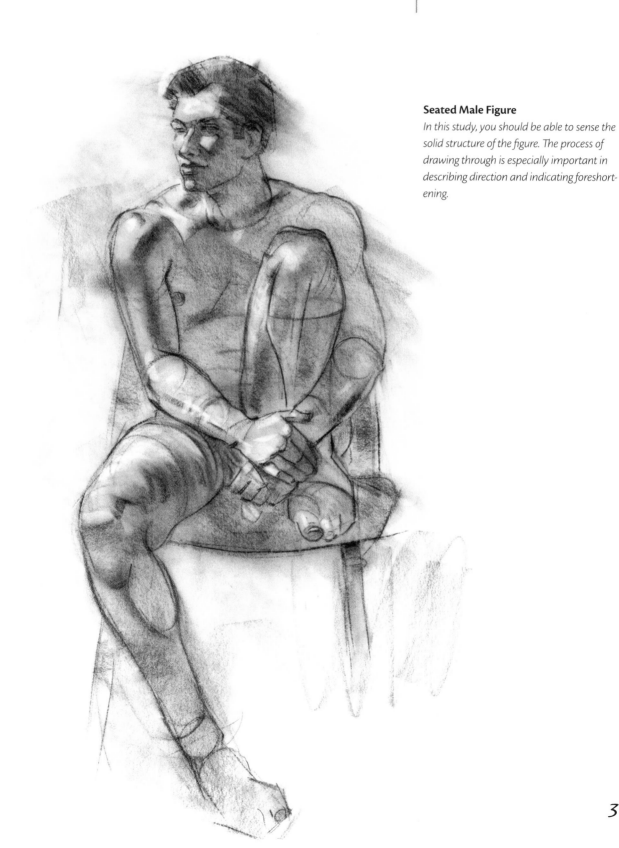

Seated Male Figure
In this study, you should be able to sense the solid structure of the figure. The process of drawing through is especially important in describing direction and indicating foreshortening.

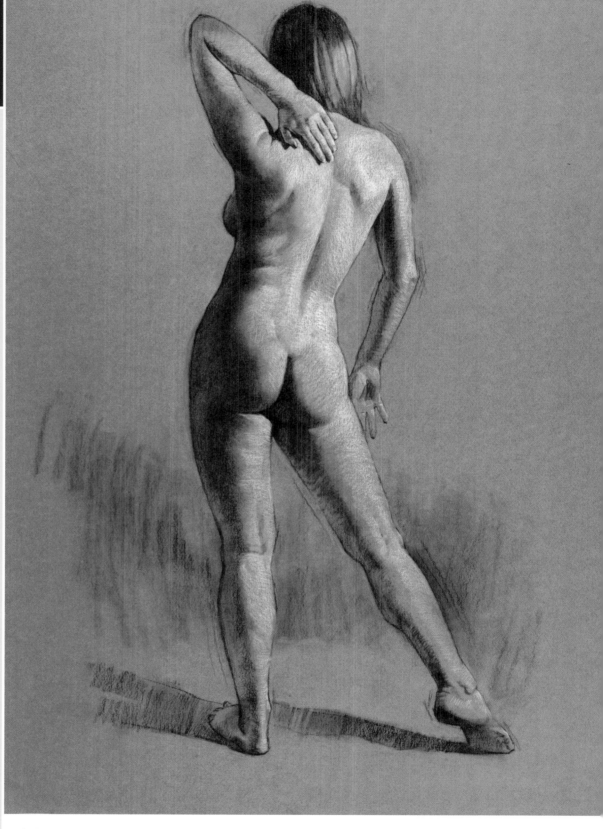

4

Proportion

Relating Parts to Each Other and to the Whole

With a standing figure, it's often easier to discern how the individual units of the body relate to one another, and to the whole.

STANDING FEMALE FIGURE
Charcoal and white pastel on toned paper
25" × 19" (64cm × 48cm)
Collection of the artist

To draw the human form in any position correctly, you must understand its basic proportions. This knowledge will add conviction to work you create both from observation and from your imagination. Understanding proportion gives you a standard with which to evaluate your work, helping you to better judge the unknown quantity of a work against a known quantity. Understanding proportion helps get you in the "ballpark," so to speak, and allows you to quickly spot-check as you begin to estimate what's correct or incorrect. Many proportional relationships can be committed to memory, and internalizing them isn't difficult if you are willing to make the effort. As a result of applying principles related to proper relationships, your drawing will acquire conviction and look correct.

As you continue to strengthen your sense of proportion, it's important to learn the various essential units or *masses* of the human body. As you better comprehend the separate parts of the body, you'll learn to draw them in relationship to each other. It's been said that anatomy is the study of individual parts, whereas proportion is about the integration of those parts. Effective integration of the parts, one to another, adds consistency to your work, which in turn gives your drawings a stronger sense of realism.

Effective Integration

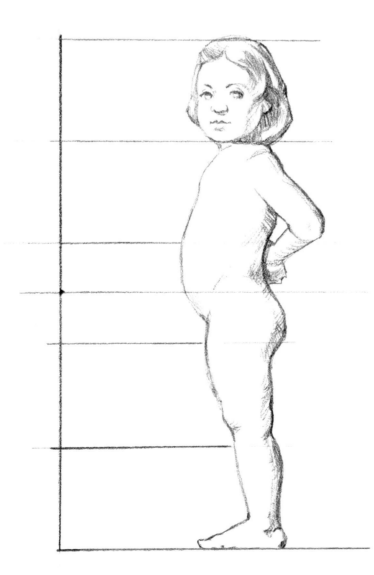

Three-Year-Old Girl
While an adult figure may be 7½ or 8 heads tall, a three-year-old is only 5 heads tall. As a child grows, their body increases in size at a rate disproportionate to the head.

The Influence of the Greek Figure

Various canons of proportion have developed in different cultures and at different times throughout history. Along the way artists discovered that proportion was concerned with relationships and relativity, and therefore it helped to have units of comparison. In ancient Egypt, for example, an adult figure measured around 18 units tall. These units aligned generally with the length of a middle finger that was approximately 4 inches (10cm) long. The Greek canon, used the head as a unit of measurement. An adult human head measures approximately 9 inches (23cm) high and the Greeks found that an adult figure could be easily divided into eight separate units. This canon is now universally accepted, though it's a slight idealization of human form. Some people do actually conform to ideal standards established by the Greeks (and later embraced by the neoclassical movement in France). Some academies were so enamored with the classical canon that they would only hire models whose proportions conformed to those standards.

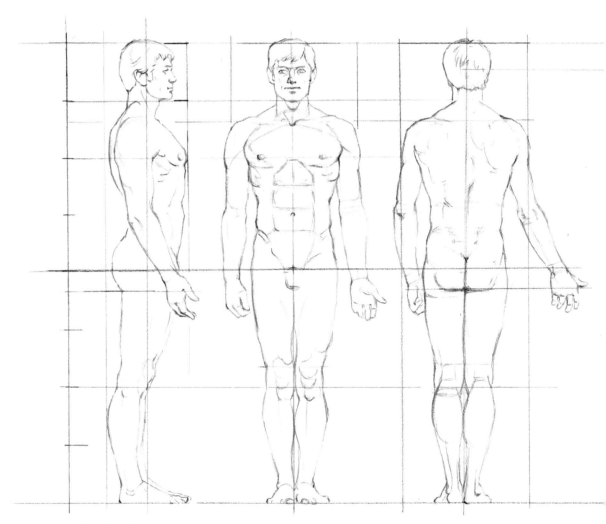

Proportions of the Male Figure

In these diagrammatic illustrations you can observe the proportions of a male adult figure. Actual proportions of the figure are closer to 7½ heads tall but using 8 heads is easier and more ideal. It divides the figure into eight equal parts—with the halfway point located at the pelvic arch. Other major divisions occur at the nipples, the waist and the knees.

It's important to understand the difference between the real and the ideal. As mentioned, the ideal we accept today regarding the human form originated from the Greeks, who established proportional relationships that were applied to their gods and goddesses. The concept of an ideal proportion also derives from "average" proportions associated with the majority of individuals in a given culture. As you become familiar with the human form, you'll need to learn the average as well as the ideal proportions of the figure. Keep in mind, however, that an idealized figure can lack individuality and character, so you'll need to make adjustments as you seek to capture the uniqueness of different models.

The Concept of the Ideal

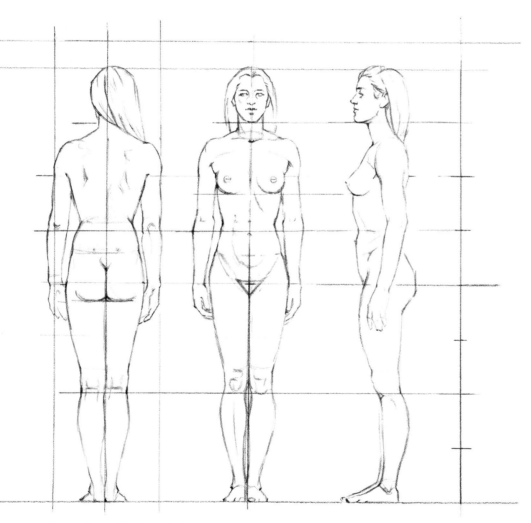

Proportions of the Female Figure
The female figure is normally shorter than the male figure but is still 8 heads tall. As a consequence, her head is relatively smaller than that of the male. You'll also notice she is only 2 heads wide at the shoulders whereas the male is 3 heads wide.

The Head as a Unit of Measurement

In reality, the average adult measures 7½ heads tall, but many masters (including Michelangelo) preferred to use a slightly idealized standard that increased the height of a figure relative to head length. This became known as an *8-head figure*. Because of its equal divisions, an 8-head figure can be more easily committed to memory. You'll notice the head can be used as a unit of measurement in two different ways—height and width. The height of the head, from the top of the skull to the chin, is 1 head and its length represents one vertical unit. For horizontal units, it's usually easier to use the width of the head. For example, the shoulders on an adult male figure measures 3 heads wide and the width of a female figure at the shoulders measures about 2 heads wide. In recent times, fashion illustrators and artists of graphic novels have created superheroes and artistic figures that are often 9 or even 10 heads tall.

The Ideal Figure

In this drawing of an idealized figure, you can observe the relationship of the different parts of the body to one another. The figure is 8 heads tall from top to bottom and 8 heads wide from tip of middle finger to tip of middle finger. As a result of these equal dimensions, the figure can easily be contained in a box, the center of which is located just above the pubic arch.

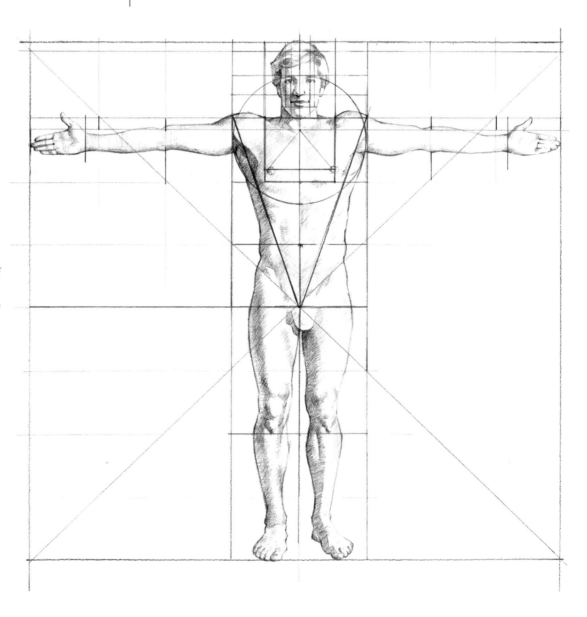

As you begin a drawing, it's helpful to keep in mind that when there's only one line on your paper, there is no sense of proportion—the first line is always correct. However, as soon as you draw a second line, proportion becomes evident and the first line may now be determined to be incorrect. That is, it doesn't relate correctly to the second line. The two lines seen together start to establish height, width and length relationships, especially if they're compared with a model. As you add more lines to your drawing, the complexity of relationships increases. As you continue drawing, you'll notice that some proportional relationships will be anatomical (such as the head, ribcage and pelvis) while others will be visual (such as those related to light and shadow or the foreshortening of an object).

As you continue to refine the drawing process, you'll find it usually works best to move from the known to the unknown—to first see broadly and then to see the finer or more complex relationships. With an idea of ideal proportions in your mind you can begin to determine how your model conforms to or differs from that ideal. You'll also notice that the slightest bending of the head or body part may alter, at least visually, those standardized proportions.

Maintaining Proportional Relationships

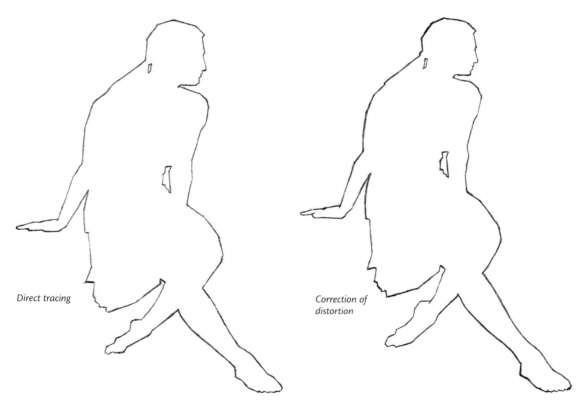

Direct tracing

Correction of distortion

Drawing from Photos

These contour drawings were made from the same photograph. The one on the left is a direct tracing while the one on the right has been adjusted to correct camera distortion. Understanding proportion can greatly aid in drawing from photos. Because the viewer assumes a photograph doesn't lie, she won't question the relationships contained in it. In reality, photographs are often distorted. For one thing, the camera is different from our vision in that it is monocular (single lens) where we are binocular (double lens). Understanding proportion will help you make necessary alterations that are based on correct relationships.

Determining Relative Sizes

Keep in mind that you only notice the head units of the entire figure when the figure is standing upright and straight. However, a clear understanding of head units will help you determine the relative sizes even in a figure that's not upright or that is foreshortened. Establish a mental picture of the size of one part of the body compared to the other parts. Remember, too, that if something *looks* wrong in your drawing, it probably *is* wrong.

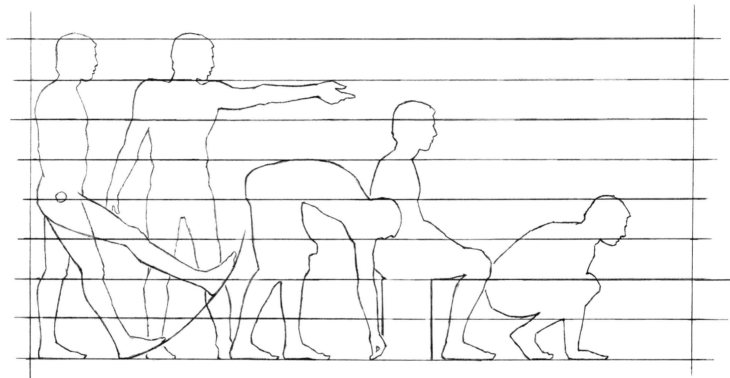

The Figure in Different Positions

In this illustration, note the relative height of the figure in different positions. A figure bending at the waist is 5 heads tall whereas a seated figure on an 18-inch (46cm) box is 6½ heads tall. Try to memorize the height of the figure in specific positions, as this will help in your overall understanding of general relationships and measurements. Once you understand the correct spatial relationship of one unit to another (i.e., the head to the foot) you will be able to relate those units regardless of the figure's position.

Using a ruler or measuring stick while you draw will make your drawings look lifeless and stilted. Skillful drawing is about skillful seeing, and the process of drawing in proportion isn't just about duplicating precisely what you see. The harmony of relationships is more important as a working objective than are predetermined ratios. That said, using a grid is a good way to practice seeing and drawing accurate proportions.

Seeing Skillfully

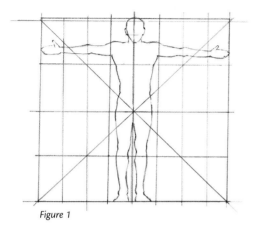

Figure 1

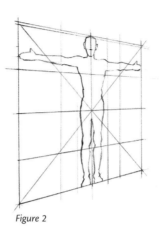

Figure 2

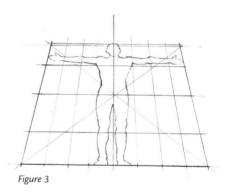

Figure 3

Drawing the Figure in Different Positions

Once you've placed the figure in a box you can practice tilting the box in different directions. Working from the measurements established in the first drawing (Figure 1), it is relatively easy to plot the figure in the foreshortened squares (Figure 2 and Figure 3).

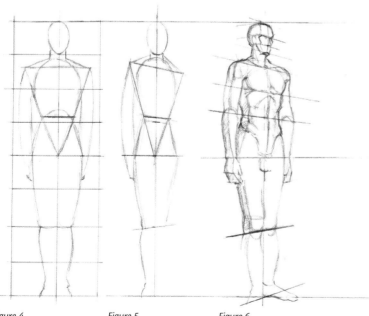

Figure 4

Figure 5

Figure 6

Moving from Two Dimensions to Three Dimensions

If you can understand and can construct a basic figure as in Figure 4, you can then tilt the figure in perspective (Figure 5) and begin to construct it as three dimensions (Figure 6).

The Relationship of Parts

As you separate the individual units of the human body into divisions you'll accurately see the relationship of one part to the other. Through the proper arrangement of individual parts, you will impart balance, harmony, and naturalism in your drawings.

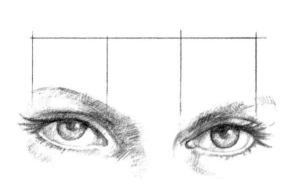

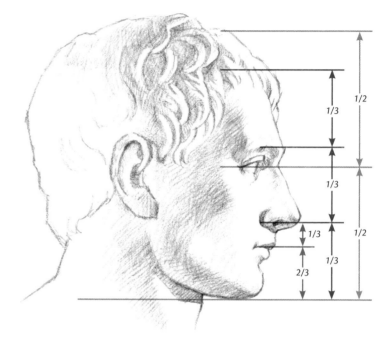

The Eyes

As you place the eyes in relationship to each other, you'll notice that there is one eye's distance between the left and the right eye.

Classical Head

Like the body, the head can also be broken down into different units. Notice how the divisions of the head help place the features in alignment.

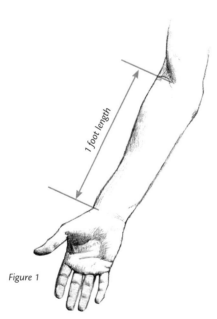

Figure 1

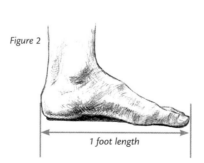

Figure 2

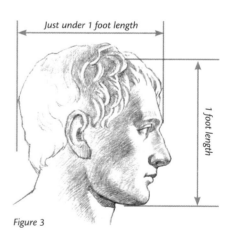

Figure 3

Relationship of the Foot

It's important to understand the relationship of the foot to other parts of the body. The length of the foot (Figure 2) is the same distance as the height of the head (Figure 3) and almost the same distance as the depth of the head. It is also aligns with the length of the inside of the forearm between the wrist and the biceps (Figure 1). Knowing the relationship between these units of the body allows you to effectively spot-check measurements from top to bottom and in the middle.

As we've discussed, to draw the parts of the figure proportionally correct is to draw them in their proper relationship to one another. Ultimately, proportion is to be felt more than plotted. What really counts is not that your drawings are accurate in reproducing what is seen (which is impossible), but that the relationships your drawing embodies are as consistent as the relationships you saw. It's the quality of consistency that will give your drawings realism and conviction.

The Quality of Consistency

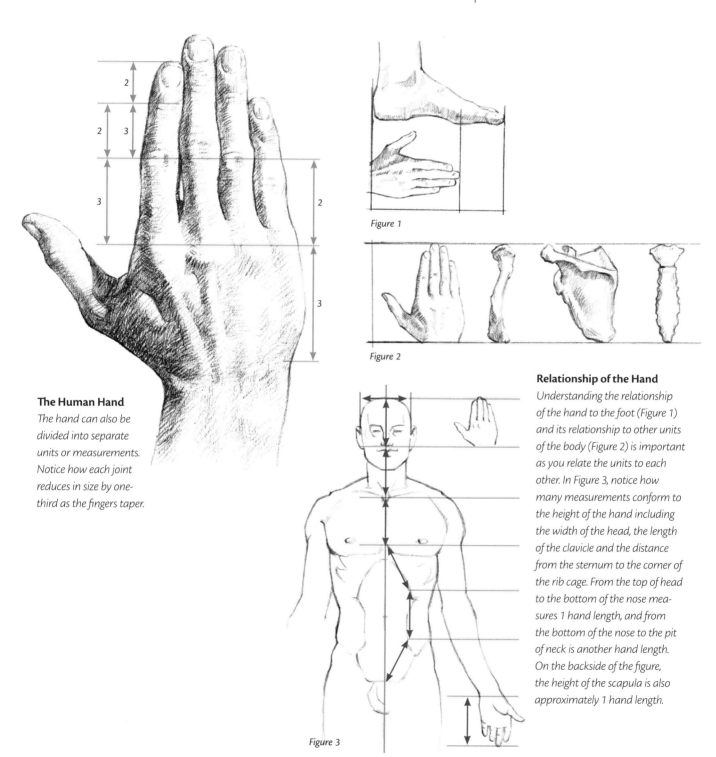

Figure 1

Figure 2

Figure 3

← → = 1 hand length

The Human Hand

The hand can also be divided into separate units or measurements. Notice how each joint reduces in size by one-third as the fingers taper.

Relationship of the Hand

Understanding the relationship of the hand to the foot (Figure 1) and its relationship to other units of the body (Figure 2) is important as you relate the units to each other. In Figure 3, notice how many measurements conform to the height of the hand including the width of the head, the length of the clavicle and the distance from the sternum to the corner of the rib cage. From the top of head to the bottom of the nose measures 1 hand length, and from the bottom of the nose to the pit of neck is another hand length. On the backside of the figure, the height of the scapula is also approximately 1 hand length.

47

Mapping, Measuring, Gridding

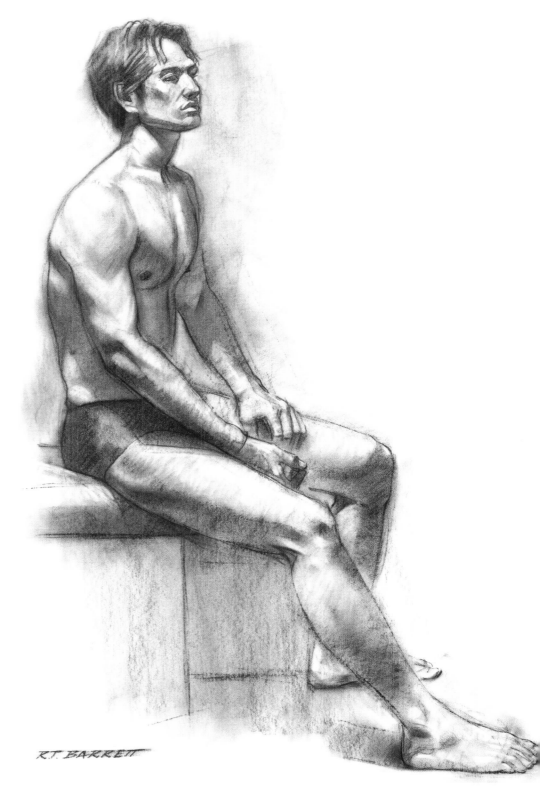

R.T. BARRETT

Mapping the Figure

This model had great anatomical definition, which made mapping his figure easier. He also had lots of energy and found it difficult to sit still. Consequently, I gave him frequent breaks.

SEATED MALE FIGURE
Nupastel on paper
30" × 22" (76cm × 56cm)
Collection of the artist

Using a grid to measure and map the figure is not a new process; in fact, there are many historical examples of gridding. Renaissance artists Leonardo da Vinci and Albrecht Dürer used the device extensively. Though some examples of gridding may seem complicated or complex, this measuring process is, nonetheless, a useful tool for adding objectivity to a drawing. Other tools used to eliminate unwanted subjectivity include mirrors, compasses and framing devices such as a viewfinder. I suggest using a simple form of gridding to plot points and angles when completing a traditional drawing because it will help you establish the correct position and dimension of proportional relationships.

Through my years of teaching, I have concluded that the practice of measuring establishes accuracy in a drawing and instills both confidence and conviction in the artist. If you know that a certain point in your drawing is accurate and that other points are correct in their relationship to that point, you're well on your way to adding conviction to the drawing process.

Using a Grid

Create an "Envelope" Around the Figure

A first step in gridding the subject is placing an "envelope" around the outside edges of the figure. It's helpful to use only straight lines during this process because landmarks will occur at intersections where the angle of each line changes direction.

Plot the Inside Landmarks

After you establish the envelope and create the outside angles and proportions, look for inner landmarks. These are often located at points where two angles intersect or at "hard places" where the skeleton is close to the surface.

Using a grid and landmarks for accuracy

MATERIALS LIST

Kneaded eraser

Nupastel stick

Paper towels

Sanding block

Sketch paper

After setting up an initial gesture drawing, use a grid to help establish relationships and proportions. This process includes using landmarks and either lines or angles. As you begin, look for the strongest angles or lines on the outside of the model. Then try to duplicate those general angles as closely as possible with lines. Simultaneously, note the points where lines change direction. It's helpful to hold your charcoal or pastel up to the model to assess the exact angle of an outside surface, then transfer it directly to your drawing surface. Assess the length of the line as much as possible. Lines don't actually exist in space but are a contrivance to help separate spaces and boundaries between objects and values.

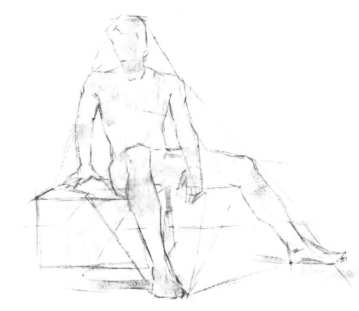

1 Start with the Angles and Big Shapes

As you begin drawing, place large areas of value lightly on your paper. Look for the big shapes and the overall silhouette of the figure. Pay particular attention to the angles of the shapes.

2 Define the Angles and Shapes

After you've ghosted in the figure in Step 1, begin to define the specific angles and shapes. At this point, look mainly at the outside contours and assess the relative distances between your points.

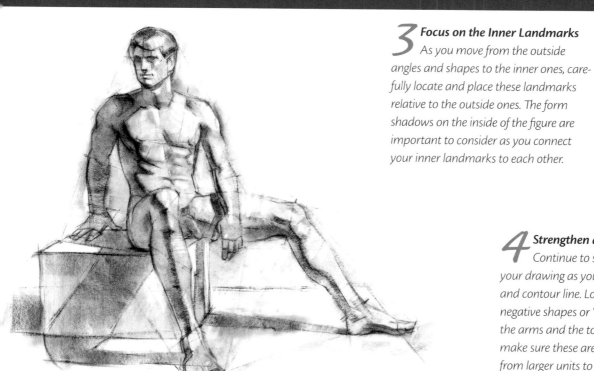

3 Focus on the Inner Landmarks

As you move from the outside angles and shapes to the inner ones, carefully locate and place these landmarks relative to the outside ones. The form shadows on the inside of the figure are important to consider as you connect your inner landmarks to each other.

4 Strengthen and Adjust ▼

Continue to strengthen and clarify your drawing as you define each shape and contour line. Look closely at the negative shapes or "windows" between the arms and the torso, for example, and make sure these are correct. As you work from larger units to smaller ones, add more detail.

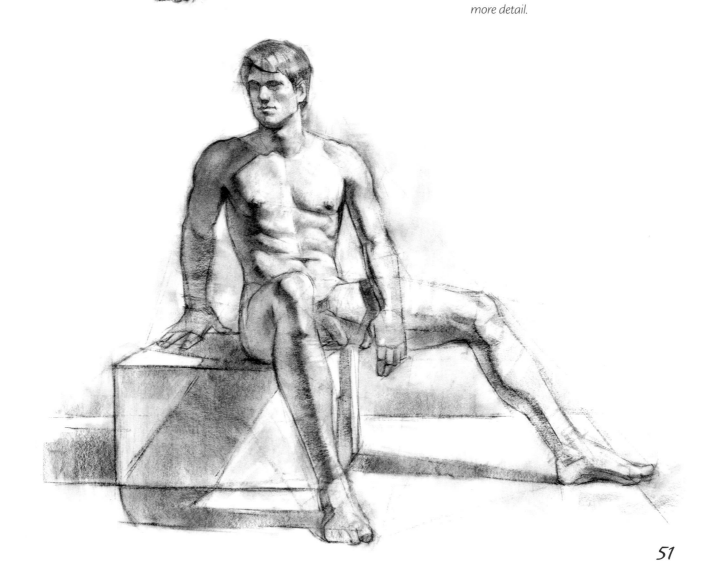

Vertical and Horizontal Plumb Lines

Check Your Points

When you've completed the lines around the figure, you'll have an envelope from which to make other measurements. It's also useful to check your landmarks (where the angles change directions), by using vertical and horizontal *plumb lines*. Plumb lines are vertical or horizontal lines that remain constant and are another objective device that will help you determine if your proportions and relationships are correct.

Don't hesitate to locate the same point by using more than one angle or measurement to assess its placement; the old adage, "measure twice, cut once" holds true here. Sometimes the technique of locating the same point with more than one angle is known as triangulation, where three lines intersect at a common location. This might be the point where a vertical, a horizontal and a diagonal line intersect, or it may be where three separate diagonals intersect. This principle could be utilized in determining landmarks where as few as two lines intersect or where many intersect, as with the center of a wagon wheel.

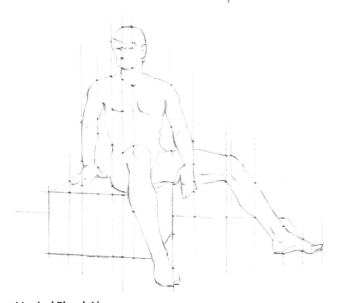

Vertical Plumb Lines
As you check the relationship of one form to another, it's helpful to use a series of vertical plumb lines.

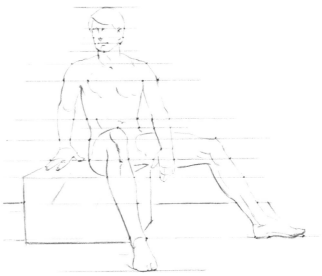

Horizontal Plumb Lines
Notice how different landmarks appear along the same line.

Diagonal Lines and Triangulation
Use diagonal lines to locate landmarks and establish the distances between them. Points where several lines intersect are important and can act as the point from which you can establish the location of other landmarks.

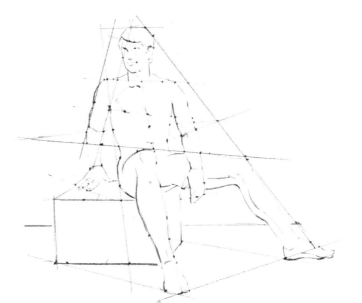

The care you give to the measuring process is critical as it will influence each decision that follows. Moving from one correct area (landmark or angle) to another helps ensure that all parts are related in their accuracy or correctness. The envelope you've created implicitly contains the ratios and proportions of your model. The specific subdivisions of the model can, in turn, be determined as they relate to the envelope and to your initial lay in.

Precision Counts

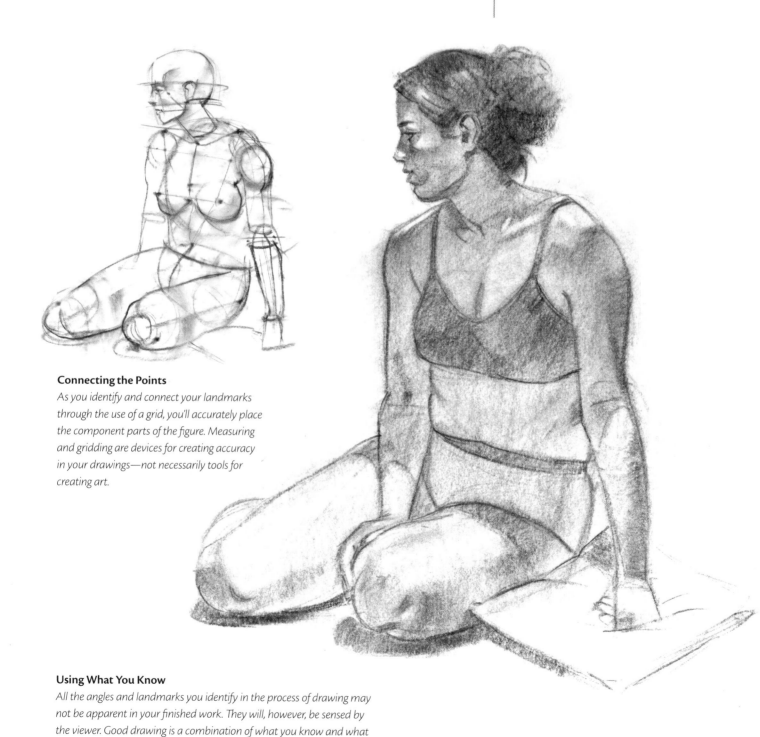

Connecting the Points

As you identify and connect your landmarks through the use of a grid, you'll accurately place the component parts of the figure. Measuring and gridding are devices for creating accuracy in your drawings—not necessarily tools for creating art.

Using What You Know

All the angles and landmarks you identify in the process of drawing may not be apparent in your finished work. They will, however, be sensed by the viewer. Good drawing is a combination of what you know and what you see.

Map the Structure Underneath

Now that you've located the outside landmarks and angles and checked that they're correct, it's time to work on those inside. In the case of the human figure, the landmarks are often designated as points on the skeleton. Simply put, these are points where the skeleton is close to the surface. Some knowledge of simple anatomy and an understanding of the skeletal structure underneath is helpful in knowing which landmarks to look for and in assessing whether or not they are in the right locations. These landmarks or *hard places*—where the bone is close to the surface—are excellent points from which to make measurements. Again, you'll determine the precise angles, and check the vertical and horizontal plumb lines to articulate these locations. These points can then work as the hub of a wheel from which other landmarks can be determined.

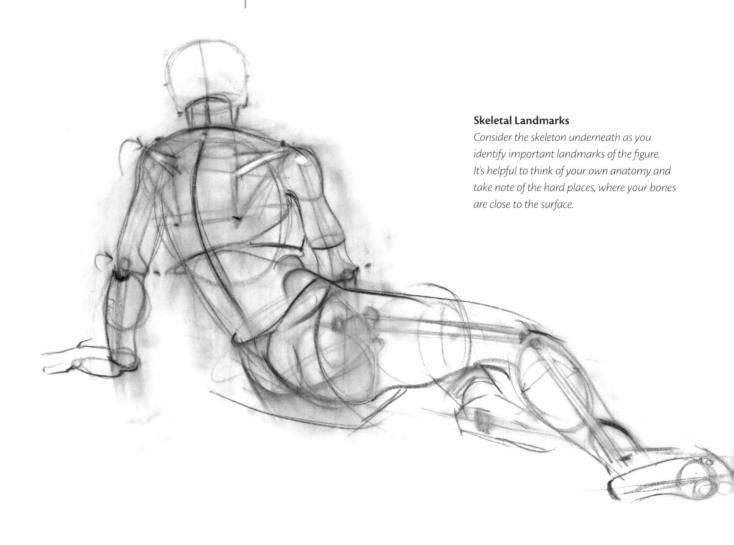

Skeletal Landmarks
Consider the skeleton underneath as you identify important landmarks of the figure. It's helpful to think of your own anatomy and take note of the hard places, where your bones are close to the surface.

Another obvious place inside the figure from which to make measurements is the edge of the core shadows that run between the light and shadow side of the model. Sometimes this edge is called a *form shadow*. The edge of the cast shadow is likewise a helpful place to continue mapping. Notice that the edges of the core shadows are much softer than those of the cast shadows.

Measure and Map Shadow Edges

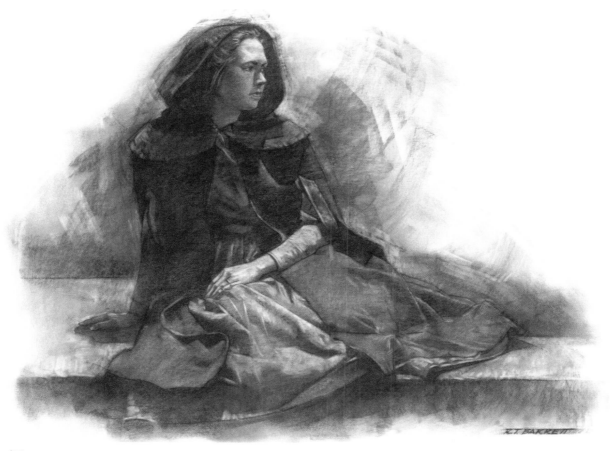

Draped Figure

Whether you draw an undraped figure or a draped one, using landmarks and angles establishes relationships and proportional accuracy. It's a useful way to translate a three-dimensional object onto a two-dimensional surface.

Three Plumb Lines at Once

In this diagram of the draped figure three types of plumb lines are used simultaneously (notice this is another example of triangulation). As you become familiar with the tools for measuring, you'll find you can easily alternate using vertical, horizontal and diagonal lines. Also notice that some shadow edges have been mapped out as well.

Contour Lines

After you accurately locate and place the landmarks, draw the contour lines. Because the landmarks are accurate, you can draw the contour lines with great conviction and "lock in" additional shapes with relatively little effort. Draw the lines carefully on either the outside or the inside of the figure to add a sense of authority and an element of detail to your drawing.

Practice Leads to Understanding

The most important element of learning to grid is practicing the process in everything you draw. It's much easier to understand the concept than it is to develop the habit of implementing it consistently.

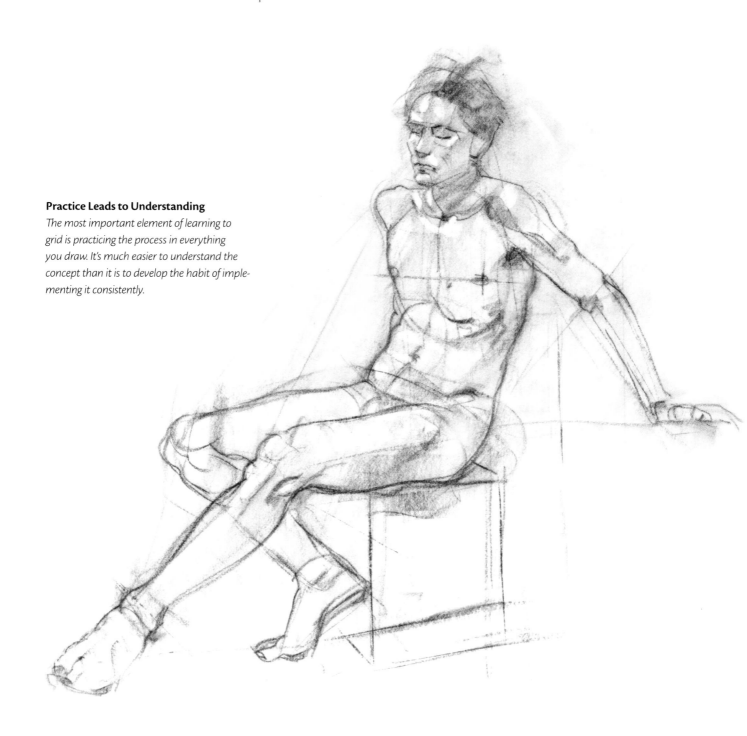

As you continue to use the tools associated with gridding and measuring, you can try different variations, such as working from the inside out or both inside and outside at the same time. Eventually, you should be able to use these tools in various orders of succession. The process becomes not mere drudgery but both entertaining and exciting as you develop your skill in establishing and refining important relationships.

Try Variations on a Theme

Pulling It All Together

As you practice and internalize the processes of measuring, try varying the order. Work from inside out as well as from outside in. Look for big angles and small angles at the same time, and be specific with your shapes and contours.

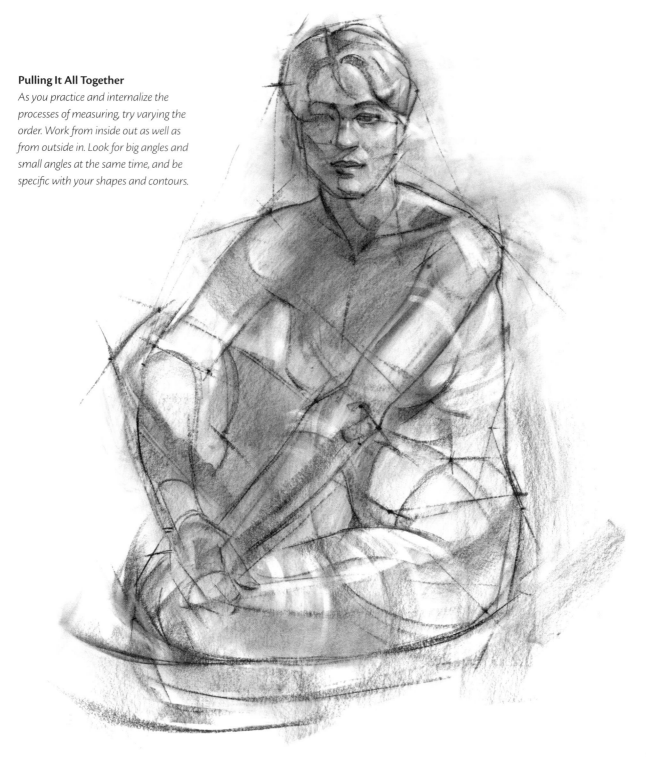

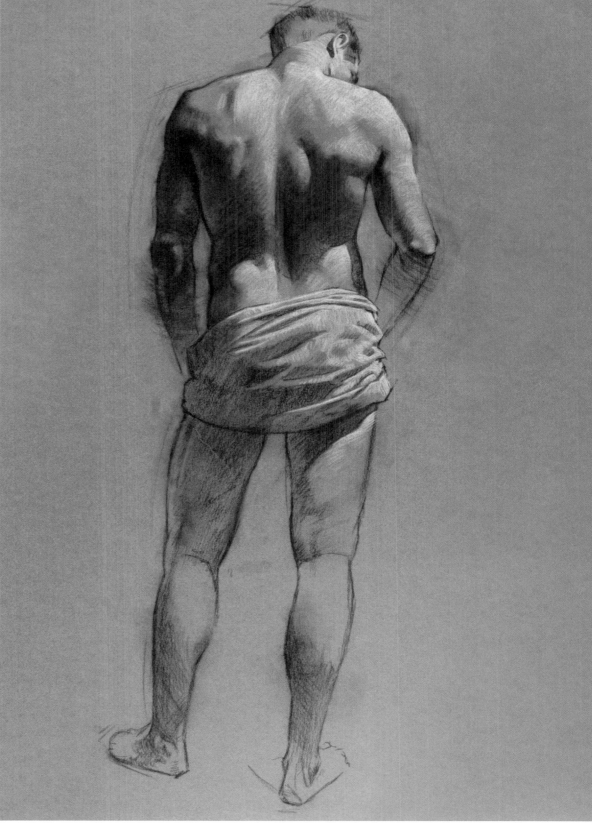

6

Design Anatomy

Design of the Human Figure

This drawing represents an overt attempt to optimize the design inherent in the human figure. It begins with the contrapposto position (see page 66) of the model and includes additional aspects of design anatomy.

STANDING MALE FIGURE
Charcoal and white pastel on toned paper
25" × 19" (64cm × 48cm)
Collection of the artist

I once heard a story about how Andrew Wyeth's father helped him learn to draw the human skeleton. Apparently, Andrew was instructed to spend several days drawing a skeleton. One day his father entered the studio, removed the skeleton, and asked Andrew to draw it from memory. Andrew found that although he had spent many hours rendering the skeleton, he had only a limited understanding of it. Among other things, he didn't understand the design of it and was therefore not able to draw it once he no longer had it to look at. He remarked that it was a humbling but memorable learning moment.

This just shows how easy it is to take things for granted. Being aware and observant are qualities that help you understand and appreciate the things around us—excellent qualities for any artist to have and to cultivate.

Know Your Subject

Classical Male Figure

As you learn to understand design principles, I suggest you draw from classical figures whenever possible. The ancients had a sound knowledge of design anatomy and relationships.

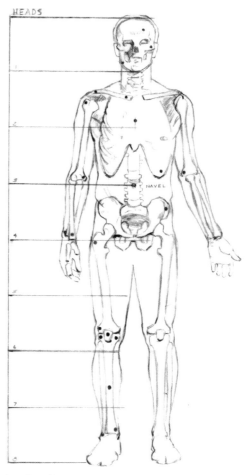

Landmarks

In this diagram of a standing figure, the places where the skeleton is close to the surface are indicated. Think about your own body and continue to develop an awareness of where your bones create hard places and surface landmarks.

Move Beyond Physiology

Knowing something well doesn't mean you can draw it well. A physician, for example, may know a lot about anatomy of the human body yet not know how to draw it well. Knowledge of human anatomy by itself is not sufficient to draw the figure convincingly. You also need an understanding of design anatomy. Design anatomy is different from actual or physiological anatomy in that it incorporates proportions and relationships, landmarks and measurements, orientations and alignments. It's the reason an accomplished artist can draw the figure in a way that an accomplished medical practitioner cannot.

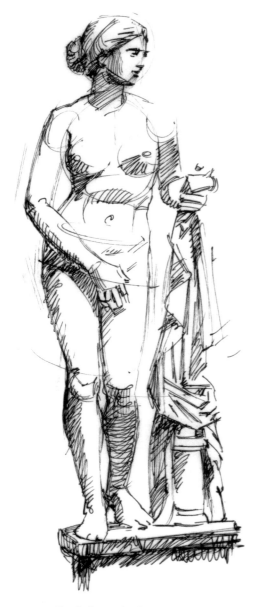

Classical Female Figure

This drawing from my sketchbook is a quick study of a classical figure. As you make your own studies from classical forms, be aware of the classical design intended by the artist, as well as the strong sense of idealization incorporated into the artwork.

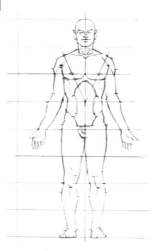

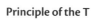

External Symmetry

In this diagram the external symmetry of the human body is obvious. Learn the landmarks on the figure—especially those that are parallel to each other. Additionally, learn their significance with regard to the large and small divisions of the body.

Principle of the T

In these studies of a famous work of art, you can easily see how the principle of the T is helpful (see pages 62 and 81). Here, the principle of the T helps align both the features of the head and the larger masses of the body. As the midline shifts, so do the perpendicular angled lines related to it. However, these lines always remain at right angles in relation to the midline.

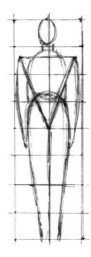

Keep It Simple

This diagram is deceptively simple in what it communicates. It includes important landmarks related to symmetry, simple geometric shapes, proportional relationships and the concept of opposites. Memorize it and you're well on your way to executing a convincing figure drawing.

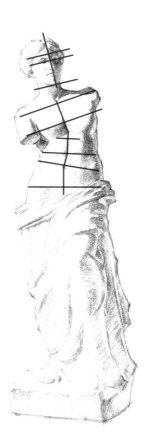

Design anatomy, with all of its various components, is difficult to address adequately in a single chapter. Many of the principles associated with it dovetail with concepts covered in other chapters of the book. However, there are some basic concepts whose applications will add significantly to the conviction of your drawings. These concepts: symmetry, shape, proportion, memory, opposites and observation, are significant enough to warrant a separate chapter especially as they become visual tools and strategies that dramatically aid the understanding of what you are drawing. It is important in the process of learning, however, that you not confuse method with message.

Add Conviction

WHAT YOU KNOW AND WHAT YOU SEE

As you proceed in your development as a draftsman, it's important to be aware of two points of view related to drawing in general:

1. THE LITERAL APPROACH. Art is the imitation of nature (what you see).

2. THE CONCEPTUAL APPROACH. Art is a concept of the ideal (what you know).

A primary requisite of the creation process is the ability to draw from your memory and imagination.

Sketchbook Studies

In these sketchbook studies you'll notice my markings related to the construction of the human form. I use the alignment of landmarks as well as gesture, symbol and principles of construction. Your sketchbook is a great, low-risk place to practice as you make observations and incorporate them into your work.

Symmetry

The fact that the figure is symmetrical on the outside is a phenomenon that's often overlooked in drawing the human figure. As you observe the symmetry of the body, you become aware of certain landmarks which can indicate important points, lines, corners or connections. Often these landmarks are aligned with physiological structures, such as where bones are close to surface (e.g., the corners of the rib cage or the ridge of the clavicle). Landmarks can also be found where muscles originate or insert or where they change directions.

Landmarks are found on both sides of the body and are parallel to each other. In addition, these points are usually at right angles to the form's central axis—often referred to as the *midline* or *medial arc*. It's helpful, therefore, to be aware of the *T principle*. Among other things, this principle means that when a central axis changes, the landmarks or corners proximate to it remain at right angles in their relationship to the axis).

Additionally, the T principle means that landmarks only move in ways that are consistent with each other and with their location to the axis. (Landmarks can also be of significant value in their ability to accentuate the shift or tilt of the axis.

The principles associated with symmetry can be used in both large and small divisions of the human form. They can be applied while drawing the torso and appendages, as well as in defining the divisions of the head.

Principles of Construction

As you learn to construct the figure from your imagination, it's critical to break things down into simple shapes that are easily understood. Try to understand the sizes of those shapes in relation to each other, as well as how midlines and landmarks facilitate your ability to be effective.

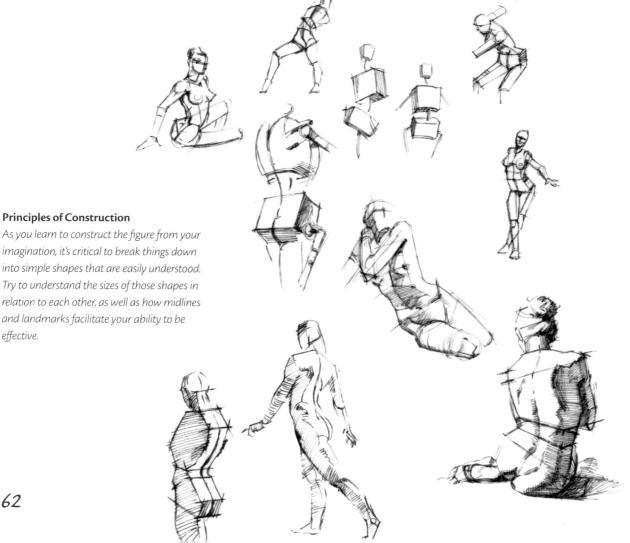

Most people find it easy to memorize simple geometric shapes. In chapter three, we discussed the importance of seeing simple shapes in the more complex structures of the figure. This ability is particularly helpful in understanding and using design anatomy. It is important to perceive the figure in terms of its major design units, as it is these structures that create the major masses affecting the outside shape of things. One approach to drawing consists of breaking basic design units into increasingly smaller components and while another consists of breaking down complicated structures into simpler ones. Both approaches accentuate the design relationships already inherent in the human body. Complex entities of the human figure can also more readily be understood as they transition into simpler structures from which additional characteristics may be developed and refined. The smaller pieces are important but need to be subordinate to the larger ones.

Geometric Shapes

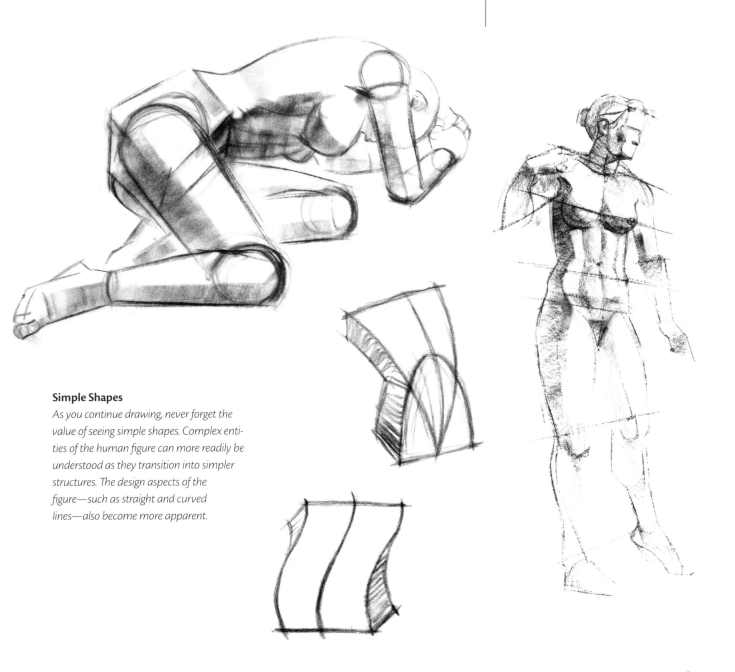

Simple Shapes

As you continue drawing, never forget the value of seeing simple shapes. Complex entities of the human figure can more readily be understood as they transition into simpler structures. The design aspects of the figure—such as straight and curved lines—also become more apparent.

Proportion and Relationships

Some artists have spent their entire careers trying to find and communicate ideal human proportions. Proportion is another important element of design anatomy and an aid in helping to draw the figure correctly. Proportion establishes standards for relationships that exist within a particular figure, as well as relationships that exist in figures of different construction, age and gender.

Internalizing the Relationships

As discussed in chapter four, it's important to understand the proportional differences between an adult male and an adult female, as well as those between an adult and a child. Once you understand and internalize these relationships, you'll be able to accurately draw an adult male or female form in a generalized way from your imagination. Keep in mind that it would be difficult for any artist to anticipate and draw convincingly, from their imagination alone, the idiosyncrasies and subtleties of any one model under a particular lighting situation.

The Thread That Binds

In addition to proportional relationships, there are also design relationships related to the *rhythm*, or line, of a figure or appendage. Rhythm refers to an element that ties or connects other things together. It can be the "thread" flowing through units or objects that provides continuity and unity. It may be associated with the action or gesture of the figure or merely with its general construction. It's also a tool for contextualizing individual or isolated forms—the line of an arm, or the S-curve or double-S-curve of the spine, for example.

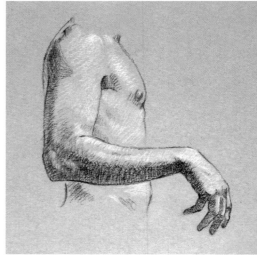

The Contour Will Change
The contours of the body will change with position and movement. In these drawings of the arm you'll notice how significantly the contour of both the upper and lower arm changes in relationship to the positioning of the hand.

Helpful Tools
In the arm on the left, you'll notice how the use of a shaft through the center helps define the contour of the arm on both sides as they each relate to the shaft. In the arm on the right, you'll notice how the midline through the arm articulates its motion or rhythm while the perpendicular lines help determine the relationships of landmarks on the contour of the arm to each other.

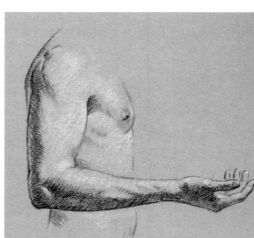

Relationships aid memory, which in turn aids in speed of execution. The beginner sees or memorizes isolated facts while the master sees relationships. *Clustering* is a design process used to aid our ability to remember, and involves creating a relationship in things that might otherwise not seem to be connected or are typically connected in a different way. Think, for example, of the way numbers are grouped to help you memorize your telephone or social security numbers quickly. With the figure, an example of clustering might be the way the head, thorax, and pelvis are linked together, or the way the volumes of a leg are positioned relative to each other. Master artists, including Leonardo da Vinci and Albrecht Dürer, took measurements and made hundreds of notations of their observations in drawings of the human figure. As most people don't have photographic memories, the drawings were probably needed to hold, share and revive the memories of these observations.

Memory

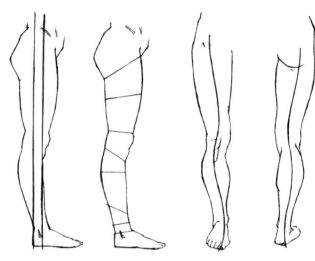

A Different Context

In these diagrams of the leg, you can see a different application of the same tools used in the drawing of the arms. You'll notice in the two drawings of the legs on the right the reciprocal curves of the front and back views of the legs.

Clustering

This drawing illustrates the alignment of pearls on a string. As you organize forms on the midlines of your figure, establish the character and position on the lines first. Clustering forms will also help you memorize their size and relationship.

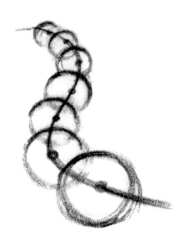

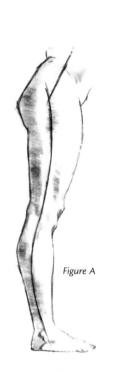

Figure A

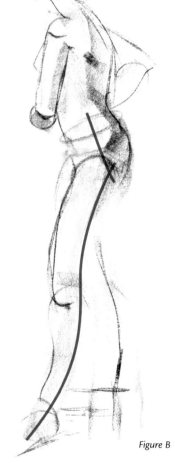

Figure B

Inherent Rhythms

In Figure A you can see how the internal midline helps establish the overall form and gesture of the leg in profile. In Figure B you can see how the line of the leg relates to the rest of the body.

The Concept of Opposites

An essential principle of design that also relates to the human figure is the "concept of opposites." The use of opposites, or *contrast*, exists in all the arts to create interest. In the human figure, a *contrapposto* position, where the weight is on one leg, is usually more interesting than one where the weight is equally balanced on both legs or throughout the figure. Each opposite helps strengthen and clarify the other.

It's helpful to use the concept of opposites when drawing the human figure to explain the nature of specific forms. A straight line helps define a curved line, and a large shape helps explain a series of small ones. The chair that supports the model can be a great aid in understanding the model that sits on it.

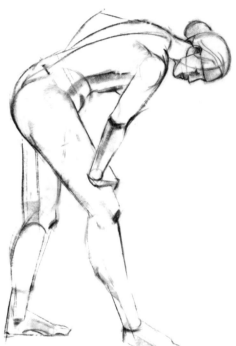

Opposing Lines ▲

In this simple drawing, you'll notice how the figure has been reduced to a series of straight and curved lines. Each opposite helps to strengthen and clarify the other. Used together, opposites advance the design inherent in your drawings.

Lines That Accent ▶

This sketchbook study was made from an Art Deco sculpture by artist Paul Manship. Notice how the straight lines of the base accentuate the predominant curves in the remainder of the sculpture.

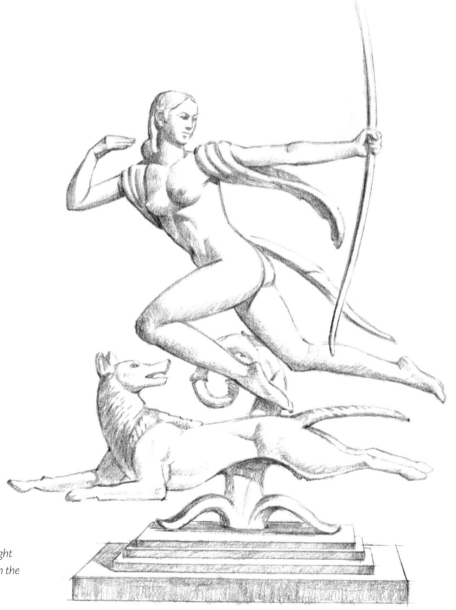

When you understand the principles of design anatomy, you can draw from life with more conviction than you would if you merely copied what you saw. This brings us back to the two viewpoints of perception—what you know (or idealize) and what you see (or look at). In most great drawings, you can perceive the evidence of both viewpoints which creates an important balance that you should strive to include in your own work. Principles related to symmetry, geometric shapes, proportions and relationships, memory and the concept of opposites will help you identify and understand more clearly the design and esthetic structure of what you're drawing.

See More Clearly

Balance

The principle of balance is another important element of design related to drawing the human form. For instance, as one leg moves back, the arm on that side of the figure moves forward. Regardless of the action or position of the figure, the form is balanced on both sides of a central vertical line.

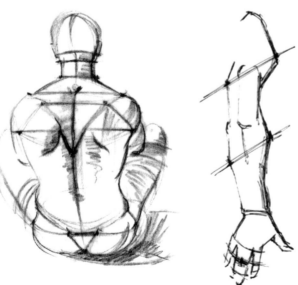

Human Anatomy

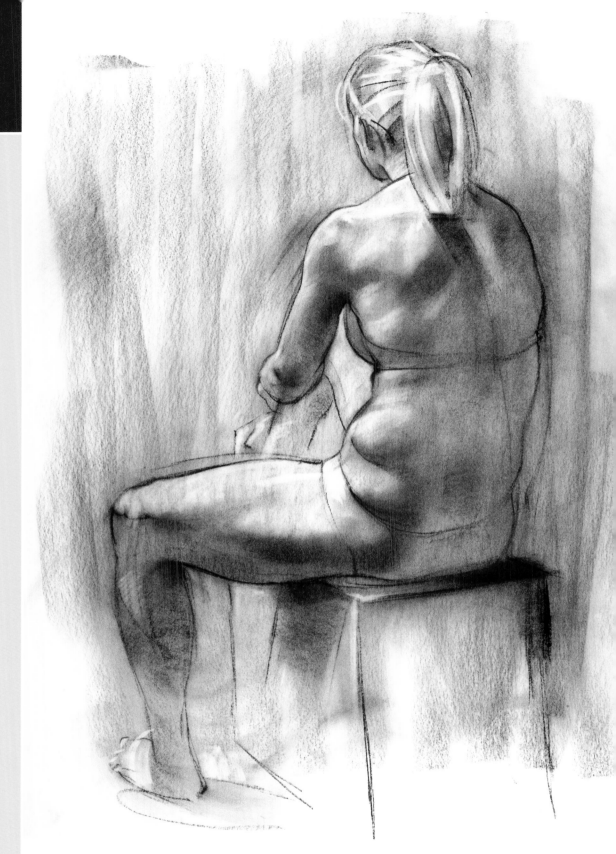

Conviction and Articulation

An understanding of anatomy will give your drawings conviction and a sense of specific articulation.

SEATED FEMALE FIGURE
Nupastel on paper
25" × 19" (64cm × 48cm)
Collection of the artist

Artist Vincent van Gogh supposedly invested in a book on anatomy. He felt that, though it was very expensive, it would last him his entire life. In this chapter we cover just a few of the essential elements related to human anatomy. Entire books are devoted to the subject, and there are several excellent titles available. I recommend you consult one that fits your particular interest as the need arises.

The human form is a marvel of design and engineering, but without a basic knowledge of its structure and composition, its complex mechanism may be mysterious and difficult to understand. Referencing a drawing done by a fellow student, my anatomy teacher remarked that he couldn't tell the difference between the knee in the drawing and a bag of walnuts. He explained that the student had rendered lots of bumps and lumps in his drawing, but there seemed to be no meaningful integration of the bumps and lumps. While my instructor was able to see the anatomical relations that existed below the surface, my classmate had only rendered what he'd seen on the surface. A more complete understanding of anatomy will allow you to draw both what you know and what you see, which greatly enhances the depth of realism and conviction in your drawings of the human form.

Anatomical Knowledge Is Key

The Parts of the Skeleton
The human skeleton is separated into two distinct units. The axial skeleton *is made up of the head, rib cage and pelvis, and forms the axis and central architecture of the figure. The* appendicular skeleton *consists of the limbs or appendages, which have more to do with motion and leveraging. They turn and bend freely as they adjust to their environment.*

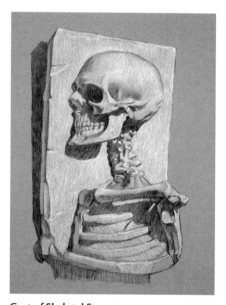

Cast of Skeletal Structure
In this cast drawing you can see the relationship of the skull to the spine, shoulder and thorax.

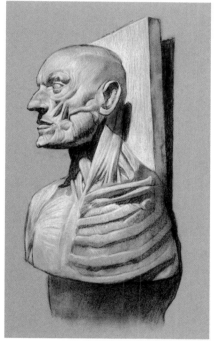

Cast of Muscular Structure
In this cast, which is proximate to the skeletal cast, you can see how the muscles of the head, shoulder and thorax are woven around on top of the supporting armature. Because of its dimensional nature, a cast approximates a live model.

A WORD OF CAUTION

Remember, proportion is about overall relationships and how individual parts relate to each other and to the whole. The study of anatomy is about the individual parts. When studying anatomy, avoid observing anatomical detail to the point where you lose sight of the figure in totality. Your goal is to increase your knowledge of specific anatomical form so you can communicate specific structures with conviction.

The Basics of Anatomy

Your study of anatomy includes an overview of the structure of bones and muscles. In addition, we'll cover joints and their interrelation to various parts of the body. It is not as critical to memorize all the names of the bones and muscles as it is to learn their shape, location and function. As you come to know each entity and its function, you'll also likely memorize its name or description. Using this terminology is often unavoidable, and you may find that doing so heightens your awareness of a structure's presence and uniqueness. I find that understanding basic terminology also helps me describe location and placement. *Medial*, for example, means toward the middle of the figure, while *lateral* means away from the middle of the figure. *Inferior* describes an position that is low and *superior* describes a position that is high. *Posterior* means behind, while *anterior* means on the front side. The superior, anterior crest of the ilium, for example, indicates of a very specific landmark.

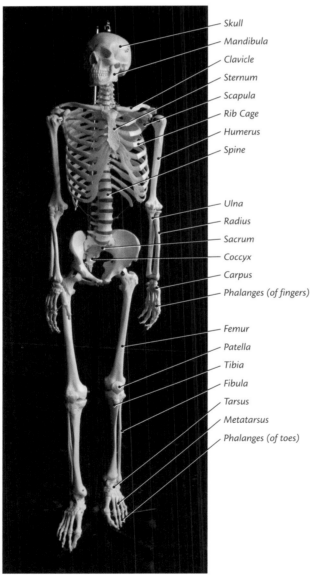

Skull
Mandibula
Clavicle
Sternum
Scapula
Rib Cage
Humerus
Spine

Ulna
Radius
Sacrum
Coccyx
Carpus
Phalanges (of fingers)

Femur
Patella
Tibia
Fibula
Tarsus
Metatarsus
Phalanges (of toes)

Anterior View of Skeleton

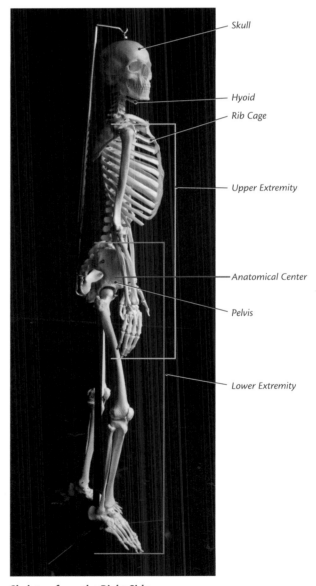

Skull

Hyoid
Rib Cage

Upper Extremity

Anatomical Center

Pelvis

Lower Extremity

Skeleton from the Right Side

Referring to his study of anatomy at the Art Students League of New York, illustrator Norman Rockwell remarked that his teacher, George Bridgman, repeatedly told students that they couldn't decorate a house until it was built. The implication was that a foundation holds up the house and the framing gives it overall shape. In the human body, the skeletal system gives form and support to the figure and is the base to which all the muscles attach. It functions as an armature does in a sculpture and is the primary factor in creating the proportion of a figure. The skeleton is apparent at many points on the surface, and though muscles may hide the bones in many places, their overall shape and direction is dictated by the skeletal structure. The skeleton also indicates gender and age.

The Skeletal System

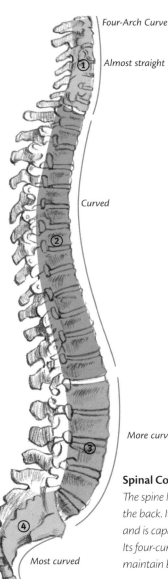

Four-Arch Curve

Almost straight

Curved

More curved

Most curved

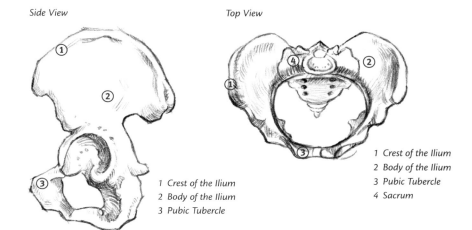

Side View

Top View

1 Crest of the Ilium
2 Body of the Ilium
3 Pubic Tubercle

1 Crest of the Ilium
2 Body of the Ilium
3 Pubic Tubercle
4 Sacrum

Pelvis

The pelvis occupies a large portion of the hip region yet is only discernible on the surface in a few places. The ilium provides the socket joint for the femur and the sacrum provides a pedestal for the spine.

Rib Cage

Skull

Scapula

Spinal Column

The spine lies across the whole midline of the back. It is both curved and tapered, and is capable of supporting great weight. Its four-curve nature also allows it to maintain balance.

Parts of the Spine
1 *Cervical*
2 *Thoracic*
3 *Lumbar*
4 *Sacral*

The Rib Cage, Skull and Scapula

Flat bones such as the rib cage, skull and scapula are designed primarily to protect the internal organs. The scapula and the pelvis each play an important role in movement.

Four Types of Bones

The skeleton is made up of four bone types—long, short, flat and irregular. Each type is designed to facilitate different functions. Long bones, for example, often act as levers and are designed to accommodate movement. Flat bones serve mainly for protection. I recommend having access to a dimensional skeleton that can be examined from all directions. Full-scale models are available from medical catalogs; smaller models are available online or from art supply stores.

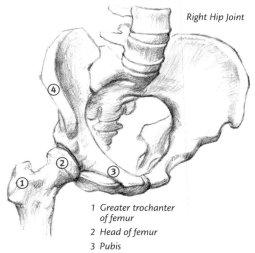

Right Hip Joint

1 Humerus
2 Radius
3 Ulna

Prone view

Supine view

Bones of the Lower Arm

In addition to the hingelike joint at the elbow, which flexes and extends the lower arm, the ulna and radius can turn the hand faceup (supination) or facedown (pronation). The ulna is large at the elbow and small at the wrist; the radius is just the opposite.

1 Greater trochanter of femur
2 Head of femur
3 Pubis
4 Iliac crest

Right Shoulder Joint

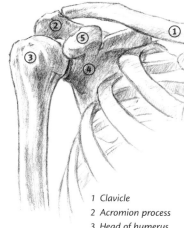

1 Clavicle
2 Acromion process
3 Head of humerus
4 Scapula
5 Corocoid process

Figure 1

Figure 2

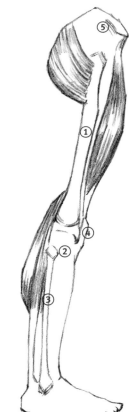

Right Elbow Joint

1 Humerus
2 Medial epicondyle
3 Lateral epicondyle
4 Olecranon process
5 Crest of ulna
6 Radius

Joints of the Hip, Elbow and Shoulder

To understand and portray realistic movement and posture, you must to know where joints are located and the range of movement they facilitate.

1 Femur
2 Tibia
3 Fibula
4 Patella
5 Ilium

Bones of the Leg

In Figures 1 and 2 you can observe what happens when the knee is bent. In Figure 3 note the oblique angle of the femur from the hip to the knee. In Figure 4 note how the musculature of the leg reinforces the rhythm established by the skeletal structure underneath.

Figure 3

Figure 4

The muscular system gives definition to the human form. The muscles weave around the skeleton and become agents of movement, as well as stabilizers of posture. If the skeletal system serves as the structural base, it's the muscular system that does the work. And while the skeleton is constant, the muscles are dynamic, which can make them more difficult to learn. Each muscle has its own personality and inherent shape, but those shapes change through movement and work.

The Musculature

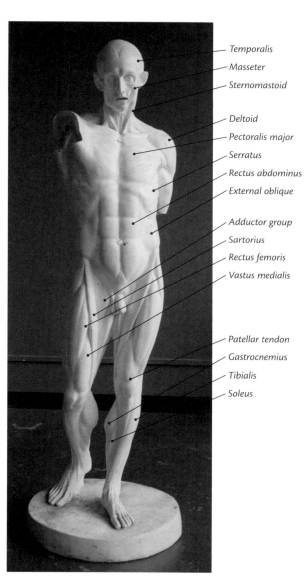

Temporalis
Masseter
Sternomastoid

Deltoid
Pectoralis major
Serratus
Rectus abdominus
External oblique

Adductor group
Sartorius
Rectus femoris
Vastus medialis

Patellar tendon
Gastrocnemius
Tibialis
Soleus

Anterior View of Muscles

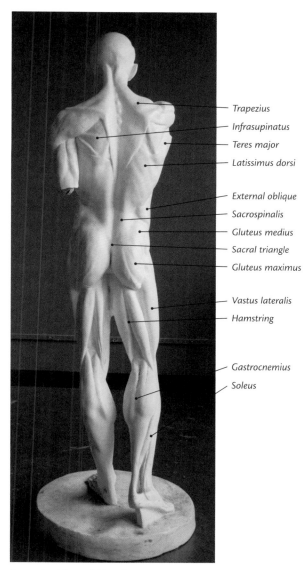

Trapezius
Infrasupinatus
Teres major
Latissimus dorsi

External oblique
Sacrospinalis
Gluteus medius
Sacral triangle
Gluteus maximus

Vastus lateralis
Hamstring

Gastrocnemius
Soleus

Posterior View of Muscles

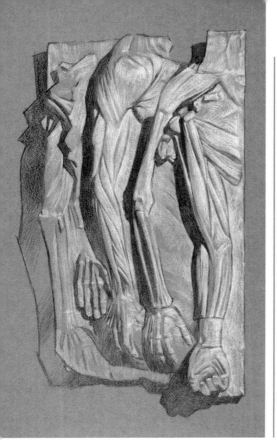

Two Types of Tissue

All muscles are composed of two types of tissue—muscle fiber and tendon. *Muscle fiber* constitutes the main body of the muscle, which is responsible for all contractions. Bundles of fiber unite to perform specific actions and modify the form of the muscle. The *tendon* tapers off the end of a muscle and attaches to the skeleton. Each muscle attaches in the same place, moves the same body parts, and contracts in the same manner for every individual—like proportional relationships, it is something we all have in common.

Origin and Insertion

When a muscle is in use, its fibers contract as they draw together and swell in girth. One end of the muscle tends to be fixed while the other end is moveable and advances toward the fixed end during contraction. The end where the attachment is fixed is the *origin*; the end that's moveable is the *insertion*. You can purchase inexpensive, color-coded charts that show the origin and insertion of every muscle. It's interesting to note when examining such a chart how much greater the volume occupied by the origins is compared to the volume occupied by the insertions. The points of attachment determine the nature of the movement and often operate across the joints they bridge.

Anatomy of the Arm

At the university where I teach we have several anatomical casts of human body parts. They're excellent resources for studying the relationship between the deep and superficial anatomical structures.

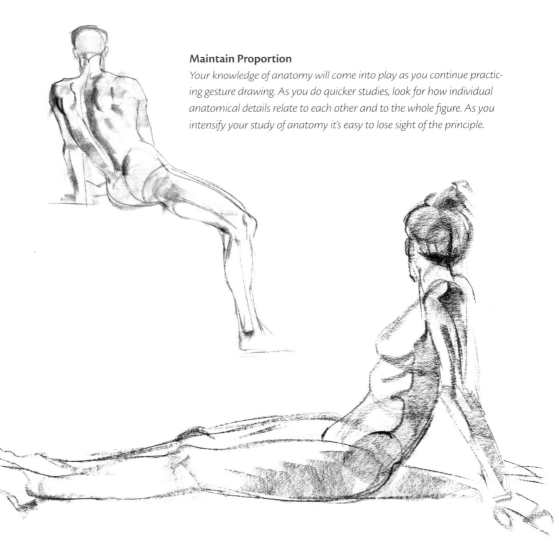

Maintain Proportion

Your knowledge of anatomy will come into play as you continue practicing gesture drawing. As you do quicker studies, look for how individual anatomical details relate to each other and to the whole figure. As you intensify your study of anatomy it's easy to lose sight of the principle.

Contraction

All muscles are capable of two types of contraction—concentric and eccentric. *Concentric contraction* causes a muscle to shorten—sometimes up to half its length. Concentric contraction takes place toward the center of the muscle and causes the characteristic bulge seen in bodybuilders. *Eccentric contraction* isn't nearly as visually dramatic. Its function is to cause a muscle to lengthen under tension. A muscle that lengthens while under tension might insure the controlled descent of specific part of the body in a given situation.

Muscle Types

The most common muscle type is *fusiform*, or spindle-shaped. Other types include *penniform*, which resemble a one-sided feather, and *bipenniform*, which look like a two-sided feather. The number of fibers contained in a muscle determines its strength. *Long-fibered* muscles are efficient muscles, whereas *short-fibered* muscles are stronger. A heavy job generally requires larger muscles.

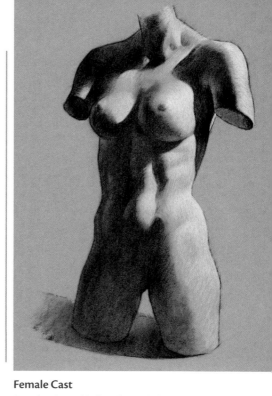

Female Cast
Drawing from this female cast helps my students understand how the female structure differs from that of the male. It allows them to see anatomy with the "skin on," as well.

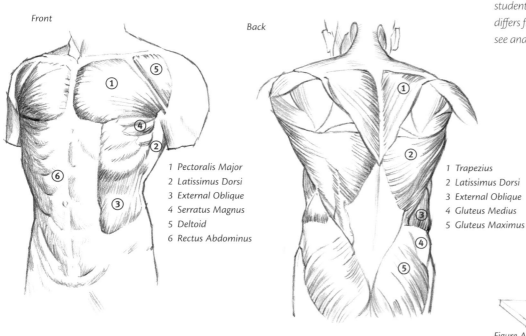

Front

Back

1 *Pectoralis Major*
2 *Latissimus Dorsi*
3 *External Oblique*
4 *Serratus Magnus*
5 *Deltoid*
6 *Rectus Abdominus*

1 *Trapezius*
2 *Latissimus Dorsi*
3 *External Oblique*
4 *Gluteus Medius*
5 *Gluteus Maximus*

Figure B

Figure A

Muscles of the Torso
The front of the torso is made up of the chest, abdomen and hips. The chest and the pelvic area are stable, while the abdomen is moveable and dynamic. The back of the torso shows a number of furrows and depression. Many thin muscles cross and re-cross the underlying structure of the skeleton. The overall appearance of the back suggests a large wedge pointing down, with its base at the shoulders.

Muscles That Contract and Stretch
Remember that muscles are both elastic and contractile. Figure A represents a muscle contracting; Figure B represents the same muscle stretched or elongated.

Antagonistic Muscles

Just as opposites exist in nature they also exist in the musculature of the body. Movement causes musculature relationships to become unbalanced and several muscles are actually designed to work in opposition to one another. These muscles, called *antagonistic muscles*, simultaneously swell and release. If the hamstring muscles bend the knee backwards and upwards, the quadriceps straightens it.

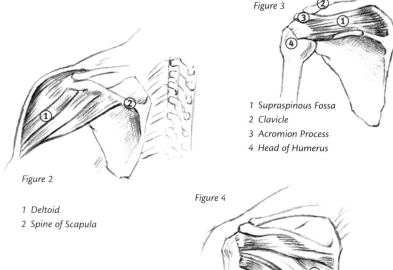

Figure 3

1 Supraspinous Fossa
2 Clavicle
3 Acromion Process
4 Head of Humerus

Figure 2

1 Deltoid
2 Spine of Scapula

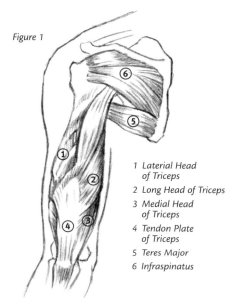

Figure 1

1 Laterial Head of Triceps
2 Long Head of Triceps
3 Medial Head of Triceps
4 Tendon Plate of Triceps
5 Teres Major
6 Infraspinatus

Muscles on the Posterior of the Shoulder

In Figure 2, you can see how the caplike structure of the deltoid originates along the spine of the scapula and inserts on the humerus. Figure 3 illustrates boney processes, which are important surface landmarks. Figure 4 illustrates the muscles that help rotate the arm backwards.

Figure 4

1 Infraspinatus Fossa
2 Teres Minor

Posterior Muscles of the Arm and Shoulder

The shoulder girdle, made up of bones and muscles, is complex and designed to create the potential for almost unlimited movement.

Anterior Muscles of the Upper Arm and Shoulder

Figures 5 and 6 illustrate muscles that help lift and rotate the arm. In Figures 7 and 8 you see the opposing action of the deltoid and petoralis major muscles. The deltoid lifts the arm while the pectoralis major helps pull the arm downward and inward.

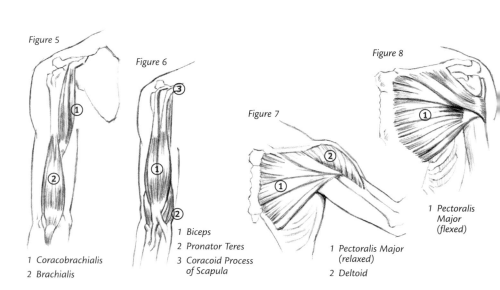

Figure 5

Figure 6

Figure 7

Figure 8

1 Coracobrachialis
2 Brachialis

1 Biceps
2 Pronator Teres
3 Coracoid Process of Scapula

1 Pectoralis Major (relaxed)
2 Deltoid

1 Pectoralis Major (flexed)

The human musculature is in a constant state of contraction whether it's in action or repose. A certain level of tension or muscle tone is present even when a person is lying still or sleeping. Muscle tone maintains posture as it works in opposition to gravity. A model with good muscle tone will nearly always possess proper body alignment. Correct posture not only results in less muscle strain, but is also considered esthetically pleasing, which may be a reason I like to draw dancers. During old age, muscles tend to lose tone and contractile force.

Muscle Tone

A USEFUL EXERCISE

I often instruct my students to copy a drawing by an Old Master. Following the initial drawing, I ask them to render an overlay with an indication of the skeleton, and another overlay showing the musculature. The Old Masters knew anatomy well, so it's not difficult (with the right drawing and a little structural imagination) to get an accurate drawing with correct placement and relationship of both the bones and muscles.

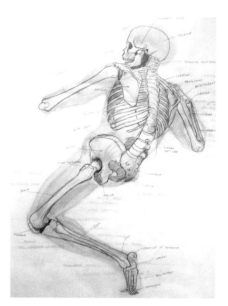
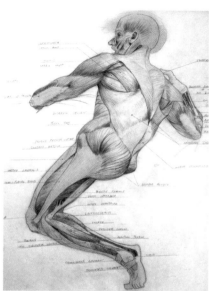

An Honest Interpretation

In summary, the bones and muscles determine the outward appearance of the human form, as well as the actions the body performs. As you supplement your rendering and seeing ability with an understanding of anatomical physiology, you'll come to understand the structure in front of you more completely. This, in turn, will free you from a total reliance on models in creating effective drawings. Once you can conceptualize the structural elements of the live model, you can render a more convincing and honest interpretation of it.

The Face, Hands and Feet

Lighting the Face

In this drawing you'll notice that the light is coming from below the figure. Lighting choice can greatly influence the mood of a drawing.

THE DEBUTANT
Nupastel on paper
20" × 16" (51cm × 41cm)
Collection of the artist

As an undergraduate at the University of Utah, I was fortunate to study with a gifted portrait painter and figure artist named Alvin Gittins. Many of his former students (myself included) felt they continued to learn from him even after his untimely death several decades ago.

Professor Gittins considered the study of the head to be a specialty or extension of the study of the figure. One reason for this belief is likely the fact that the human head is complex and incorporates numerous subtleties associated with its structure and proportion.

Without quesiton, the head is compelling to look at and invites our attention. The face, with its features associated with the senses (i.e., the eyes, nose, mouth and ears) creates an automatic optical center of interest. The face is enhanced by details such as hair texture, reflection associated with the eyes, and value contrasts associated with the mouth and teeth. When you think of someone, the first thing that likely comes to mind is a likeness of their facial features.

A Natural Focal Point

AN ESTABLISHED FOUNDATION

Historically, the portrayal of the human head has been an intriguing subject for artists. In most paintings, in fact, the head is the focal point. The idea of visualizing the head and its features was optimized by the Greeks in their art, and we discussed earlier their notions of ideal proportions associated with the human body.

Later those concepts were refined by Renaissance artists who assembled both systems of proportion and anatomical information. They found that the structure of the head revealed a blending of expressive form and anatomical function. In many ways, we are still building on the foundation established by these earlier masters.

Classical Head
I recommend doing some head studies from classical busts and sculpture. You'll find they conform to idealistic proportions and are readily available in museums and other public places.

Proportions of the Head

Astists throughout history have noted that the proportions of the head are almost identical for every person regardless of gender or ethnic origin. Since the human head conforms to standard measurements, it's helpful to understand the proportional relationships associated with it. It's best to begin with the norm or even the ideal, and then move to the unique aspects of a particular person. As you learn the parts of the head and how they relate to each other, you'll notice how age and gender change those relationships. In a male figure, the jawline and glabella (area between the eyebrows) are more angular and pronounced. A woman's face is more oval and curvilinear, while a child's face is rounder than it is oval, with eyes that are proportionally large for the rest of the face.

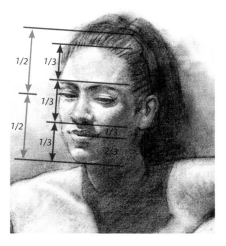

Child's Proportions

You'll notice that the proportions of a child's face differ from those of an adult. The eyes, for example, are more than halfway below the height of the head.

Divisions of the Head

Here, the eyes mark the halfway point between the top of the head and chin. From the hairline to the chin, divide the face into three equal units, with the eyebrows and bottom of the nose as the markers. Between the bottom of the nose and the chin, the mouth marks the 1/3, 2/3 division.

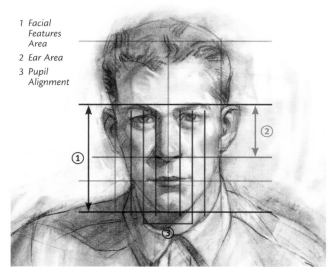

1 Facial Features Area
2 Ear Area
3 Pupil Alignment

Patterns of the Head

Here you can see different alignments that can be made between the features and divisions of the head. The height of the ears matches the distance between the eyebrows and bottom of the nose. The pupils line up with the corners of the mouth. The space between the eyebrows and the chin is designated as the facial features area.

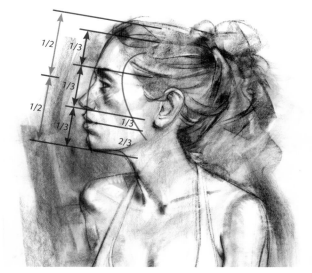

Patterns from Another View

In profile you'll notice many of the same divisions you can observe from a frontal view, but you'll also notice how the corner of the mouth lines up with the eye above and the angle of the jaw at the side. An imaginary arc swinging from the temporal plane will hit the edge of the eyebrow and the angle of the jaw.

As you begin laying in the head, it helps to establish the overall dimensions through a quick sketch or gesture drawing. As mentioned earlier, this helps you manage the overall proportions of the head, and how it's staged or positioned on your paper. As you progress, work from the general to the specific. As you block in the different stages of your drawing, try to parallel the steps of a sculptor. That is, don't begin with the features and then build the head around them. Instead, start with the shape of the head and then add the features in their proper place or alignment. As you consider the different planes of the head, it may be helpful to remember the skull has six surfaces—a top, a bottom, two sides, a face and a back.

The T Principle

As you continue to set up the proportions of your head, remember how symmetrical its construction is. The presence of pronounced symmetry has often been a hallmark of beauty throughout the ages. You'll observe that the masses and divisions on each side of the head are balanced in a remarkable way and are mirror images of each other. As a consequence, the use of a midline with some additional horizontal division lines is helpful in aligning the various features. To maintain proper relationships, it's critical that the vertical midline and different horizontal lines remain at right angles to one another. This principle was discussed in chapter six as the *T Principle* (see pages 60 and 62).

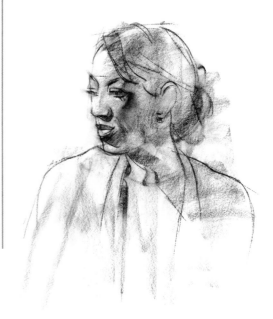

Blocking in the Head

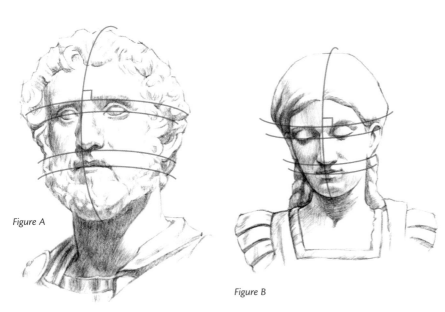

Figure A

Figure B

The Medial Arc
Using a medial arc through the middle of the face and some horizontal lines perpendicular to it is helpful for aligning the features. The opposing arcs must consistently remain at right angles. In Figure A, the horizontal lines arc upward through the face. In Figure B, where the head is tipped downward, the opposite is true.

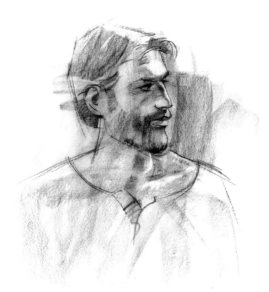

Head Studies
I recommend you draw more gestural studies of the head. These quick studies were drawn at a workshop I conducted at the Portrait Society of America's annual conference.

Features of the Head: The Eyes

It's important to understand the unique attributes of the various features of the face, as their proper alignment adds to both the integrity of the head and its mood. It's been said that the eyes are the most expressive facial feature. A common mistake students make is to place the eyes in the wrong spot relative to the rest of the head—usually too high. The eyes are actually located halfway between the top of the head and the chin.

Parts of the Eye

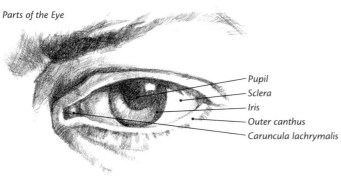

- Pupil
- Sclera
- Iris
- Outer canthus
- Caruncula lachrymalis

The Eye

As you draw the eye, keep in mind its overall construction. It is, first and foremost, a ball sitting in a socket covered with eyelids. It's made up of various parts and is highly reflective due in part to the fact that it's always wet. The eyes are a key factor in rendering the features of the head, so their location and spacing must be correct.

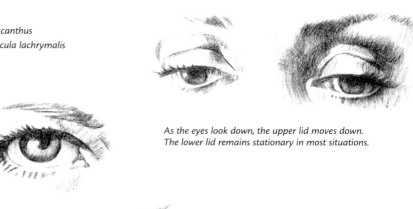

As the eyes look down, the upper lid moves down. The lower lid remains stationary in most situations.

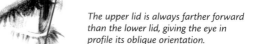

The upper lid is always farther forward than the lower lid, giving the eye in profile its oblique orientation.

By contrast, the mouth, which is often called the second most expressive feature is too often placed halfway between the nose and the chin. In reality, it's only one-third of the way down (see page 80).

(see page 80)

Features of the Head: The Mouth

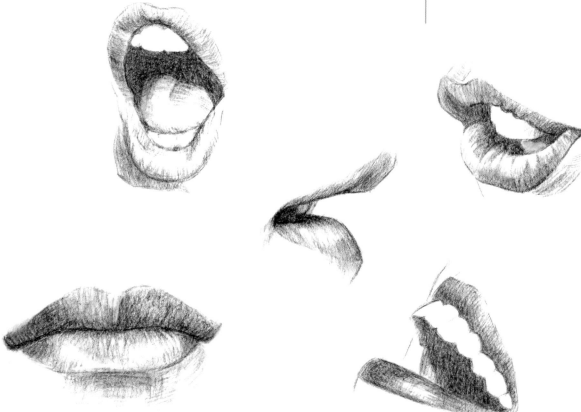

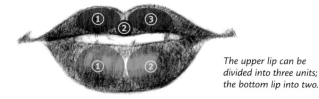

The upper lip can be divided into three units; the bottom lip into two.

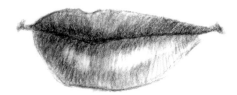

The Mouth

As you place the mouth in its correct position, keep in mind it doesn't sit on a flat surface. This is especially critical when drawing the mouth in positions that are not facing forward. It's also helpful to understand the teeth's relationship to the mouth—even when drawing a closed mouth.

Notice the upper lip juts forward while the lower lip hangs back. Because of this, the lower lip generally receives more light than the upper lip.

Features of the Head: The Nose

The nose is the most important architectural feature of the face. Its size, angle and character add greatly to the likeness of specific individuals. As the nose descends from the bridge (the area between the top and bottom half of the nose), it becomes narrower, then rounds out at the tip where it's wedged between the nostrils.

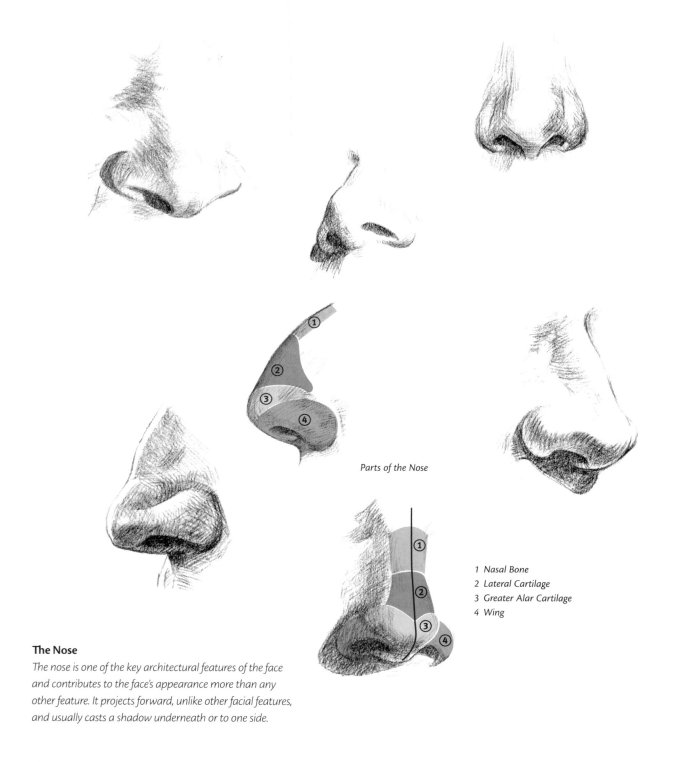

Parts of the Nose

1 Nasal Bone
2 Lateral Cartilage
3 Greater Alar Cartilage
4 Wing

The Nose

The nose is one of the key architectural features of the face and contributes to the face's appearance more than any other feature. It projects forward, unlike other facial features, and usually casts a shadow underneath or to one side.

Like the nose, the ears are significant in the way they project away from the head. Their structural design should be studied carefully. Remember, the length of the ear is equal to the length of the nose. The ears are also parallel to the nose on the head.

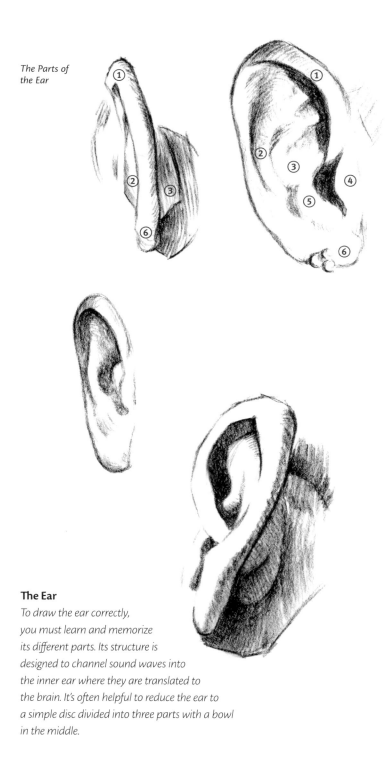

The Parts of the Ear

1 Helix
2 Antihelix
3 Concha
4 Tragus
5 Antitragus
6 Lobe

The Ear
To draw the ear correctly, you must learn and memorize its different parts. Its structure is designed to channel sound waves into the inner ear where they are translated to the brain. It's often helpful to reduce the ear to a simple disc divided into three parts with a bowl in the middle.

Agents of Expression: The Hand

The head and the hands are extremely significant in their ability to reveal the emotion and character of a particular model or individual. In many ways, drawing the hand is a problem of action—the shapes that make up the hand aren't especially complicated, but it has sixteen moving parts. Due to the number of separate masses, each capable of pointing in its own direction, drawing the hand has been compared with drawing the entire figure. Try filling several pages of your sketchbook with hands in several positions, as the relationship of the hands to the head is critical in any portrait that contains the hands.

The Hand

Like the face, the hand can show an amazing range of expression. Many students avoid drawing hands because they think they're too complex. By studying the various masses and planes of the hand and drawing them well, you'll greatly add to the quality of your figures.

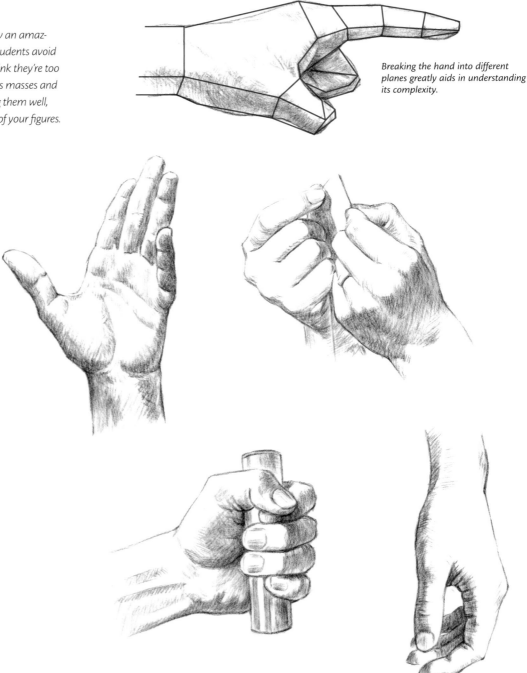

Breaking the hand into different planes greatly aids in understanding its complexity.

The length of the foot is equivalent to the height of the head and is almost the same dimension as the head's depth. The feet are designed to support the full weight of the body, but it's also spring-like with an arch that's capable of nearly flattening itself under pressure. As with the hand, it's well worth your time to fill your sketchbook with drawings of the feet.

The Foot

The planes in the foot are almost exclusively determined by the boney structure underneath. As you learn the design of the foot, keep in mind its function to bear the weight of the body.

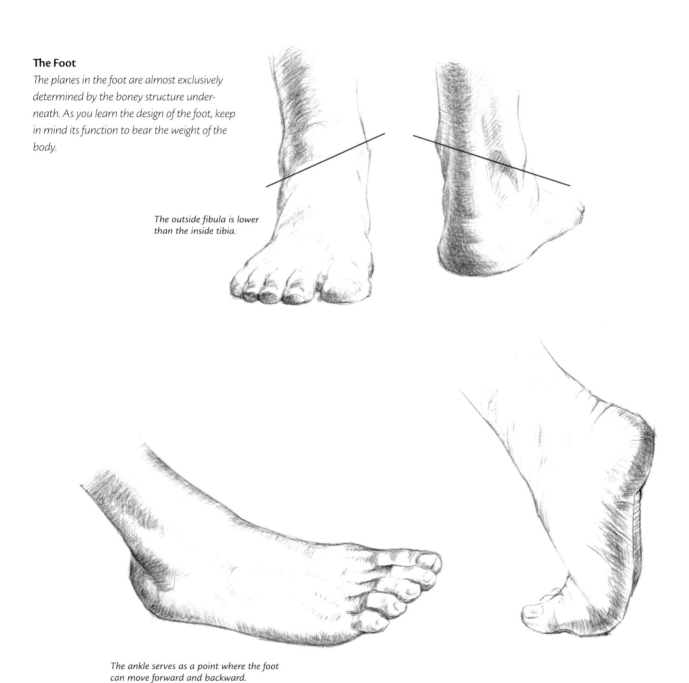

The outside fibula is lower than the inside tibia.

The ankle serves as a point where the foot can move forward and backward.

Light and Shadow

R.T. BARRETT

Lighting the Focus

This drawing of one of my students from Korea was done with powdered charcoal and charcoal pencils. It was designed so that the focus would be on the face.

MIRYOUNG
Charcoal on paper
30" × 22" (76cm × 56cm)
Collection of the artist

Artist Howard Pyle, often called the father of American illustration, once said that the ability to separate light from dark was the foundation of all picture making. Certainly, since the Renaissance, the effective use of light and shadow has been a convincing way to create the illusion of space and form.

Value refers to the degree of light or dark occurring between white and black. These various gray values must be distinguished from one another to assign them to the correct areas and shapes in a drawing. Because they don't know how to see value, beginning artists often place the lights and darks in the wrong contexts. When shading or indicating tone, some artists are too detail-conscious and try to put in too much information, which often creates unnecessary complexity and confusion. Others over-model or try to do too much rendering—especially in the shadows. These procedures are not productive and weaken their drawings.

Value

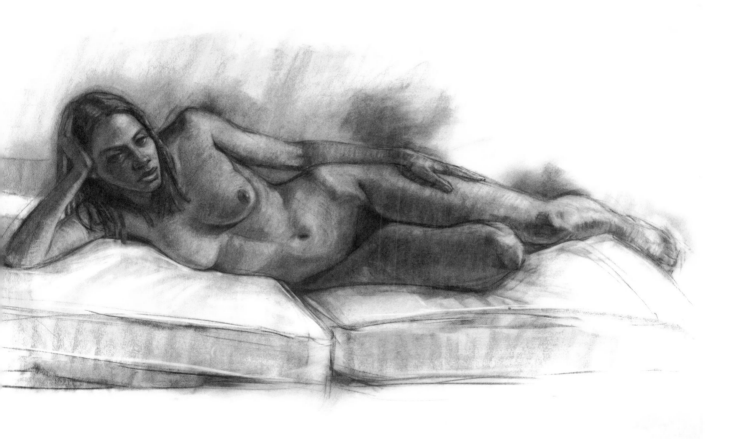

Local Values

As you work with value, it's helpful to realize that different objects have different overall values. In this drawing, for example, the model's hair is a different value than her skin, which is, in turn, a different value than the cushions.

Understanding Light and Shadow

The initial step in using value to your advantage is to identify the degree, intensity and direction of light striking your subject. Ordinarily, we see objects under a variety of different light sources—often simultaneously. But to more clearly define and describe form using light and shadow, try working under a single light source. The direction of the light will determine what portions of the form appear in the illuminated areas, what portions transition away from it, and what portions remain in shadow. The forms that face or are at right angles to the light source are brightest and reflect more light.

Squinting Down

As you observe your subject, try to separate the light and dark into two distinct areas, or families. It usually helps to "squint down," which involves closing your eyes partially so that your eyelashes come in front of your pupils. This screens the amount of light reaching the back of your eye where the rods and cones reside. As the rods are more sensitive to dim light and more attuned to interpreting value than color, this process greatly helps you see the grouping of values and the separation of light and dark. As it turns out, the secret of creating strong value patterns is to teach yourself to see less—not more.

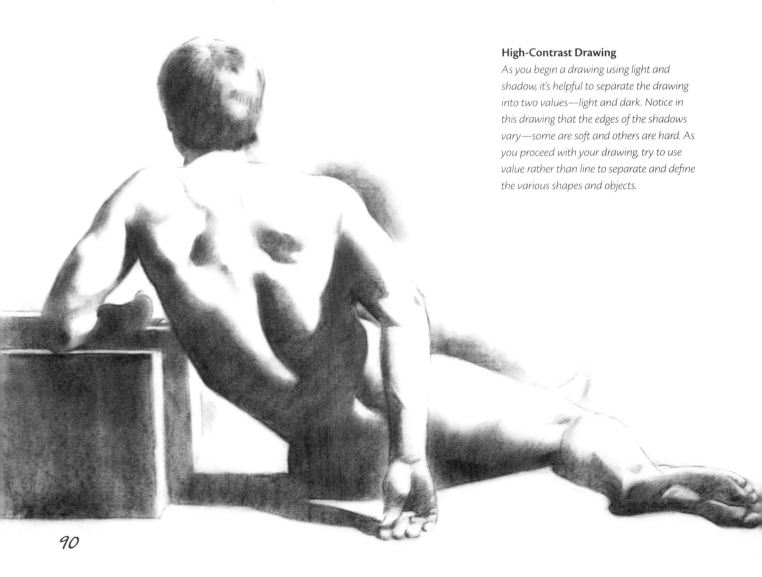

High-Contrast Drawing

As you begin a drawing using light and shadow, it's helpful to separate the drawing into two values—light and dark. Notice in this drawing that the edges of the shadows vary—some are soft and others are hard. As you proceed with your drawing, try to use value rather than line to separate and define the various shapes and objects.

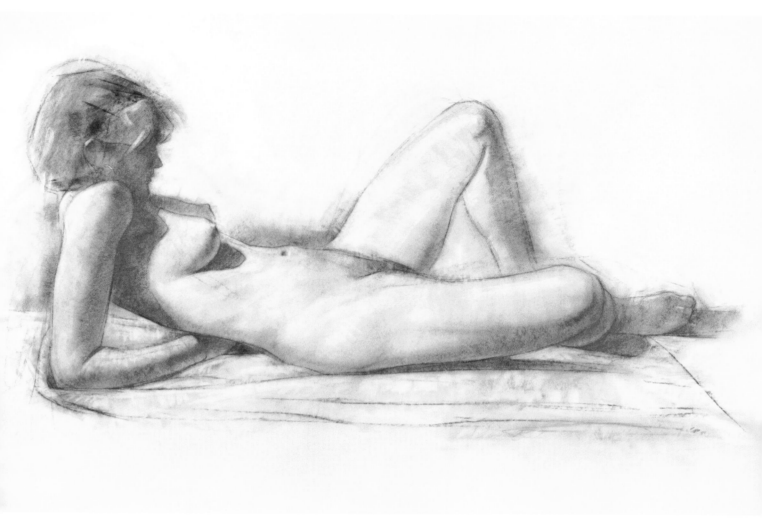

Full-Value Drawing

After you've separated your values into families of light and dark, start to vary the value within each major family. In this drawing you can see at least two different values in the lights and three different values in the shadows.

TOOLS OF THE TRADE

As you consider values and the impact they have on your subjects, it's helpful to remember that the absence of light obscures, and the presence of light illuminates and defines. According to Howard Pyle, light areas reveal color and texture while shadow areas articulate form and shape. Through exploring the nature of light and its unique effects on natural forms, you become aware of just how expressive, powerful and necessary light and shadow are.

Creating Full-Value Drawings

Light and the shadow can be categorized into five degrees of value: two in light and three in shadow. This system is very effective because it reduces light and shadow to their essential elements and helps define several degrees of tone between white and black while maximizing contrast. The five values I use can be numbered and assigned to the following areas of a form:

1 | Highlight
2 | Halftone
4 | Core shadow
3 | Reflected light
5 | Cast shadow

This arrangement creates a simple value system, in which the numbers correspond to the lightness or darkness of a tone: 1 being the lightest and 5 being the darkest. It may appear that the numbers are out of order (core shadow, value 4 before reflected light, value 3), but remember that the numbers correspond to the values, and the order in which they're listed corresponds to the way they move across a form or object.

A "Valuable" Exercise

1 | *Separate the values into dark and white, or light and shadow, only. This makes a strong, simple statement. Note that the core shadow edge is soft and the cast shadow edge is hard.*
2 | *Add halftone to the light side.*
3 | *Now, add reflected light to the shadow. This separates the cast shadow from the core shadow.*
4 | *To separate the lights into halftone and highlight, add the highlight to the light side.*
5 | *Don't get carried away. This over-modeled example shows what happens when the lights in the darks are too light and the darks in the lights are too dark. This is complex and confusing.*

①

②

③

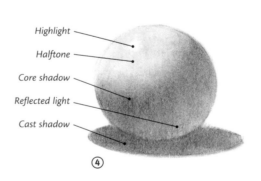

Highlight
Halftone
Core shadow
Reflected light
Cast shadow

④

⑤

The Light Areas

Within the light areas there are two basic types of lights with a corresponding value:

1 | *Highlights* occur at right angles to the light source and reflect the original light source. The highlight isn't fixed (as if pasted onto the form); it shifts relative to the position of the light, the object and the observer. Highlights should usually be placed last in a drawing. Don't make them too light—they may be the lightest value, but they aren't always white.

2 | *Halftones* occur in the light areas away from the highlights or right angles. As you develop these values, make sure you don't "dirty up the lights" or make them darker than they need to be.

The Dark Areas

There are two are types of shadow: core shadow and cast shadow. The other dark area is a form of light, called reflected light.

4 | *Core shadows* occur where the form turns away from the light source. None of the main light falls upon this surface. These are the soft-edged shadows.

3 | *Reflected light* is a secondary light that bounces back into the core shadow. All objects that receive light also reflect light. Keep a tight rein on these; nothing kills a shadow faster than overstated reflected light.

5 | *Cast shadows* happen where one object casts its shadow across another. Cast shadows are darker than core shadows, as they aren't as diluted by reflected light. They're also the hard-edged shadows.

The Transition to Portraits

Placing values on a figure is really no different than placing them on a more symmetrical object like a sphere (see the exercise on page 92). Here I simply looked at the light source to see how the light played off the figure. You'll notice that the highlights are at right angles to the light source and that the core shadows are always more soft-edged than cast shadows.

1 Highlight
2 Halftone
3 Core Shadow
4 Reflected Light
5 Cast Shadow

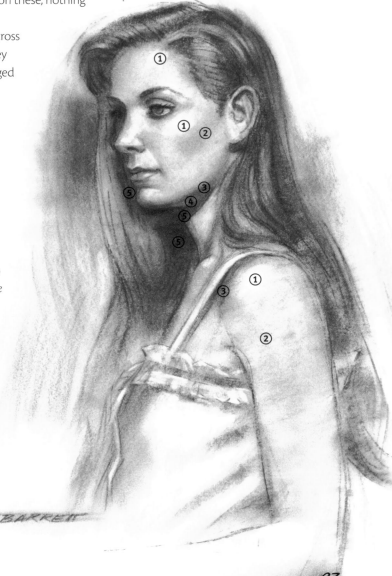

HEAD AND SHOULDER STUDY
Nupastel on paper
24" × 18" (61cm × 46cm)
Collection of the artist

Tips for Using Value

- As you develop light and shadow to describe form, try not to over-model. Simply stated, this occurs when the darks in the lights are too dark and the lights in the darks are too light. Over-modeling may be expressive, but it destroys the illusion of form. (See the last sphere on page 92.)
- Look at each area of value in comparison to the other areas and values rather than in isolation. This will help you maintain the integrity of the value relationships, and will help you move consistently around the entire drawing as you proceed.
- See values, shapes, angles and so forth, instead of objects. When you draw "named things" you have a tendency to forget to draw the effects of light.
- Consider the distance that an object is located from the light source. If the light is the same on the head of a figure as on the feet, for instance, you're telling your viewer that they're the same distance from the light source and suggesting that they occupy the same space.
- Don't be timid about making values dark enough. Otherwise, you could diminish their depth and richness.
- Consider the overall key of a work. Key refers to the overall lightness or darkness of the entire picture. It could be high (light), middle (middle value) or low (dark) key.
- Understand the nature of and place for local value, which is the value or values of the actual object. Don't draw your subject as though it were all the same local value. On the human figure, for example, the hair may be much darker than the skin. Some artists refer to this as the value pattern.
- Use a drawing medium that's flexible and can easily be changed. Charcoal, pastel or graphite are good choices.

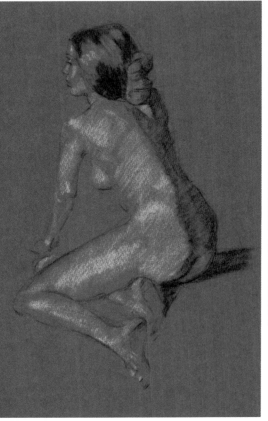

Let the Paper Provide Tone

This drawing was done on toned paper and uses the value of the paper to establish the middle tones of the figure. This technique has been used by master draftsmen for centuries.

Quick Study ▶

In this drawing a range of value was created by applying varying degrees of pressure with the pastel as the drawing progressed.

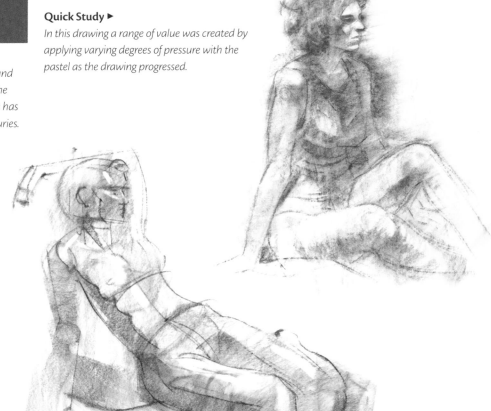

Gesture Sketch ▶

In this gesture drawing, movement, construction and value are orchestrated simultaneously.

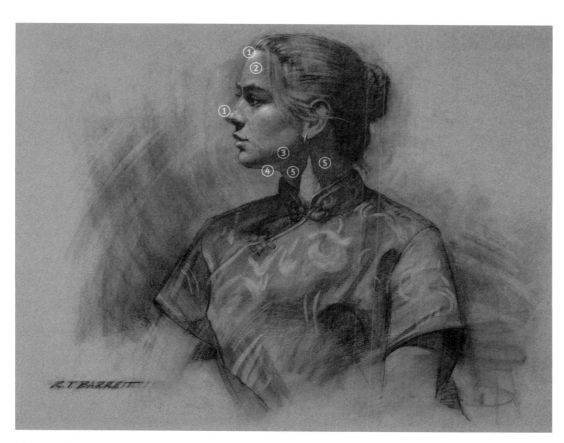

An Automatic Middle Value

To understand the concept of a five-value system, it may be helpful to draw on toned paper. The highlights can then be added with white chalk or pastel while the reflected lights remain the value of the paper or close to it. If the white is used only on highlights and some halftones, the reflected lights won't compete.

1 Highlight
2 Halftone
3 Core Shadow
4 Reflected Light
5 Cast Shadow

Simplify the Values

To create successful drawings, simplify the values you see and organize them in meaningful ways. Whether on toned paper or not, I use a five-value system to structure and understand the fundamental roles of both local value and light and shadow.

EVE (TOP)
Charcoal and white pastel on toned paper
19" × 25" (48cm × 64cm)
Collection of the artist

A PERIOD PIECE
Charcoal and white pastel on toned paper
25" × 19" (64cm × 48cm)
Collection of the artist

Full-Value Drawings

Here's a sampling of completed full-value drawings. In addition to the values and the shadow edges, the tone helps communicate the illusion of the third dimension. The relationship of these figures to the ground helps imply the impression of space.

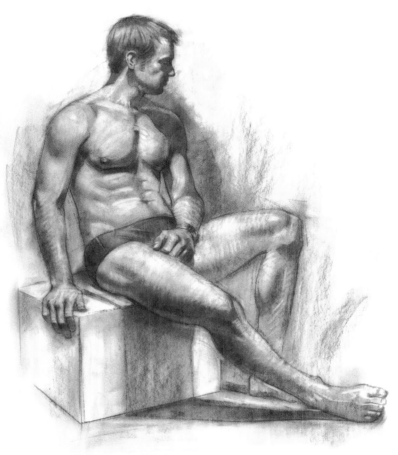

SEATED FIGURE II
Nupastel on paper
30" × 22" (76cm ×56 cm)
Collection of the artist

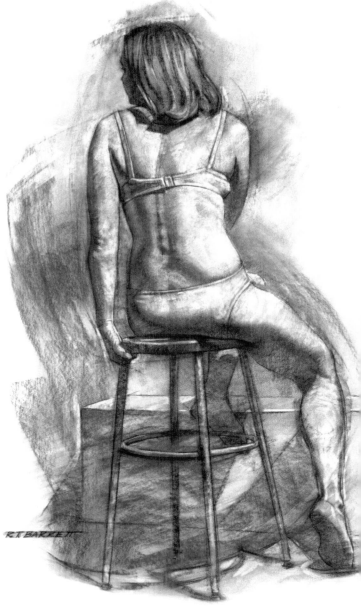

REAR VIEW—FEMALE FIGURE
Nupastel on paper
30" × 22" (76cm ×56 cm)
Collection of the artist

Full-value portrait

MATERIALS LIST

Blending stumps

Kneaded eraser

Nupastel sticks

Paper towels

Powdered Nupastel

Smooth drawing paper

Here, you'll develop a drawing from a general tone to a fully rendered portrait. This process reflects a painterly way of drawing because you'll be working with broad areas of tone that you'll continually refine. This is a visual way of thinking of your subject and is similar to the way we actually perceive objects in the real world.

1 Lay Down the Middle Value
Few things in reality are pure white, so begin by laying down a middle value. Try to approximate the overall gesture and placement of your subject as you do this. Use powdered pastel or charcoal blended somewhat with a paper towel.

2 Establish the Proportions
While there are no lines in space, using lines on top of your value wash helps to establish proportion and relationships. Work from big to small and from general to specific.

3 Lift Out the Lights
After establishing proportions, begin lifting out the lights with a kneaded eraser. Try to determine which planes are at right angles to the light source, as they will be the lightest lights. Working from dark to light makes you more aware of the shapes.

4 Add Local Values and Shadows

Start developing the darker darks in the shadows. Take care to notice that some shadows are hard-edged and some are soft-edged. Make the local value of the hat and uniform darker than the soldier's face.

5 Add Additional Detail

Continue to add detail and articulation to both the lights and the darks. As you do this, move from place to place strengthening and clarifying. Be sure to keep the areas of light and shadow separated into two separate families.

6 Finish the Drawing ▶

Define the shadow areas of the eyes and clarify the mouth and nose. You'll notice that no lights in the shadow are as light as any light on the light side of the face.

PORTRAIT OF A SOLDIER
Nupastel on paper
20" × 16" (51cm × 41cm)
Collection of the artist

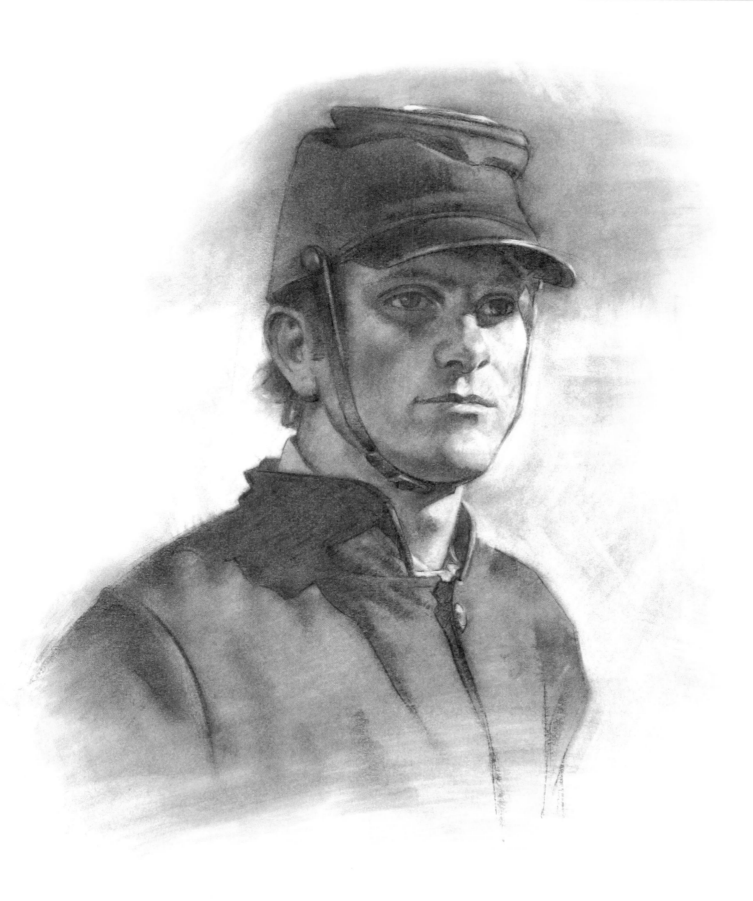

Drapery

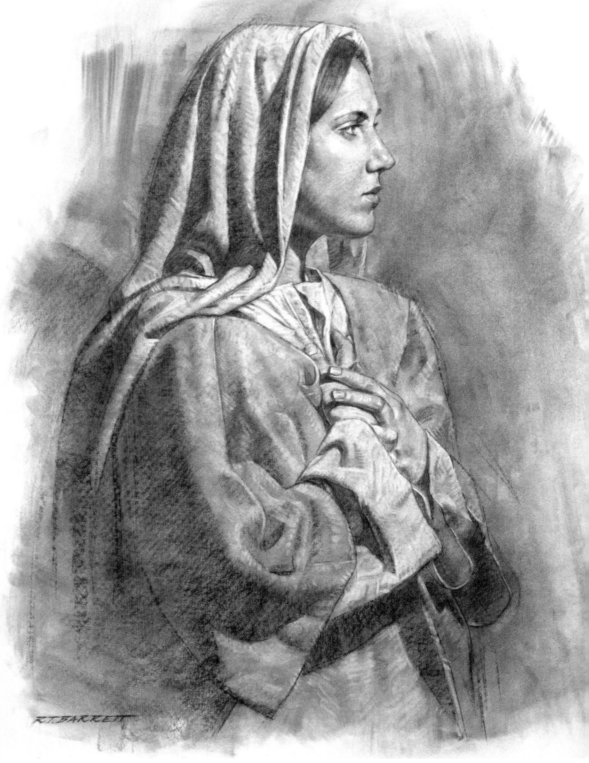

Drapery Has Structure

When you look at a piece of drapery, you may wonder how to begin drawing all those wrinkles. At first glance you may see only masses of unorganized forms in the fabric, but you'll soon discover that those undulating folds have a structure and beauty all their own. Just as it's important to understand the anatomy of the human body to draw it successfully, it's likewise important to understand the anatomy of folds to draw them with understanding and conviction.

This drawing of my daughter grew out of studies I did for a series of paintings on Biblical themes. Historical costumes can create excellent opportunities to study drapery and the construction of folds.

BRENDA
Charcoal on paper
30" × 22" (76cm × 56cm)
Collection of the artist

The first step in drawing drapery is to understand the three basic principles that govern fold construction:

- gravity
- points of support (what holds up the fabric) and tension (stress points where the fabric is stretched)
- the form underneath the fabric

As you observe the effects of gravity, you'll notice that heavy material drapes differently from lightweight material. As you identify points of support and tension, you'll discover predictable folds that will consistently either radiate from them or occur between them. There is often an interesting relationship that develops between what a fold reveals or hides about the structure underneath and how the structure underneath helps to construct the individual fold. For example, a piece of fabric tacked to a wall or other surface creates interesting folds as the fabric falls from or between single or multiple points of support.

Understanding Drapery

AN EXERCISE IN RELATIONSHIPS

To better understand the relationship between the form underneath and how it influences the drapery on top of it, try the exercise on this page. Repeat it several times with a variety of poses. While the model is posed with the drapery, try to design the drapery and understand the construction of the various folds.

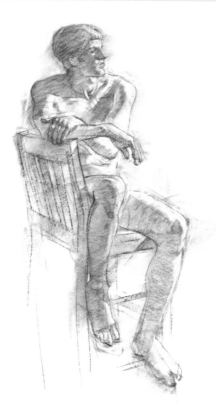

Focus on the Form Beneath
Draw an undraped figure (or a person in a bathing suit, if a nude model is unavailable). Give the model a break and have them put on a costume with loose-fitting drapery. Have the model assume the same pose as before—this time in costume.

Clothe the Figure
Now place a sheet of tracing paper over your drawing that's big enough to fully cover it. Draw only the costume on your tracing paper. At times you may find it helpful to lift up the tracing paper to observe the figure underneath and review its relationship to what's on top.

Quick Studies

The drawings on this page are all quick studies of the draped figure. The drapery is an integral part of each figure, pose and gesture. It's an important ingredient in communicating movement, structure and personality.

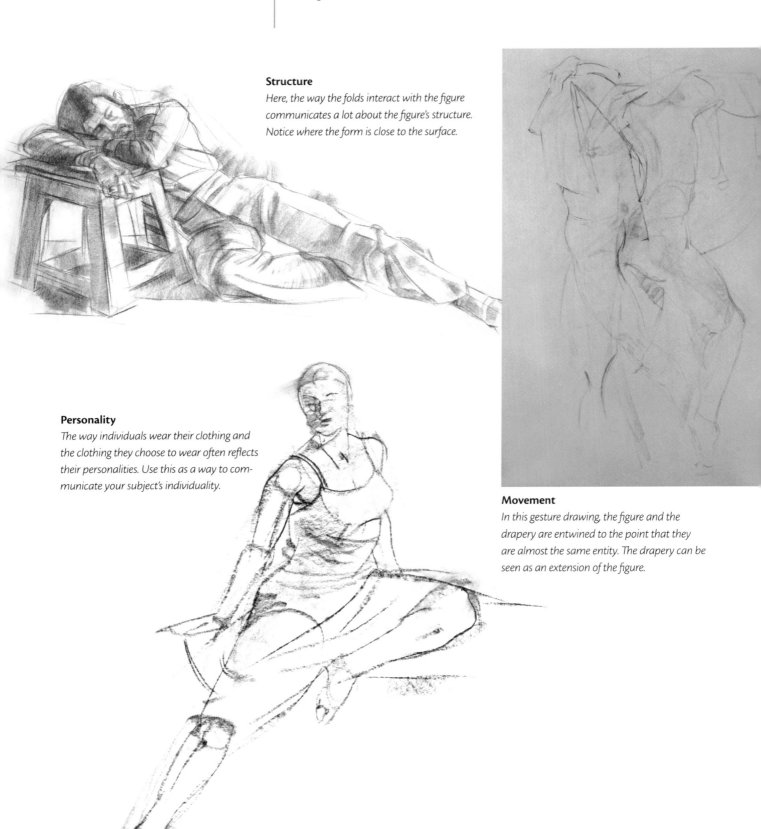

Structure

Here, the way the folds interact with the figure communicates a lot about the figure's structure. Notice where the form is close to the surface.

Personality

The way individuals wear their clothing and the clothing they choose to wear often reflects their personalities. Use this as a way to communicate your subject's individuality.

Movement

In this gesture drawing, the figure and the drapery are entwined to the point that they are almost the same entity. The drapery can be seen as an extension of the figure.

Fashions trends may change, but the human figure remains constant. When drawing models in costume, look carefully at the construction and design of the clothing and imagine the form underneath. Notice how the male and female forms influence the folds, creating unique points of support.

Using Costumes

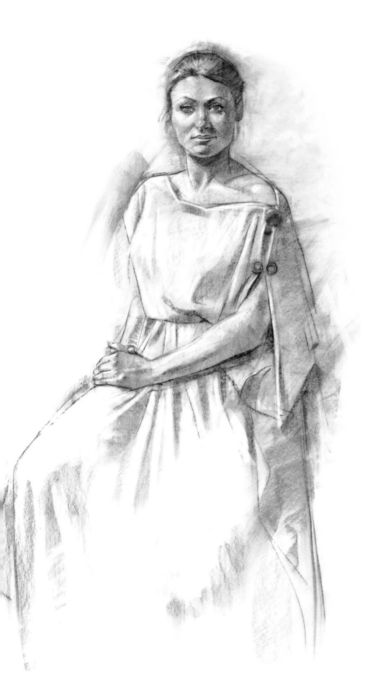

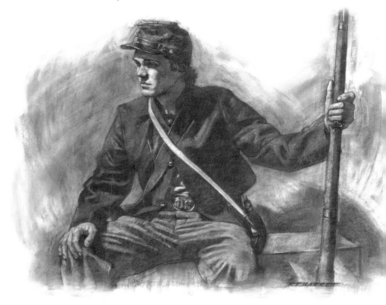

Radiating Folds

In this drawing of a figure in uniform, you can see several different folds that describe the garment as well as the figure underneath. The soldier's left knee is a strong point of tension and acts as the "hub of a wheel" from which several tension folds radiate.

Revealing and Disguising

In this toned drawing of a female in a Renaissance dress, the figure of the girl is both revealed and disguised by the design and construction of the costume. Notice how the arms of the costume are designed to be formfitting in some places and not in others. The skirt of the dress is influenced by the position of the legs underneath, but also has a life of its own.

The Intention of Drapery

As you gain experience in drawing costumes from different historical periods, become aware of the "intentions" of the designers of those periods. The intention of one period may be quite different from another, but most will be concerned with revealing, emphasizing or exaggerating some aspect of the human body.

Folds as Elements of Design

My students often ask me such questions as: "Should I copy what I see?" "Should I eliminate complex detail and simplify what I'm seeing?" or "Should I alter the drapery in my drawing?" The answers to these questions lie in appreciating what folds can do for the design of your drawing. Just as too much anatomy in a figure drawing can be distracting, rendering every wrinkle in draped fabric can also be confusing. When I'm drawing folds, I keep these procedures in mind:

Procedure 1: Work from Large to Small. Draw the big form first and work your way to the smaller details. In other words, move from the general to the specific or from the simple to the complex. In the initial lay in, it's also important to look for the underlying movement or gesture of the drapery. Establishing the overall rhythm of the fabric is an important step in relating one part to another.

Procedure 2: Establish Proportions. Just as in drawing the figure, you should look for angles and landmarks to help establish proportion. Landmarks are the reference points where one plane changes into another or where one edge ends and another begins. They often relate to the underlying structure and help amplify points of support or points of tension. Additionally, gridding is a helpful process to remember in drawing drapery. Once you locate landmarks, you can establish contour lines between them, and, as you develop the contours, you'll identify and articulate specific shapes, from which you can construct the different folds.

Procedure 3: Simplify. Simplify or reduce folds to their primary geometric shapes. This will help you deal with the folds that begin as one form and then transition into other forms.

Procedure 4: Describe the Form. Apply the same principles of light and shadow used in depicting other basic forms. Understanding highlights, halftones, core shadows, reflected light and cast shadows is important in establishing the appearance of believable structures. By specifically and accurately rendering the edges between light and shadow, you create a convincing description of form.

THE SEVEN FOLDS

As the study of drapery has evolved over the years, folds have been grouped into seven categories: pipe, diaper, zigzag, half-lock, spiral, drop and inert. Some are governed by action, while others are actionless or governed by gravity. Consequently, some are more vertical in nature while others are more horizontal.

LEARN TO EDIT

Stated more simply, the meaningful arrangement of folds on a figure creates design. As all good drawing involves both translation and interpretation, it's important to be able to edit your own work. Design implies eliminating some elements and amplifying others. The process of analysis and selection is essential in creating drawings that go beyond the mere reporting of facts.

One Drawing, Several Folds

In any one drawing you may encounter several different folds that describe the garment and the figure underneath. In this drawing of my son-in-law, you can see spiral, zigzag and half-lock folds, along with what I call "hub of the wheel" folds.

1 *Spiral folds*
2 *Half-lock folds*
3 *Hub of the wheel*
4 *Zigzag folds*

EVEN
Charcoal on paper
22" × 30" (56cm × 76cm)
Collection of the artist

Pipe Fold

The pipe fold is the simplest and most common fold. You'll see pipe folds hanging in a series on curtains supported by a rod or on the skirt of a dress supported at the waist. They usually fall from a single point of support (such as a belt or curtain rod) and are governed more by gravity than action. They are either tubular or conical in shape. On occasion, a pipe fold may have two points of support and may be an action fold, which is created more by movement and stress than by gravity.

Point of support

Point of support

① ②

Pipe Folds

1 Long pipe folds falling from a single point of support
2 Pipe fold pattern

Pipe Folds Filled Out by the Model

Here is the same cape worn by a model. As the model is in a static pose, the folds are mostly vertical and similar to those in the previous drawing, though now "filled out" by the model. The folds are still primarily governed by gravity and points of support.

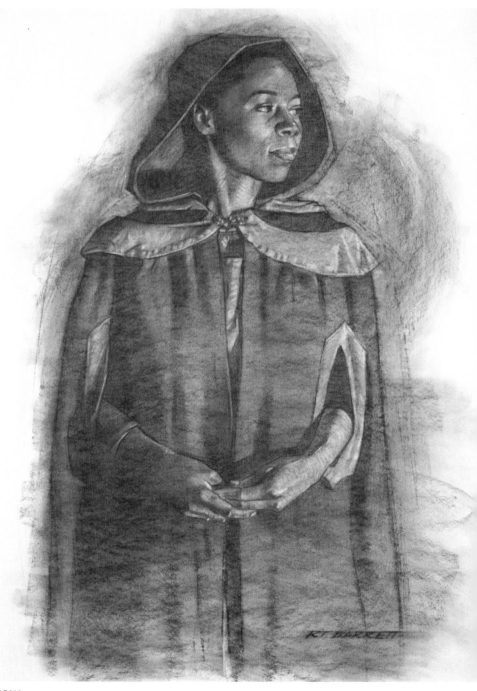

FIONA
Nupastel on paper
30" × 22" (76cm × 56cm)
Collection of the artist

The diaper fold has as triangular shape and falls between two points of support, which may or may not be at the same level. You'll often see a diaper fold on the back of a man's jacket between the two shoulders (points of support), especially if the arms are raised laterally. On a loose-fitting tunic or robe, a diaper fold will occur between the shoulder and the waist, or even between the shoulder and a raised knee. The actual fold occurs at the break, or turn, of the cloth—usually on a wide or flat surface. The degree of break depends on the amount of slack between the points of support. If the points are at different levels, the break will be closer to the lower point.

Diaper Fold

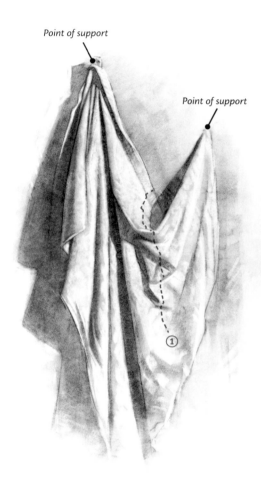

Point of support

Point of support

Diaper Folds

This diaper fold was created by tacking the cloth to a wall. The tacks now create the points of support. Notice how the top of the fold is sharp while the fold's curve becomes softer as it moves down the fabric.

1 Diaper fold pattern

Diaper Folds on the Model

Here is another example of drapery on a model. The diaper fold in this drawing is created by the two points of support originating at each of the model's shoulders.

MARY
Charcoal on paper
30" × 22" (76cm × 56cm)
Collection of Brigham Young University, Idaho

Zigzag Fold

This fold occurs on the slack side of a bent pipe fold and is characterized by uneven, crisscross buckling. Inside the crisscross you can see concave diamond shapes, or recesses, sometimes referred to as "diamond folds." If you look at the anterior (front) surface of a draped arm when the arm is slightly bent, you'll see a zigzag fold. It may also be seen as an "echo fold" on the back of the knee, for example, when the leg is straight, indicating past movement.

Zigzag Folds

1 Zigzag pattern
2 Behind the zigzag is stress or tension
3 Inside shapes are compressed diamonds

Zigzag Folds on the Model

Notice the alternating folds on the jacket. Their predictable pattern creates zigzag folds where the arms bend. These zigzag folds are apparent and emerging on both sleeves.

PATRICIA
Nupastel on paper
30" × 22" (76cm × 56cm)
Collection of the artist

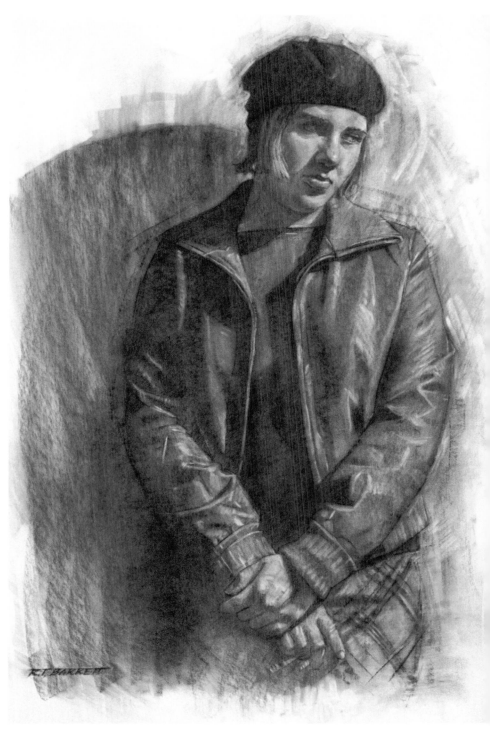

The half-lock fold is similar to the zigzag fold—it occurs when a tubular or flat piece of cloth changes directions abruptly—but it's more compressed. The fold always occurs on the slack side, with extreme tension on the opposite side. Bulging may occur at the change of direction, as well as multiple half-locks or a smaller half-lock sliding or disappearing into a larger one. These folds typically occur at the elbow on the front side of a bent arm or at the knee on the back side of a bent leg. They can also be located at the waist on the anterior side of a figure who's sitting at a desk or table.

Half-Lock Fold

Half-Lock Folds
Half-lock folds are usually more obvious from a side view. You'll often notice multiple half-lock folds in the same location.

1 Slack causes buckling
2 Half-lock fold pattern
3 Point of tension

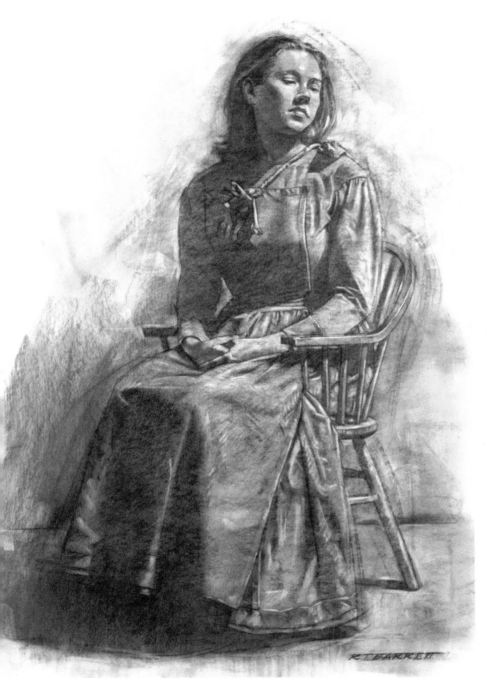

Half-Lock Fold on the Model
There are several half-lock folds in this model's pose; the most visible is at the elbow in the front of her left arm.

THE PIONEER
Nupastel on paper
30" × 22" (76cm × 56cm)
Collection of the artist

Spiral Fold

The spiral fold is usually wrapped around a tubular form and becomes more pronounced as the fabric is condensed. A spiral fold can also be created by twisting a piece of cloth with no solid form underneath it. The spiral fold follows the form, revolving toward the point of tension, and will change direction as points of tension and support vary. Spiral folds often occur on a sleeve between the shoulder and elbow or between the elbow and wrist. They can also occur on the torso between the shoulder and the hip. You'll notice that the point of support can also be part of the garment itself, depending on its construction.

Spiral Folds

The overall direction of a spiral fold will relate to the gesture of the form underneath. The amount and the weight of the material also affects how many folds occur and whether they are soft or sharp.

1 Point of tension behind
2 Point of support
3 Spiral pattern

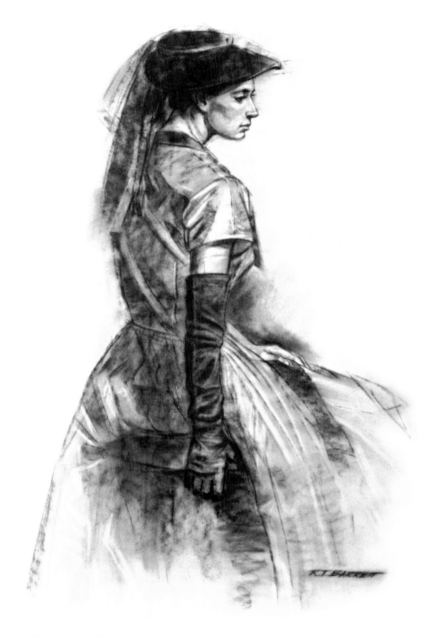

Spiral Folds on the Model
Spiral folds in this drawing originate from the model's far shoulder and rotate down, around, and over her near hip. There are additional, smaller spiral folds evident in the glove on her arm.

PERIOD PIECE
Nupastel on paper
30" × 22" (76cm × 56cm)
Collection of the artist

The drop fold is an irregular fold characterized by its vertical or dropping nature from one or more points of support. Drop folds may contain small spiral, zigzag or half-lock folds as they "cascade" downward, influenced primarily by gravity but also by the form underneath. A "flying drop" occurs when the force of gravity is replaced by the wind and the folds become horizontal. A flag fastened to a pole while the wind is blowing is a typical example of a "flying drop" fold.

Drop Fold

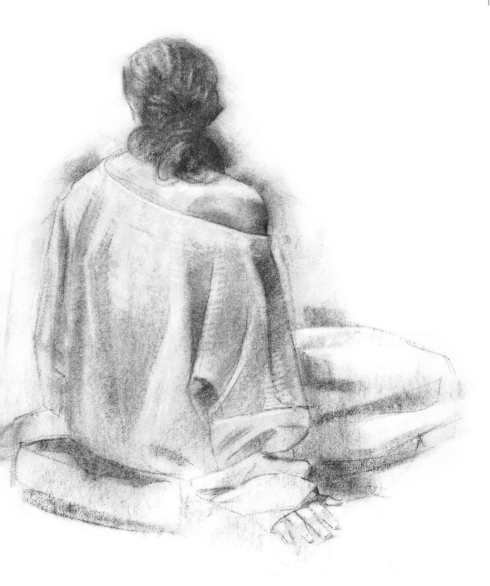

Drop Folds

A garment draped over the back and seat of a chair will form a series of drop folds between the top of the chair and the lower points of support.

1 *Point of support*
2 *Drop fold pattern*
3 *Drop folds as cascading vertical folds*

Drop Folds on the Model
Several drop folds are visible in the drapery across the arm and back of this model.

SEATED FEMALE MODEL
Nupastel on paper
30" × 22" (76cm × 56cm)
Collection of the artist

Inert Fold

The inert fold is an inactive or "dead" fold governed primarily by gravity and the surface upon which it rests. It is generally horizontal in nature and, like the drop fold, is irregular and may contain a variety of other folds, both regular and irregular. Though the individual folds within the mass may change, the mass itself remains inert or "action-less." Sheets on a bed that's recently been occupied are an example of this type of fold, as are the folds created in the laundry lying on a bathroom floor. Inert folds can include both irregular and regular folds. They are usually horizontal in nature.

1 Spiral patterns
2 Zigzag pattern
3 Zigzag and half-lock pattern
4 Irregular folds

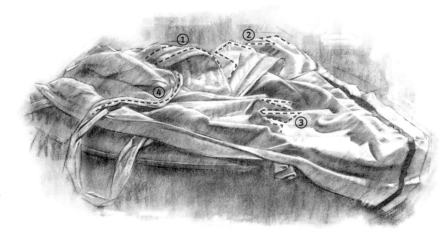

Inert Folds

Inert Folds on the Model

There are both inert and cascading drop folds falling over this model's legs and onto and across the sofa. The lightness of the material and the fullness of the area covered give them an almost surreal quality.

DREAM DAYS
Charcoal on paper
30" × 22" (76cm × 56cm)
Collection of the artist

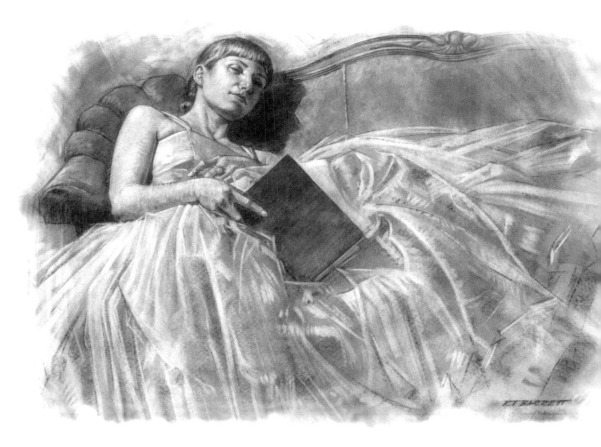

There are many types of contemporary and historical head coverings. They have personality and are often important extensions of the costume. As you gain experience drawing head coverings, always be aware of the size of the model's head in relation to them, and the position of the crown of the head.

Hats and Bonnets

Line Up the Hat with the Model's Head
Notice that the top of the hat is the same width as the model's head, and that it's width lines up with the outer contours of the head.

COWGIRL II
Nupastel on paper
24" × 18" (61cm × 46cm)
Collection of the artist

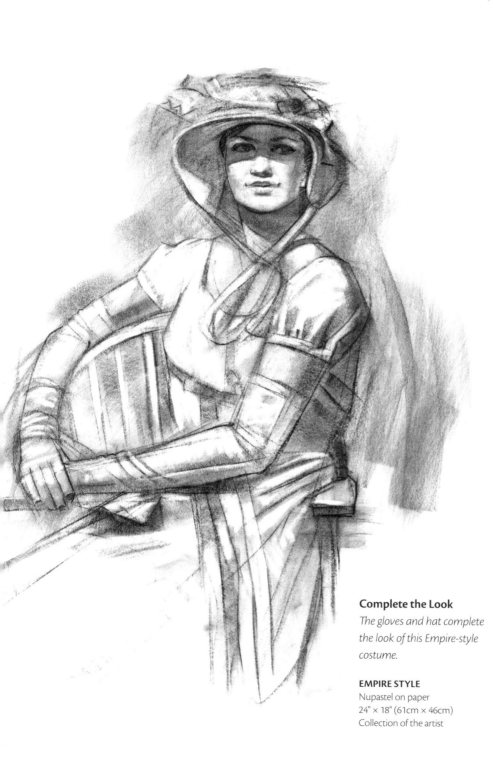

Complete the Look
The gloves and hat complete the look of this Empire-style costume.

EMPIRE STYLE
Nupastel on paper
24" × 18" (61cm × 46cm)
Collection of the artist

Edges

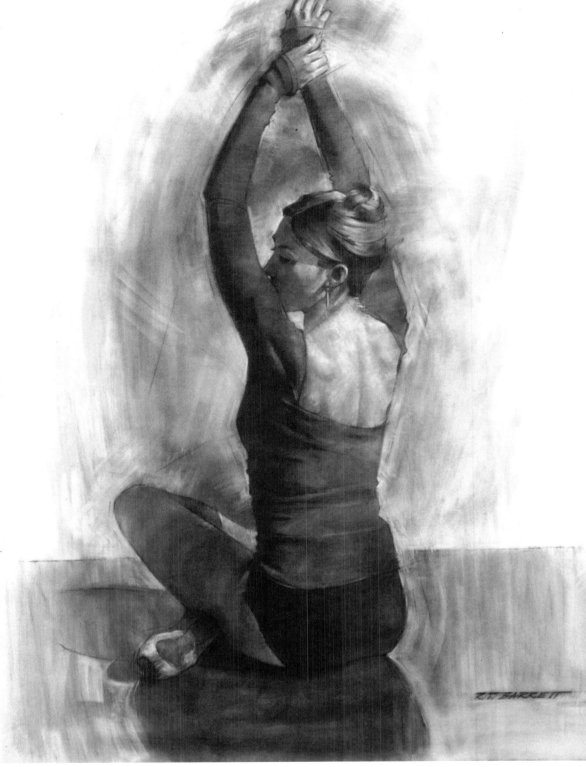

A Variety of Edges

This drawing of a ballet dancer is a good example of the variety of edges you can encounter in a single pose. You can see form shadows, cast shadows, and areas where the material itself is soft. There is also a sense of atmospheric perspective and the softening of edges at junctions where objects overlap.

CLASSICAL DANCER II
Nupastel on paper
30" × 22" (76cm × 56cm)
Collection of the artist

A key element in communicating the sense of reality or dimension in your drawings is the indication of edges. Remember, one of the challenges you face in traditional drawing is creating the appearance of three-dimensional items on a two-dimensional surface. You'll recall that we don't see or discern reality in terms of line, but rather by value contrast.

Edges occur at both the junctions of different values and different forms. The hardness or softness of an edge depends a lot on how slowly or abruptly the change between objects or values occurs. Some transitions are barely discernable while others are razor-sharp. The hardest edges are found where there is a quick or sudden change and where there are no in-between planes to break up or soften the transitions along an edge.

Hard and Soft Edges

You'll see hard edges first, as they assert themselves into our vision more easily than soft ones. They are also what usually gives a drawing its two-dimensional quality, so using too many of them will flatten your drawings.

Soft edges, by comparison, create a stronger sense of reality, but we usually don't see them as readily. In reality, they are all around us, but because they don't assert themselves, you'll need to teach yourself to see them. It's important to notice that they can occur, and should be indicated, even at junctions where two hard objects meet each other—especially where the value of those two objects is similar or the same.

Edges and Value

LOST AND FOUND

As you look at the work of great artists, you'll observe that their work has a balance of hard and soft edges. Even in the work of the so-called "tight realists" you'll find a number of soft edges. Often what differentiates less experienced artists from master artists isn't so much technique but vision—the ability to understand and incorporate important visual principles into their drawings. As many of the past masters incorporated the qualities of lost and found edges in their work, we can determine that the presence of these contrasting edges is less connected to individual style than it is to visual principles. This quality is especially present in the drawings of Georges Seurat, as well as the work of other nineteenth and early twentieth century artists such as John Singer Sargent, James McNeill Whistler and Edgar Degas.

Cube vs. Sphere ▶

Here you can see the difference between the interior edges on both a cube and on a sphere. Where there's an abrupt change in planes, as there is between the light and shadow side of the cube, the edge between the two is sharp or hard. The transition between light and shadow is much more gradual on the sphere and the edge is consequently soft.

Use Soft and Hard Edges in Studies ▼

Even in quick studies it helps to be aware of hard and soft edges. You'll notice there are abrupt and gradual edges on both the outside and inside edges of the figure.

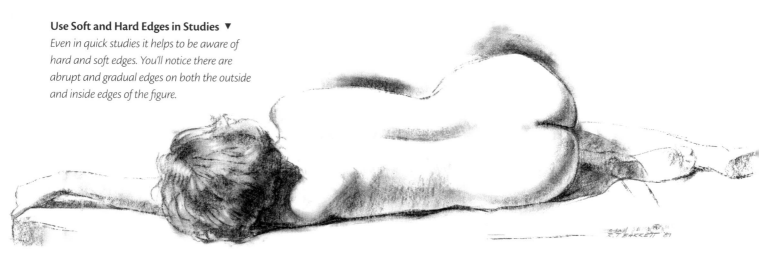

Learn to See Soft Edges

As mentioned in chapter nine, learning to squint is critical. "Squinting down" not only helps you simplify the values and see the relative nature of each tone, but also helps you determine the clarity or obscurity of the edges of shapes in or around the model. Remember, every shape has different sides or edges—a few are hard on all sides, but most are soft on one or more.

Six Types of Soft Edges

To help you learn to see soft edges, I've identified the six most common circumstances under which you'll find soft edges in the figure. These are: (1) Where there's a halation of the light; (2) Where the material of the subject is soft; (3) Where the edge lies within or along a core shadow (where the object turns from light into shadow); (4) Where a value fuses with a similar value nearby; (5) Where the soft edge is used for esthetic reasons or vignetting; and (6) Where the edge is blurred as a consequence of atmospheric perspective (a term borrowed from landscape painting but useful in showing deeper space and in separating forms). You'll explore atmospheric perspective in greater detail in chapter twelve.

Strength and Clarity

Adding strength and clarity to your drawings may be more about softening edges than making them harder. After all, clarifying what's happening also means being truthful about what is occurring visually. And, as mentioned in chapter two, a little exaggeration often comes closer to the truth.

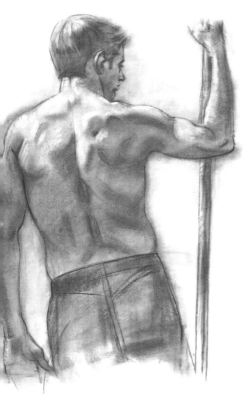

Outlining
Placing hard lines around the outside of your figure adds strength to your drawing. Be careful, though—it can also make it look like a cartoon.

Going Soft
Look at your model and squint to see the soft edges. Some will occur where an object (such as the hair) is soft. Others will be in the background tones, or where values fuse together (such as where the coat and the chair merge).

ELISE
Nupastel on paper
22" × 30" (56cm × 76cm)
Collection of the artist

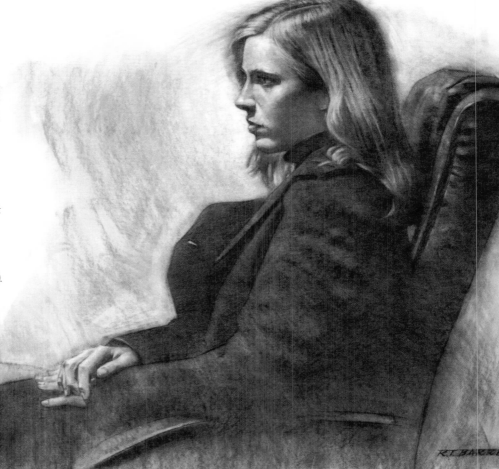

Edges are one of the most important tools you have to direct the viewer's eye around and through your drawing. Hard edges have a tendency to stop the movement while soft ones allow the viewer to keep moving as they transition from one area to another. Consequently, consider placing hard edges close to or around the focal points of your drawing where you'd like the viewer to linger for a while. To further emphasize your focal point or center of interest, consider placing the strongest darks in the area next to or against the strongest lights.

Focal Points

Analysis and Selection

As you design your drawings, create and then direct your viewer to a focal point or center of interest. One way to do that is to use hard edges in areas next to or proximate to your center of interest. Another way is to soften edges away from your center of interest. Placing the softest edges away from the main focal points will, by contrast, make them seem more obvious and important.

DEAN
Nupastel on paper
30 " × 22" (76cm × 56cm)
Collection of the artist

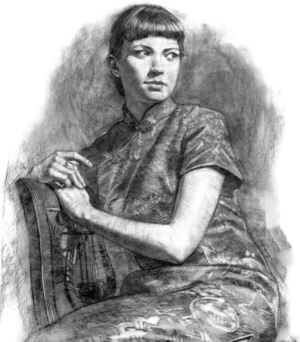

Enhancing Depth

This figure reads mainly as light against dark. The feeling of depth is enhanced in those places where two objects meet (in this case, the model and the chair) by softening and lightening the edge of the object that goes behind the foreground object.

FIGURE IN A CHINESE DRESS
Nupastel on paper
30 " × 22" (76cm × 56cm)
Collection of the artist

Create soft edges

MATERIALS LIST

Carbon or charcoal pencils

Charcoal powder

Kneaded eraser

Large brush

Paper towels

Soft vine charcoal

Stonehenge printmaking paper

Stumps

The tools you'll need for creating soft edges are simple: pastel or charcoal, paper and an eraser. Stumps and paper towels can also be helpful. I typically blend big edges with my hand or a paper towel, medium edges with my fingers, and small edges with a stump. You can also create soft edges by pushing down and letting up on your charcoal as you move the medium.

1 Prepare the Surface
Start by using a large, soft brush to "paint" charcoal powder over a sheet of Stonehenge printmaking paper.

2 Establish the Figure's Position
Using a piece of soft vine charcoal, lay in the drawing and establish the overall position of the figure and the relative proportions.

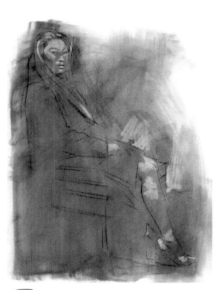

3 Begin to Build Dark Values
Add additional detail to the drawing and begin to add some loose patches of dark value in different places.

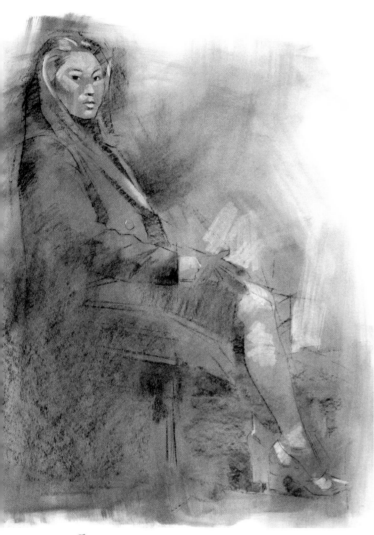
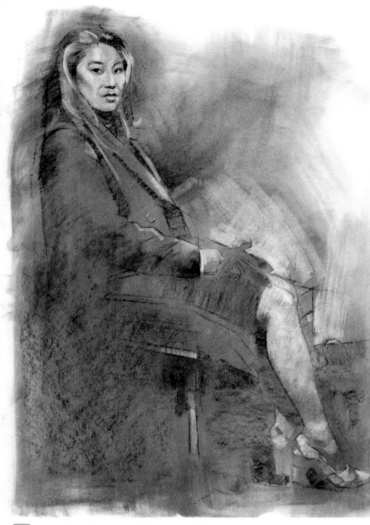

4 **Lift the Lighter Shapes**
Using a kneaded eraser, begin to lift out the lighter shapes located both inside and outside the figure.

5 **Strengthen the Overall Composition**
Continue to strengthen your drawing by adding larger and smaller areas of dark. Some areas or shapes should have hard edges and others should have soft edges. At this point, you can finish some of your edges. You can complete the remaining edges as you continue your drawing.

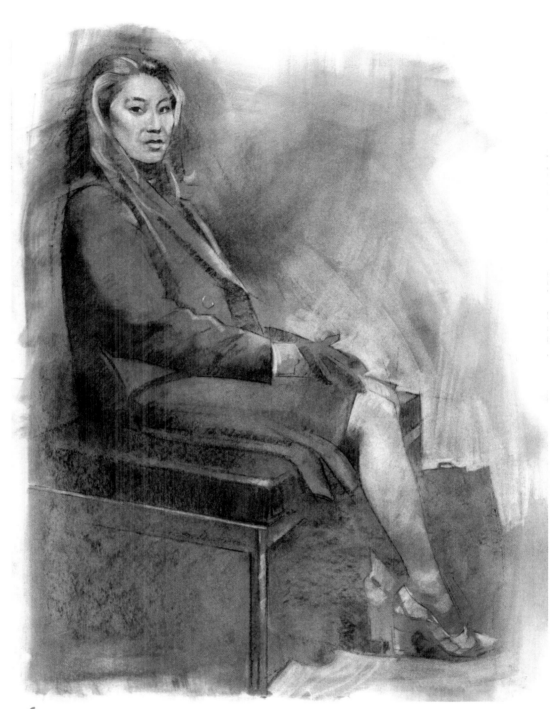

6 Refine the Light Areas
Now go back and refine the light shapes. The kneaded eraser is a great tool for creating interesting shapes with a variety of edges.

7 Add the Finishing Touches ▶
As you work you can use different tools to help control the values and the edges. Paper towels, stumps and your fingers are all possibilities for smoothing and blending the edges. In addition to vine charcoal, use carbon or charcoal pencils to refine smaller details.

ANTICIPATION
Charcoal on paper
30 " × 22" (76cm × 56cm)
Collection of the artist

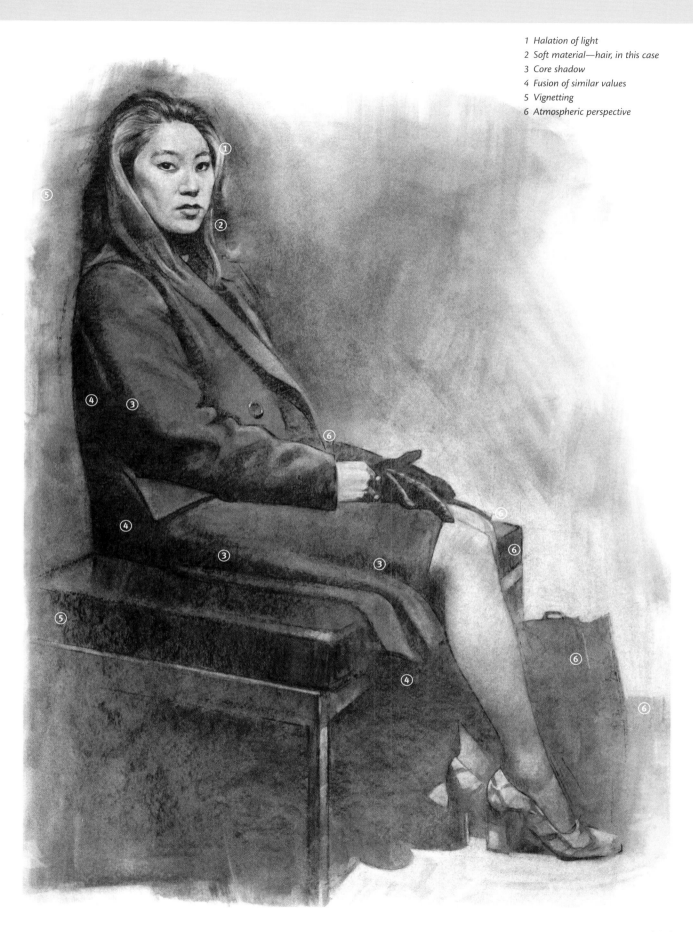

1 Halation of light
2 Soft material—hair, in this case
3 Core shadow
4 Fusion of similar values
5 Vignetting
6 Atmospheric perspective

Alter the Order

A general phenomenon of edges is that hard ones advance and soft ones recede. In spite of this fact, you may on occasion choose to alter the order of things by making foreground objects softer and less important. The needs or demands of your drawing will govern whether you should vary from established perceptions. Creating strong drawings involves more than simply following specific guidelines or rules.

SEEING VISUALLY

A challenge you'll face in drawing the figure is learning to see things visually. Briefly stated, this means seeing shapes instead of things. The tendency to perceive things symbolically is deeply entrenched in us and, unfortunately, stops us from visually interpreting what we see. In fact, we often don't draw what we see but, rather, what we think we see. If you can resist the temptation to name things as you draw, and increasingly learn to see them as shapes with angles, values and edges, your drawings will dramatically improve in their spatial and dimensional quality.

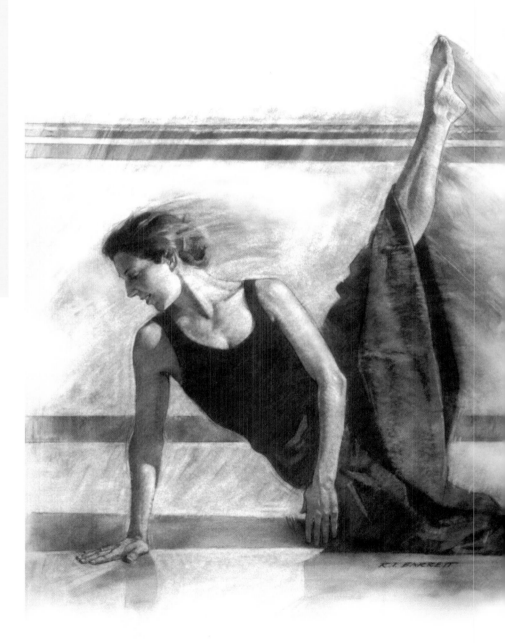

Edges for Expression

In this drawing of a modern dancer, soft edges are used to express energy, emotion and movement.

MODERN DANCER
Charcoal on paper
30 " × 22" (76cm × 56cm)
Private collection

As you progress in your development of traditional drawing methods, you'll understand how important it is to control edges. Edges are indispensable not only for achieving the illusion of reality but also for creating the sense of unity in a drawing. Learning to see edges will also help in your general development as a painter, since painting is more about seeing and using shape than it is about using line. As you incorporate the quality of lost and found edges in your work, your drawings will appear less like renderings of objects cut out and pasted on the surface of your paper. In addition to accuracy, your drawings will begin to take on a look of freedom and expressiveness.

Edges Are Indispensable

Seeing Shapes

As you translate reality into a drawing, it's important to see objects in terms of visual shapes. One way to do that is to lock or fuse together shapes of the same or similar values.

A MOMENT OF REFLECTION
Nupastel on paper
30 " × 22" (76cm × 56cm)
Private collection

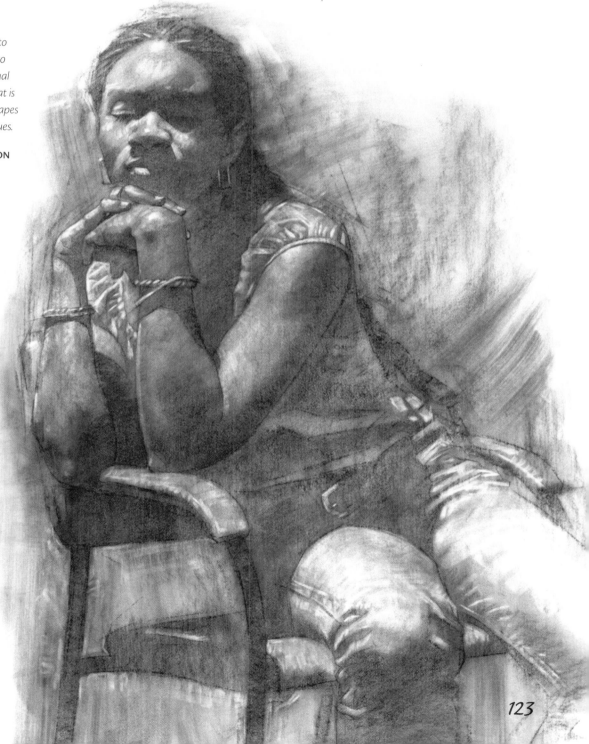

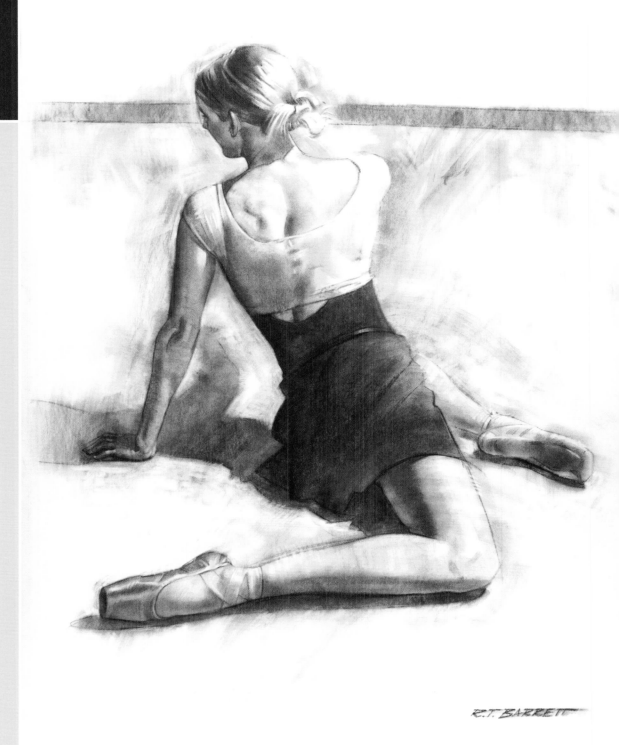

R.T. BARRETT

Establishing Atmosphere

In this drawing of a dancer, there's a strong presence of atmosphere and a sense of where she's located in space. The values and marks around the figure reinforce the gesture and rhythm of the pose, and contribute to the figure-ground relationship.

KRISLYN
Nupastel on paper
30" × 22" (76cm × 56cm)
Collection of the artist

The term "atmospheric perspective" has often been used in reference to landscape painting. It's usually associated with great distances and the way objects appear as they recede from the viewer. In nature, we observe that things become less clear when seen from a distance and are usually lighter in value and grayer in tone. They are also less distinct and tend to have softer edges.

Artists noticed that these same principles could be applied effectively to objects in a much shallower space to achieve the illusion of depth. Representational painters noticed that incorporating atmospheric perspective in this way helped them create a strong sense of dimension in their work.

The fact that things get lighter and grayer as they recede into space (with less texture, detail and value differentiation) is helpful for you to know as you continue to separate human forms in space. These principles can also be used in more formulaic ways to "push and pull" different aspects of your drawing as you work to create the illusion of depth.

Atmospheric Perspective and the Figure

Landscape Painting
In this painting you'll notice how objects in the distance become less distinct and lighter in value. Conversely, objects in the foreground are more distinct and darker in value.

TONES ON LIGHT, DARK AND GRAY

On black surfaces, white marks advance; on white surfaces, black marks appear closest. On a gray surface, both black and white come forward. Working from dark to light is a way to develop form quickly since light is the substance of visual experience. Working on toned paper allows you to simultaneously go down with shadows and up with lights.

Using Lines

Lines that are thin and less distinct tend to move back in space. Conversely, lines that are thicker and darker tend to advance. Those that stand out in starker contrast to the background will seem nearer to the observer, while those closer in value to the background will seem fade into the distance. Three-dimensional form is suggested most effectively by a contour line that changes as it moves around the edge of the form. Lines that are varied will also help turn the form.

Over-Defining

It's common for beginning artists to overly define objects in their drawings; for instance, by adding heavier lines along the edges of their figure. However, objects in the visual world aren't separated by outlines, which tend to separate things in a way that is more symbolic than visual. By varying the thickness of your lines, you'll create a "lost and found" quality in your work that's more atmospheric and closer to the way we actually perceive things visually. It's equally important to define what is indefinite.

A Heavy Outline Appears Cartoonish
A hard or heavy line surrounding the outside contour of the figure will make your drawing seem flat, like those of a cartoonist or primitive artist. The drawing will look cut out and pasted on.

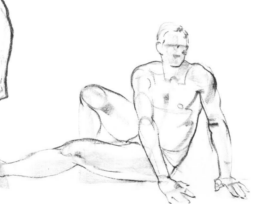

Varying Light Weights Adds Depth
In this quick gesture drawing, observe how varying the weight of the line adds an element of depth and atmospheric perspective to the forms. Using darker and thicker lines in your drawings brings forms closer to the surface.

GOOD PERCEPTION

Good drawing does not necessarily depend on good eyesight, but on good perception. In other words, you must perceive your drawing as both a tonal progression and a tonal unity. Study the model in context to incorporate the tonality of your total field of vision into your work. In naturalistic drawing, it's important to incorporate what you see visually, which means that you must include blurred or undefined elements. When you balance the defined and undefined elements in your work, you approximate more closely what you perceive in the world around you, and your drawings look more realistic.

Incorporating Lost Edges
Here you'll notice a number of lost edges. To make your drawings appear more naturalistic, it's often helpful to plan them from the beginning in a way that incorporates several lost edges. Including lost or fused edges is also more visual and interesting and allows your viewer to become more involved as they complete in their minds the information you've omitted in your drawing.

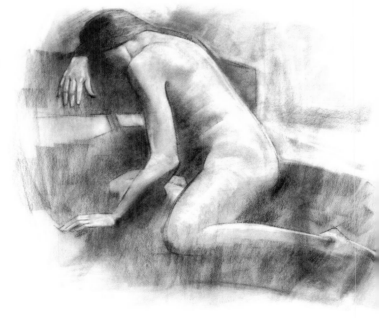

Crouching figure

The technique of working on a toned surface has been around for centuries. Many of the Old Masters implemented it because of its efficiency in creating the appearance of reality. As you work through the steps of this demonstration, keep in mind how important it is to have a clear idea of where you're going. It's easy when drawing to let your initial concept get away from you.

MATERIALS LIST

Soft vine charcoal

Charcoal stick

White pastel stick

Canson toned paper

1 Establish the Important Angles

Begin by establishing the most important angles on the outside contour of the figure, creating an "envelope." Make sure you place your angles as accurately as possible.

2 Define the "Envelope"

Keep moving around the figure until the whole "envelope" is defined. You may also want to begin indicating background elements, such as the cast shadow under the figure.

3 Develop the Interior

Move inside the envelope to the inner contour lines. Use a grid to continue to map and define important relationships, as well as the separation between light and shadow. Initially, with all the gridding and measuring, this approach may seem less atmospheric.

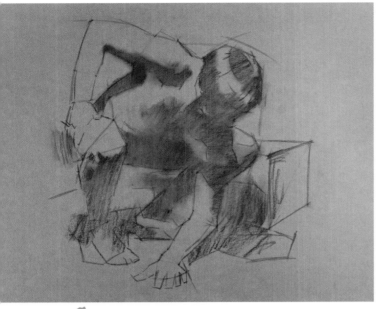

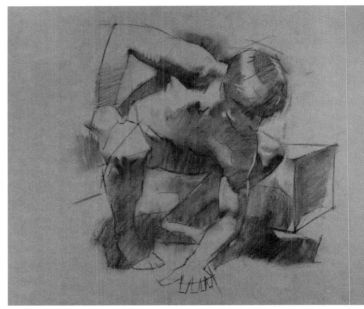

4 Add Value

Add value that you can render relatively quickly, since you already indicated the lines that separate light and shadow in the previous step. You'll notice that adding the darks also contributes to the overall sense of atmosphere.

5 Define Light and Shadow

As you continue to define the light and shadow, be clear about which edges are created by cast shadows and which are created by form shadows. By extending your darks into the background and into neighboring shapes, you'll continue to strengthen the atmospheric components of your drawing.

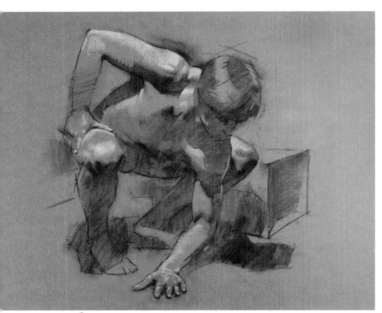

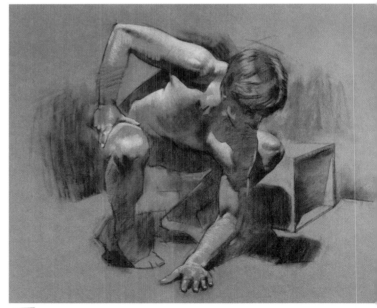

6 Add Lights

Begin to add the lights using your white pastel. At this stage it's helpful to remember the position and direction of your light source and which planes are perpendicular to it

7 Refine the Subject Relative to the Light Source

As you continue to develop your drawing remember that the parts of the figure closest to the light source will be lighter than those that are farther away. Continue adding more background darks to make your drawing more atmospheric.

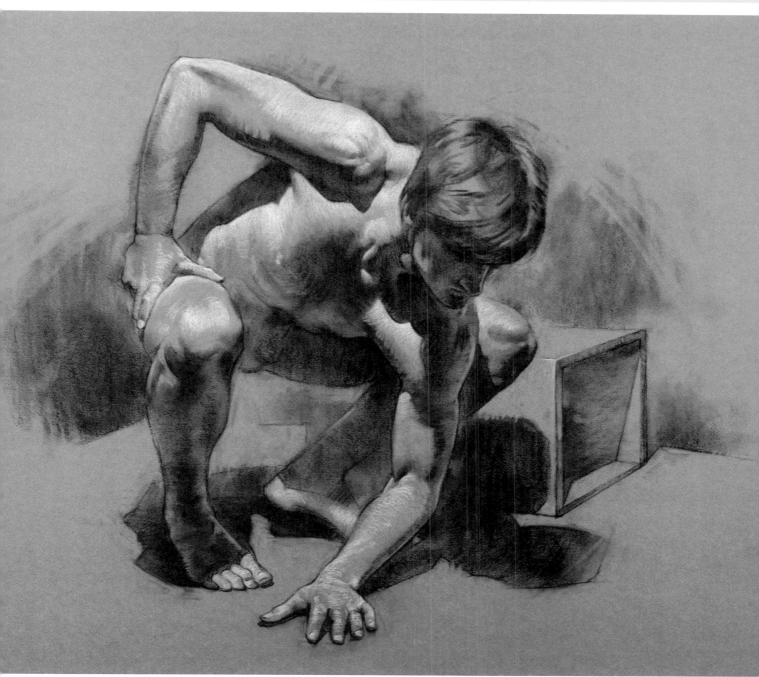

8 Complete the Drawing

In the finished drawing strive to create an effective balance between light and dark, and between elements that are defined and those that are not defined.

CROUCHING MALE FIGURE
Charcoal and white pastel on toned paper
19" × 25" (48cm × 64cm)
Collection of the artist

Amplifying Movement

Another way to think about atmospheric perspective relates to the way you use the figure-ground relationship. Placing background marks just outside the figure, but in proximity to it, can emphasize or amplify the movement or design of the pose. Manipulating the ground or area around the figure repeats the action or compositional elements of the total concept.

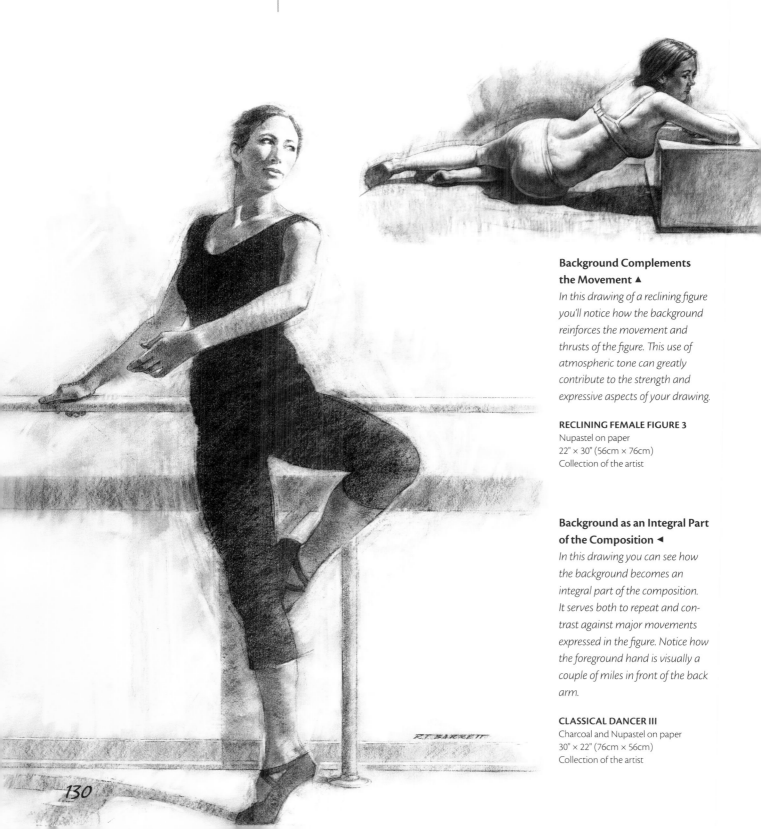

Background Complements the Movement ▲

In this drawing of a reclining figure you'll notice how the background reinforces the movement and thrusts of the figure. This use of atmospheric tone can greatly contribute to the strength and expressive aspects of your drawing.

RECLINING FEMALE FIGURE 3
Nupastel on paper
22" × 30" (56cm × 76cm)
Collection of the artist

Background as an Integral Part of the Composition ◄

In this drawing you can see how the background becomes an integral part of the composition. It serves both to repeat and contrast against major movements expressed in the figure. Notice how the foreground hand is visually a couple of miles in front of the back arm.

CLASSICAL DANCER III
Charcoal and Nupastel on paper
30" × 22" (76cm × 56cm)
Collection of the artist

Representational drawing is tied to the notion of appearance, but you'll find that you often draw what you preconceive rather than what you perceive. That is, you draw symbols for what you see rather that what's actually there. In some ways, this may be an attempt to fit your experiences into a preconceived or standardized structure. In reality, however, you'll notice that your experience is often not what you imagined or expected. If drawing were tied only to seeing, we could all draw accurately what we see. There's nothing inaccurate, per se, with drawing symbolically—it only becomes inaccurate when you incorporate it into a traditional drawing process. So the process of "de-symbolizing" will help you to draw more representationally. An essential focus of traditional drawing is making comparisons, and you'll find through the process of comparing that your preconceptions become tested against your observations.

De-Symbolizing

Adding Expression

As tone continues around and through your drawing it will strengthen the concepts associated with "lost and found" and defined and undefined. It will also strengthen the ephemeral character of your edges, thereby adding to the expressive nature of your work.

SEATED FEMALE FIGURE 5
Nupastel on paper
30" × 22" (76cm × 56cm)
Collection of the artist

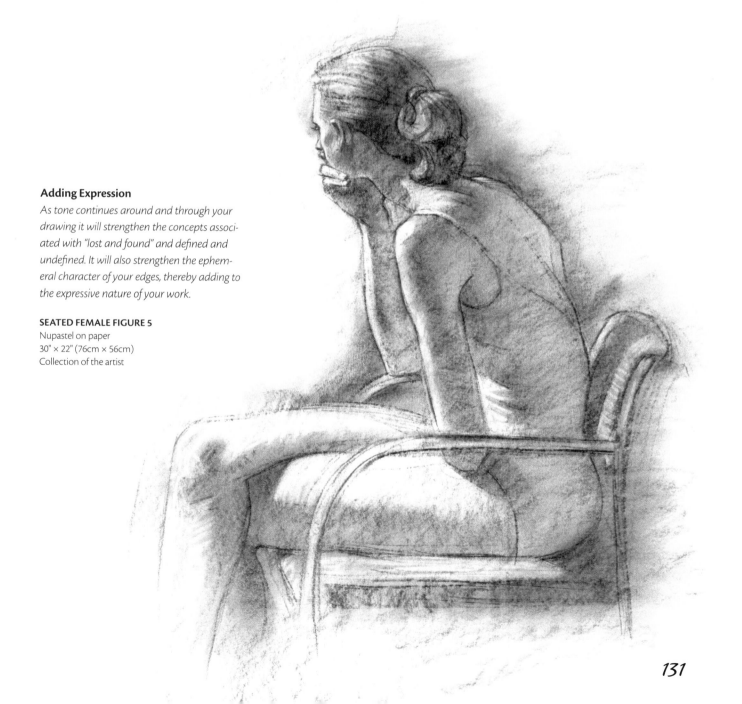

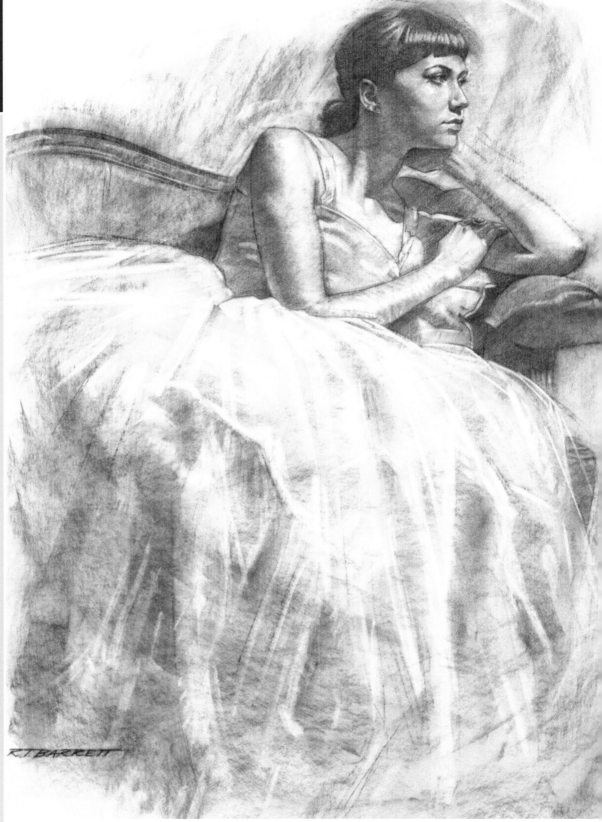

Shape and Texture

In this drawing of my daughter you'll notice a variety of shapes and textures. The abstract shapes and textures of the dress are balanced with the more realistic shapes and textures of the arms and face. The drawing includes a strong center of interest and the various elements are designed to lead the viewer to it.

MELISSA
Nupastel on paper
30" × 22" (76cm × 56cm)
Collection of the artist

Have you ever wondered what makes some pictures or visual experiences so compelling? Why are we drawn to or attracted by some images? And what helps us remember some more than others? Often they will remain in our minds and we'll reflect on them again and again. This may happen not only with paintings or drawings but also with movies and scenes from the theater. Has it ever occurred to you that it may be the way the image was designed or how the center of interest in a work of art caught your attention or fueled your imagination?

Design, some have said, is a creative enterprise used by humans to establish order out of chaos. It's also a way to establish a hierarchy of meaning between different elements of a drawing or composition as they are organized to communicate the concept, idea or value system of the work. There are many ideas and different formulas for what constitutes good design. Some have changed over time while others have remained more or less constant. In times past the use of grids, floating diagonals, or variations of the golden section were used to divide space and create centers of interest in works of visual art. Today, there are many less formal arrangements in use but most rely on certain principles or devices to engage an audience in interesting or significant ways.

Design

The Golden Section
This division of an "ideal rectangle" has been used since ancient times to design and compose works of art. The ratio of the division is 1:1.62.

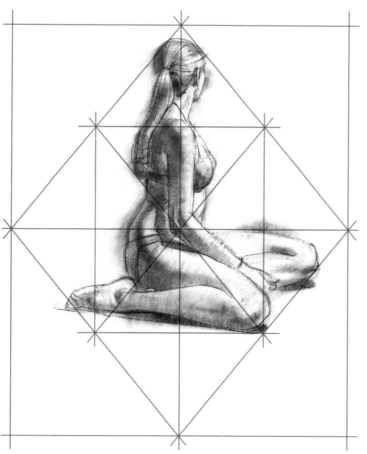

A Symmetrical Grid
The formal divisions of space in this grid can be helpful in establishing the format of your composition. When you use a symmetrical grid, your composition seems stable even if it doesn't appear symmetrical.

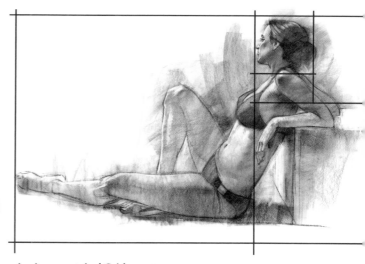

An Asymmetrical Grid
Using the golden section or ideal rectangle as a compositional format is an interesting way to establish your center of interest. The repetition of the divisions of the rectangle into increasingly smaller proportions creates both contrast and harmony.

133

Three Design Principles

When designing a work of art, it's helpful to keep three main design principles in mind: contrast, dominance and repetition.

The effective use of these principles in combination with other compositional elements can significantly strengthen your drawings. It can contribute to the entire mood or concept of your work, and amplify its important details and centers of interest.

Contrast

To achieve definition or focus in a drawing, use darker values, hard-edged lines, additional detail, or a variety of textures. These elements will appear more significant if they are balanced against opposing or contrasting elements. Dark areas in a drawing, for example, will appear darker if they are proximate to lighter areas and a hard edge will appear more acute if it's placed next to soft edges. (In music, loud sounds are usually balanced against a variety of soft tones, and fast tempos are amplified through slower passages.) Part of learning to design is learning how to control contrasting elements in your work. Including a variety of contrasting elements in your drawing will keep things more interesting.

Dominance

If the dominant value or tone in a drawing is dark or low, the mood of the drawing may be mysterious or somber. A preponderance of soft edges in a drawing sets up a relationship that helps the hard edges take on more focus. Textures in a drawing can alternate between rough and smooth, but allowing one type to have dominance adds conviction to the work.

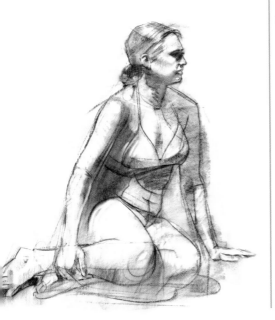

Dominance of Line

Here the dominant use of contour line leads your eye through the drawing and helps to establish harmony through its character and consistency.

Contrast of Line ◄

Here, you'll notice the balance established between line and tone and between lines that are straight and strong and those that are curved and more subtle. The use of compositional elements is often easy to detect in quick studies like these, or in the earlier rendering stages of a traditional drawing.

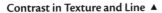

Contrast in Texture and Line ▲

In this drawing, observe the contrast between the smooth textures in the head and torso and the rough textures of the appendages. You'll also notice the difference in line quality between those lines that are heavy and thick and those that are light and thin.

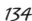

Repetition

On the other hand, repeating textures in a drawing creates harmony. The shapes in your drawing can alternate between big and small or between realistic and abstract with the potential to add a different type of harmony and strength to your work. While some elements in a drawing will be more centered or defined than others, they should all be contextually interesting. The careful use and integration of these design principles will help you create both important focal points and effective centers of interest in your drawings. Good design is expressive and helps clarify and reveal the intent of your work.

Harmony Through Repetition

In this drawing, harmony is created through the use of repeated values and shapes. There is consistency in the way the darker values are laid down with the pastel, and in the way the lighter ones are lifted out with a kneaded eraser. Look for ways in your drawings to establish unity through the repetition of different principles and processes.

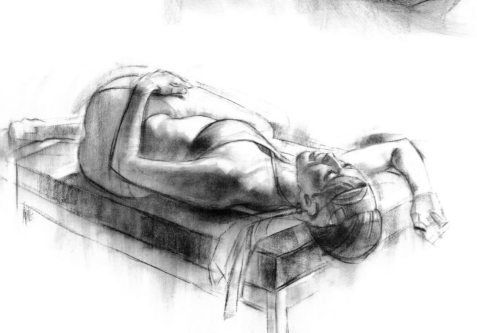

Contrast and Harmony in the Figure and the Ground

Using linear and atmospheric perspective is another way to direct your viewer to the center of interest in your composition. It may be helpful in a drawing like this to remember principles of landscape painting where darker "hills" in the foreground advance and lighter ones in the background recede.

The organic forms of the figure create harmony and contrast nicely with the mechanical lines of the bench.

Subordination and Balance

Another approach of design involves using a principle of composition, wherein all parts of a picture do not receive the same amount of attention. A colleague of mine who taught literature said, "Not every idea deserves the dignity of a sentence." By that I believe he meant that subordination in some areas of a creative work makes other areas more important. It also helps the various areas of a composition—whether it's a written text or a drawing—work together effectively to communicate a specific message. If you think about some aspects of film or theater, for example, it may be useful to understand the role of supporting actors as subordinate in their relation to the main actors. It may also be helpful to consider an antagonist/protagonist relationship where each character, by contrast, helps define the role of the other. It is often useful to ask what role a certain character is designed to perform? In a painting or a drawing, these "actors" might be the different elements that contribute to the overall composition. A foreground object, for example, might "play the role" of a space indicator, adding depth and texture to a composition, and might also "act" to help balance the spaces between the middle ground and background objects.

Study for a Portrait
In this quick head study much of the information present in the model was subordinated. As you design your drawings, edit the information you see to create stronger centers of interest. This drawing is designed to lead the viewer to the profile and the features of the face.

Back View
The center of interest in this drawing is located on the upper back of the figure where the strongest darks are located. Much of the detail in the hair, lower torso and hand has been subordinated. As you design your drawings, develop a balance between the general and the specific and between looseness and tightness.

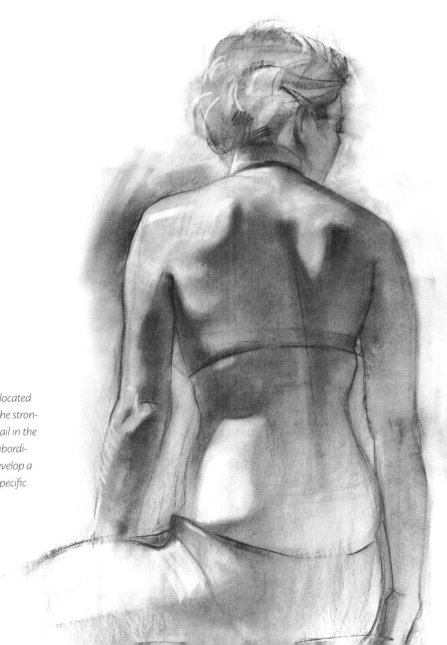

An additional compositional element of any picture involves eye movement or the way we visually move through a picture. In our culture, we're conditioned to "read" a picture from top to bottom or from left to right —the same way we read a newspaper or book. Visual journeys or eye "trips" help entertain the viewer as they are lead to and through the focal points and centers of interest in a drawing. In a similar way, the text of a novel leads the reader to and through the climax of a story. "Eye traps" (including what's sometimes referred to as a "bull's-eye" composition, where important elements in a drawing are in the exact center) can set up a center of interest but may bore the viewer because the composition lacks a visual journey. If you're not careful, you may place tangents or other "eye traps" in your drawings that are too predictable or appear in the wrong places. Using principles of asymmetry (placing things off center) is usually more compelling than a bull's-eye approach.

Eye Movement

The eye will travel along the edges.

Vignetting is an important device that helps contribute to a strong center of interest.

In this drawing, as in most portraits, the center of interest is the face.

Eye "trips" should lead to and around the center of interest.

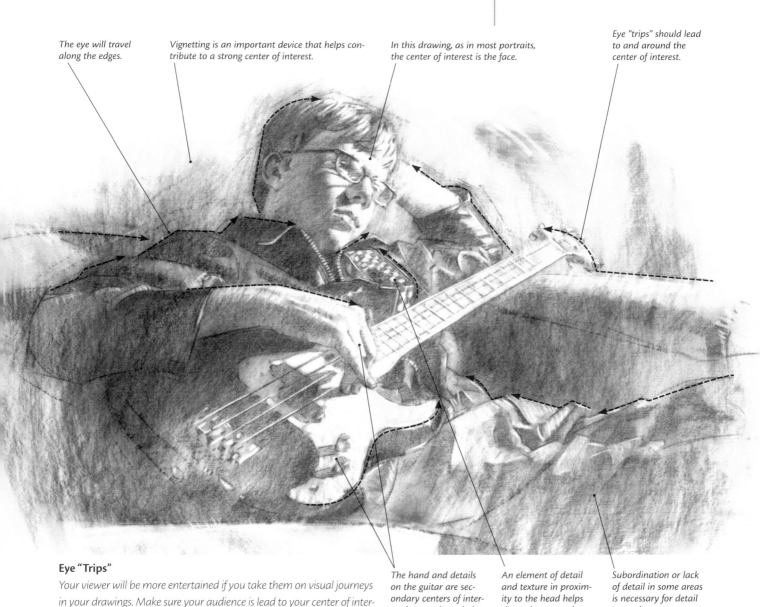

Eye "Trips"

Your viewer will be more entertained if you take them on visual journeys in your drawings. Make sure your audience is lead to your center of interest through a variety of different eye "trips."

The hand and details on the guitar are secondary centers of interest (supporting roles).

An element of detail and texture in proximity to the head helps direct the eye to the center of interest.

Subordination or lack of detail in some areas is necessary for detail to read more powerfully in other areas.

MICHAEL
Nupastel on paper
22" × 30" (56cm × 76cm)
Collection of the artist

Vignetting

A final principle to explore as you "stage" your pictures is *vignetting*. This device (often used in theater and films) makes the edges much softer or more blurred as the viewer moves off center stage or to the edges of a composition. The contrast in these areas is usually diminished by placing darks against darks, grays against grays, or lights against lights.

Remember, most good design is concerned not only with what you put in your drawings but also with what you leave out. All successful writing, cinematography, musical composition, choreography and painting require editing.

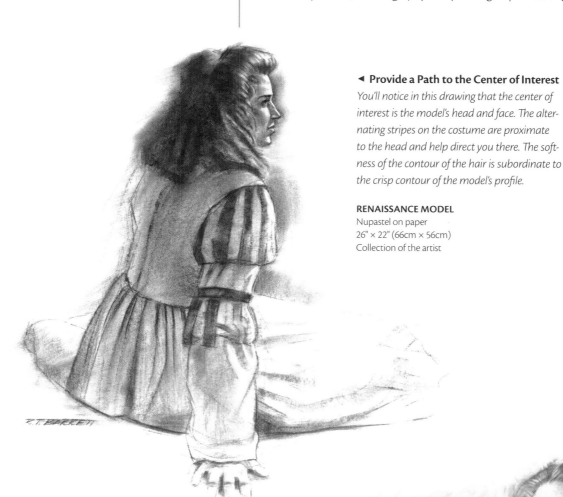

◄ **Provide a Path to the Center of Interest**
You'll notice in this drawing that the center of interest is the model's head and face. The alternating stripes on the costume are proximate to the head and help direct you there. The softness of the contour of the hair is subordinate to the crisp contour of the model's profile.

RENAISSANCE MODEL
Nupastel on paper
26" × 22" (66cm × 56cm)
Collection of the artist

Keep the Viewer Focused ►
I've used vignetting in this drawing to keep the viewer from being led away from the center of interest. You'll also notice a strong sense of lost and found in the drawing. Both devices are often used in theater and film to keep the attention of the audience focused on center stage or the center of interest.

MICHELLE
Nupastel on paper
22" × 30" (56cm × 76cm)
Collection of the artist

As in other art forms such as dance and music, elements of time, space, rhythm, movement and pacing all have their place in the composition and design of your work. Always consider the essential story or concept being communicated in your work—is it formalistic or expressive, real or abstract, loud or quiet? Ask yourself if each element you incorporate into your drawing and the way you do it adds to the story or concept. It's always helpful to have a concept in mind before you begin drawing. It's also necessary to stick with your concept as the drawing progresses especially if you think the idea or the story viable. The process of putting down your media and making adjustments is complex and varied enough that it can take you in directions different from those of your original concept. These excursions may be interesting from a creative point of view, but will stop you from communicating a great idea. Try to be disciplined enough to stay faithful to the essential story that excited you before you began.

The Essential Story

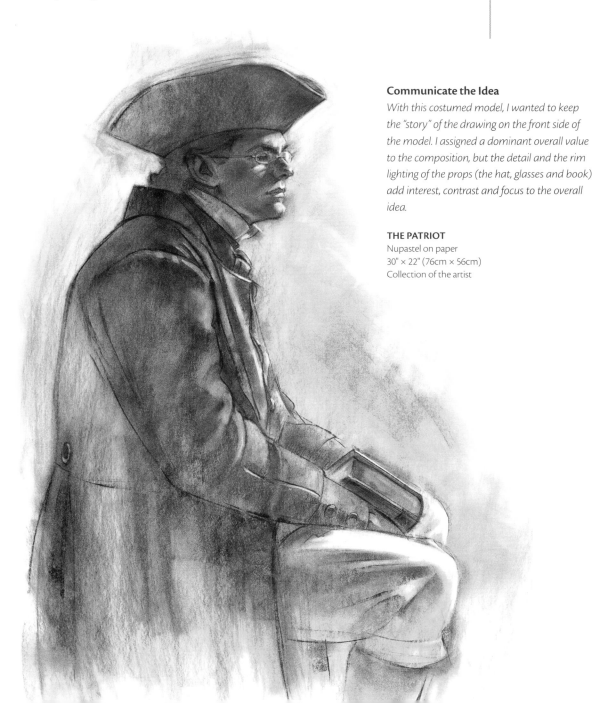

Communicate the Idea

With this costumed model, I wanted to keep the "story" of the drawing on the front side of the model. I assigned a dominant overall value to the composition, but the detail and the rim lighting of the props (the hat, glasses and book) add interest, contrast and focus to the overall idea.

THE PATRIOT
Nupastel on paper
30" × 22" (76cm × 56cm)
Collection of the artist

The Sketchbook

Sketchbook Studies

These drawings were done using a quill pen and a flexible tip marker in a large sketchbook. Drawings in these mediums have been done for centuries because the approach is both quick and expressive.

Just as keeping a diary is often a natural response to a writer's experiences, keeping a sketchbook or a visual repository of drawings is a natural response to an artist's experiences. Most sketchbooks include a combination of what the artist sees, thinks and feels. Every artist needs a place to "draw things out" (vs. just "think things out"). The sketchbook offers a place to strengthen your skills, document your experiences, work out visual problems, and explore new ideas.

Recording Your Experiences

A Shelf of Sketchbooks

A number of different sketchbooks sit on a shelf in my studio. They represent a record of my travels, personal notes, observations and influences.

A Visual Journal

Sketchbooks are visual journals that tell a lot about an artist and what they're interested in or attracted to. They reveal how you think and what you think about. They allow you to experiment with new or different mediums, and to document the world and your travels in it. In a sketchbook, you can draw what you imagine as well as what you see.

KEEP YOUR SKETCHBOOK CLOSE AT HAND

One of the best things about a sketchbook is that it is personal and low risk, meaning it's generally not shared with others, and the drawings in it take relatively little time compared to larger, more ambitious work. Also, if small enough, it can be taken just about anywhere. I recommend having a few sketchbooks in different sizes and always keeping one close at hand. Artists learn to draw by drawing and they improve their drawing skills by practicing them. Drawing is also an activity that allows you to use the right hemisphere of your brain (the spatial, visual hemisphere).

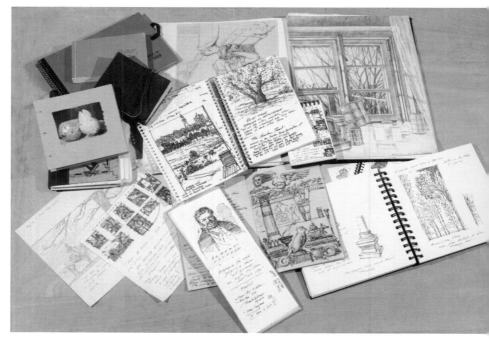

My Sketchbooks

Over the years, I've kept a variety of sketchbooks in different formats and sizes. I use them to record experiences and ideas and to work out visual problems. I often work in different sketchbooks simultaneously.

Drawing Portfolios

I also keep separate portfolios of professional assignments. This one contains drawings for a children's book I recently completed.

142

Your sketchbook can be your playground and your practice field. Its contents can represent artistry of a higher order, or it can include work that is raw, mistake-ridden and repetitive. In spite of limitations or idiosyncrasies, you'll come to love your sketchbooks because they're filled with honest, spontaneous and progressive attempts to solve relevant problems and conceptualize intriguing ideas. These ideas may be the springboard to unexpected investigations and innovative solutions.

Developing a Range of Ideas

Future Possibilities

If you're open to them, many situations and circumstances can provide inspiration for more serious work. This rough idea for a possible drawing or painting was sketched very quickly from an actual, but fleeting, situation.

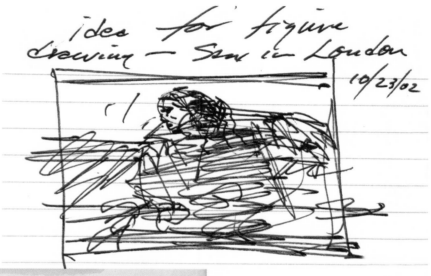

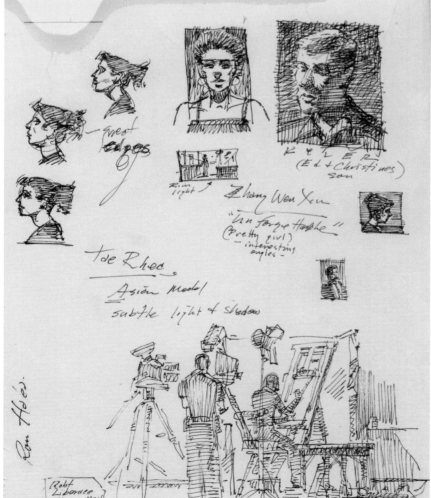

Studies at a Conference

At a recent conference of the Portrait Society of America, I made some quick studies of artwork, models, and artist Anthony Ryder completing a demonstration. This is a great way for you to visually remember what you experience as you attend workshops and seminars.

Keep Drawing

A sketchbook allows you to draw for the pure pleasure of it. Most children draw because they *want* to, and so should you! Your sketchbook will become a self-portrait of sorts, reflecting your understandings and limitations, your assuredness or timidity, and your ability to devise solutions to problems.

◄ **Sketching Masterworks**

I made these notes and studies on a visit to the Frick Art Museum in Pittsburgh. I forgot my sketchbook and had to draw on a paper sack I had with me. Many museums don't allow you to take photos of the artwork, but making observational notes is a great way to preserve your museum experience.

A Quick Study of a Former Teacher ►

I recently made this quick study of my former teacher, Albert Handell, who taught my basic drawing class at the University of Utah. He was posing at a workshop for another artist, so I took advantage of the opportunity to draw him.

Although there aren't exclusive or precise ways to work in your sketchbook, there are some valuable drawing types that yield important results. In looking through my sketchbooks and those of others, I've determined there are some significant types of sketching activities.

① Observational Records

To record what they see is probably the most common reason artists use sketchbooks. It's important to understand that this process is more than an idle activity. Keeping observational records can help you learn the properties of light, perspective or composition. Observing the relationships of people, objects, nature and space helps train your eye to confidently record the things you experience in the visual world. As a result of documenting scenes or events while traveling, you'll create a repository for future ideas. In addition, the process of drawing helps you think spatially, as opposed to reading and writing, which train the more logical or analytical parts of your brain. Sketching is an opportunity to study and explain things visually—especially to yourself.

Five Ways to Use Your Sketchbook

Study from Life
These studies were drawn from life as I observed a horse and rider. Working from live animals at the zoo or in other settings forces you to record your observations rapidly and directly.

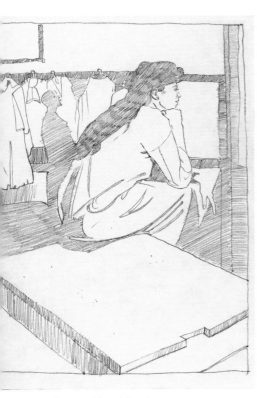

Compositional Study
I made this sketch in the drawing studio at school using mainly contour line and local value. I recommend drawing inside a "compositional box" as you look for ways to strengthen your design and the sense of a complete picture. You can do very quick drawings or more sustained ones using this approach.

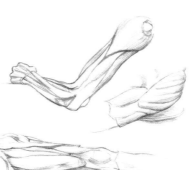

Anatomy Studies
These drawings were made in the gross anatomy lab at the University of Iowa where I completed my graduate studies. If you have the chance to draw from actual cadavers, it's a memorable way to learn human anatomy.

A MEANS TO AN END

The Old Masters often made drawings or studies as means to an end. They usually had a clear idea of what they needed from their model or from the environment to solve the bigger problem of the painting or sculpture. Often included in their sketchbooks were written observations about the drawing experience as well as their visual notations. I remember seeing sketchbooks of the artist John Constable at the Victoria and Albert Museum in London and being impressed with his notes related to the climate, time of day, atmosphere, etc. As mentioned, Old Master drawings were often means to an end, but they were also ends in and of themselves—the expressiveness in their work being a by-product of the process.

② Practice

Drawing should become an everyday part of what you do as an artist. You learn to draw by drawing, and repetition helps build conviction and confidence. Through the process of drawing you have an opportunity to work out problems of line and value, and of anatomy and proportion. Because the act of drawing in a sketchbook is basically self-initiated, the activity also builds discipline and motivation. Although you'll be drawn to specific subjects, no subject should be avoided or omitted in this process. Another purpose of practicing drawing is to help you warm up. Warming up before a drawing or painting session will loosen your hand, arm and mind. It's not unlike an athlete or dancer doing calisthenics or a musician practicing their chords or finger exercises.

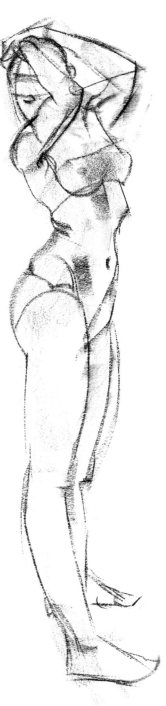

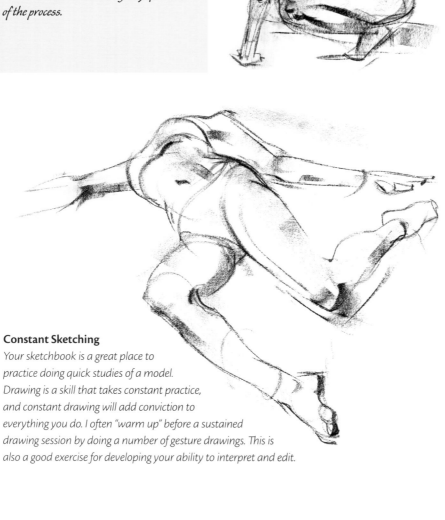

Constant Sketching
Your sketchbook is a great place to practice doing quick studies of a model. Drawing is a skill that takes constant practice, and constant drawing will add conviction to everything you do. I often "warm up" before a sustained drawing session by doing a number of gesture drawings. This is also a good exercise for developing your ability to interpret and edit.

③ Solving Problems

Once you've applied something in paint to canvas or paper, it can be difficult to correct. If you work out the problems for your paintings or ambitious drawings ahead of time in your sketchbook, you can feel free to take risks and try out many different solutions. As a result the finished work will be done more efficiently and will be a more effective solution to the problem. The sketches of the prolific Edgar Degas demonstrate his pursuit toward excellence through multiple studies of his subjects. He worked on design principles and life studies simultaneously in a way that looks both loose and effortless. His studies were often done to prepare for final paintings, and each drawing exhibits a searching quality as it attempts to clarify his idea more fully. As the sketches were often means to an end—the end being a complete painting—they often included written notes related to composition, color or concept. He often used a favorite drawing of a dancer's pose in several different paintings, thus expanding the idea—"variations on a theme." As an illustrator, you'll find that working out different ideas within a compositional box is an excellent way to understand the problem and ultimately present the best solution to the client or art director.

Sketches for a Book Cover Assignment

Here's a preliminary idea, with notes, for a book cover assignment. Doing compositional sketches is helpful as you think about paintings you might like to complete.

Sketches for an Editorial Assignment ▲

These three drawings represent initial ideas I had for a magazine assignment several years ago. Preliminary sketches are expected of professional illustrators and provide an excellent opportunity to try different solutions for the same concept. The art director liked this sketch, and you can see his notes at the bottom of the drawing.

One of a Series of Sketches

This book cover sketch is one of three covers I completed. Working out problems in a drawing is low risk as opposed to in a finished painting. I strongly encourage you to use this process in your own work.

Sketch While Travelling

This sketchbook drawing is from a recent trip to London. I did a contour drawing very quickly without value and added the value later from memory. Consider using the same process when you want to make a quick record of an event.

④ **Interpretation**

All drawing is interpretive, but sketchbook work can be even more so due to its intimate, low-risk nature. Unlike detailed drawings that document specific facts about form and texture (and thus are more faithful to reality), sketchbook art takes greater liberties with value, perspective, gesture, subject matter, and so forth and are usually considered more interpretive. Exaggeration is a form of interpretation, which, in many ways, comes closer to reality or the truth.

Editing is an important component in the process of creating drawings that are interpretive. Essentially, interpretation is largely about subtracting or adding some of your own vision or story to a subject. It's also about forming an opinion about your drawing and, more specifically, about designing your drawing. After all, you're not a copy machine nor should you try to be. Doing gesture drawing or rapid contours is a helpful way to learn how to effectively interpret your subject.

Sketch While Doing Everyday Activities ▲

I sketched this contour drawing in a waiting room at my doctor's office. If you have a drawing tool and some kind of drawing surface handy, any situation can be readily documented.

Sketch While at the Studio ►

In this contour drawing, I quickly recorded information about the model and the environment. Drawing using only line is a great way to efficiently record your observations. Additionally, there's an opportunity to do some extensive interpretation along the way.

⑤ Imagination

Daydreaming and imaginative drawing can be closely related. In other words, you don't need to be on location to perceive or record the images that lie dormant in your mind. With some experience and confidence, you can take those ideas and make them tangible.

This is no small feat for some artists. In opposition to his contemporaries, Parisian artist Paul Cézanne often drew images out of his head, which seems to have been an end unto itself for him. Unlike those who used practical studies for specific purposes, he used a sketchbook to preserve and protect his inner life.

Humorous artists and fantasy artists often draw from their imagination, but so did many of the Old Masters, including Leonardo da Vinci, Albrecht Dürer, Titian and El Greco.

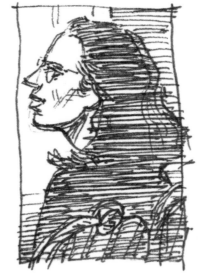

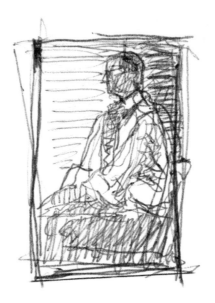

Drawing in the Margins

These drawings are a few of many I've done from my imagination. Drawing from your head can release ideas that lie dormant in your thoughts and can also help you begin to reflect on who you are as an artist. I often use this activity to solve problems—usually compositional—as well as to stimulate ideas.

Although some of these sketches are taken from formal sketchbooks, many are not. Don't limit yourself to working in an actual sketchbook.

Gallery

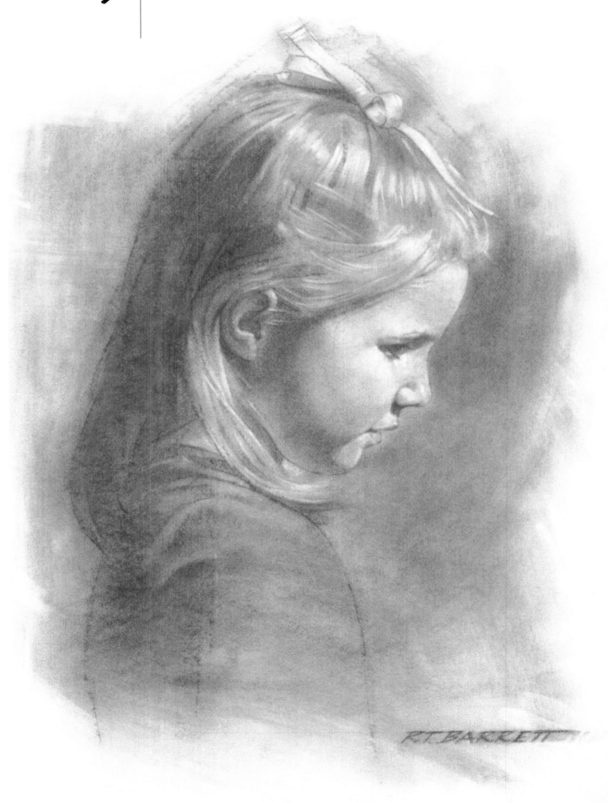

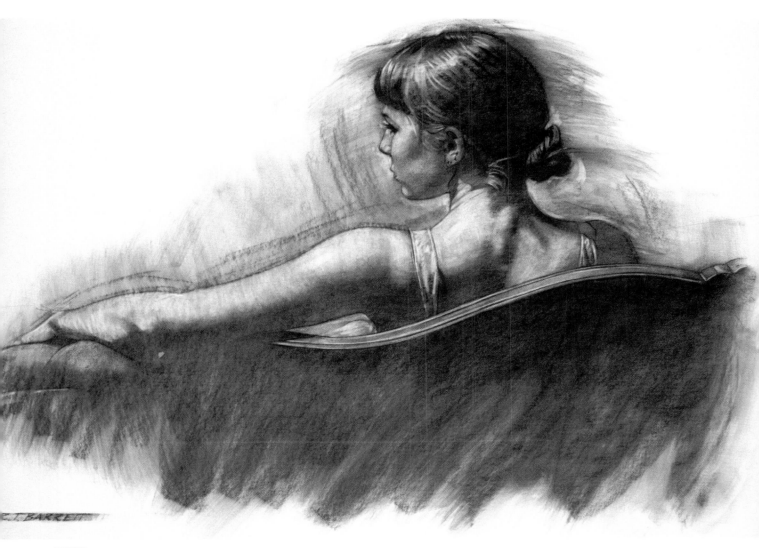

REPOSE
Nupastel on paper
22" × 30" (56cm × 76cm)
Collection of Brian and Ruth Arnst

◄ **EMMA**
Nupastel on paper
20" × 16" (51cm × 41cm)
Collection of Blake and Cora Barrett

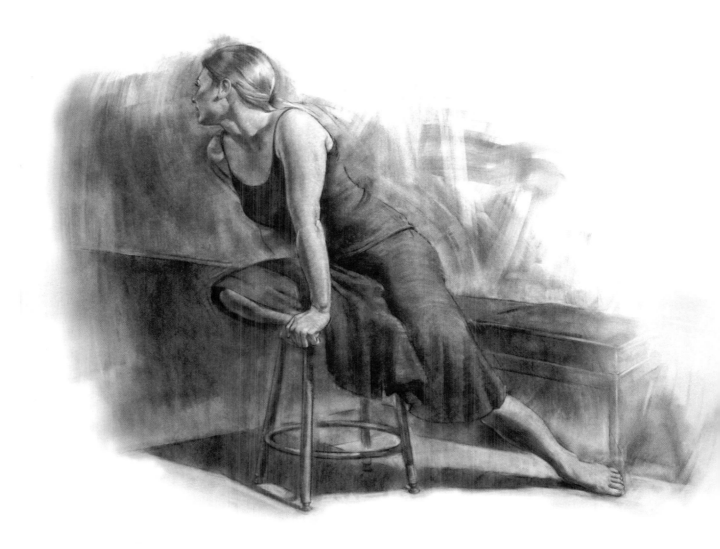

IN THE STUDIO
Nupastel on paper
22" × 30" (56cm × 76cm)
Collection of the artist

STANDING MALE FIGURE
Nupastel on paper
30" × 22" (76cm × 56cm)
Collection of the artist

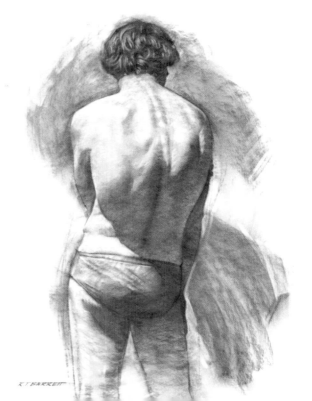

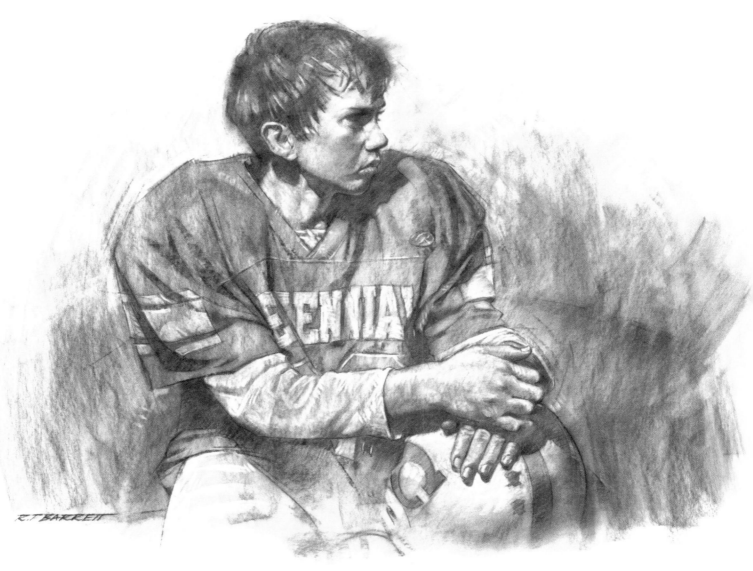

ERIC
Nupastel on paper
22" × 30" (56cm × 76cm)
Collection of the artist

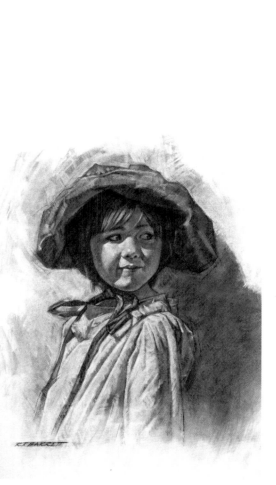

PIONEER GIRL
Charcoal on paper
30" × 22" (76cm × 56cm)
Collection of the artist

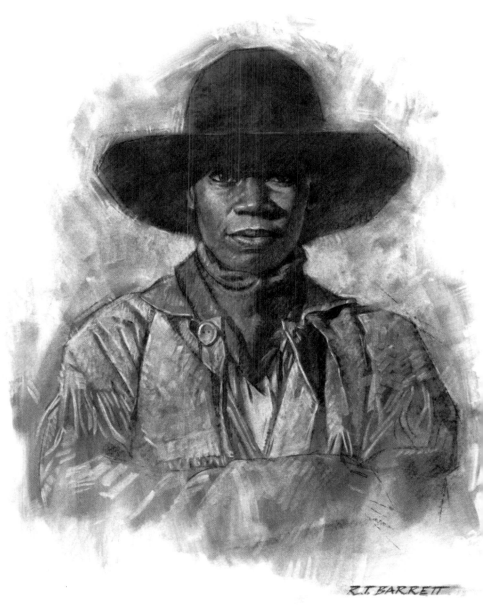

COWGIRL
Charcoal on paper
30" × 22" (76cm × 56cm)
Collection of the artist

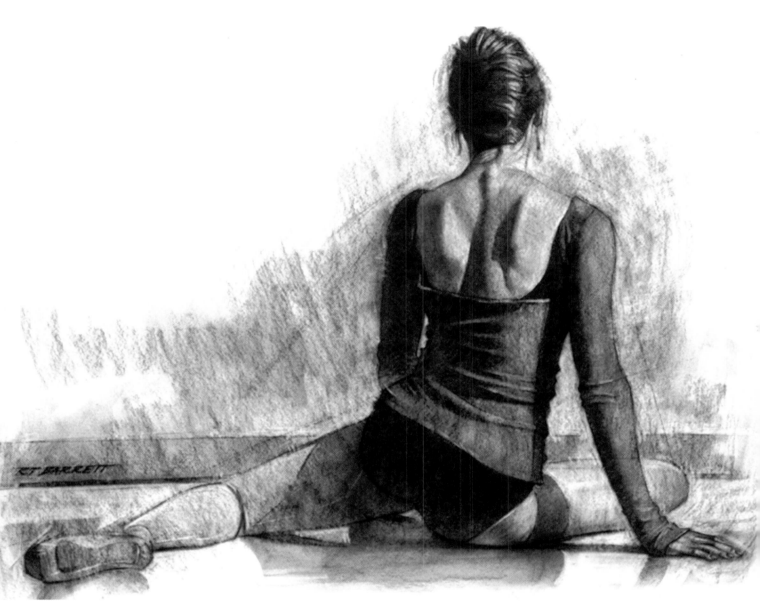

CLASSICAL DANCER
Nupastel on paper
22" × 30" (56cm × 76cm)
Collection of the artist

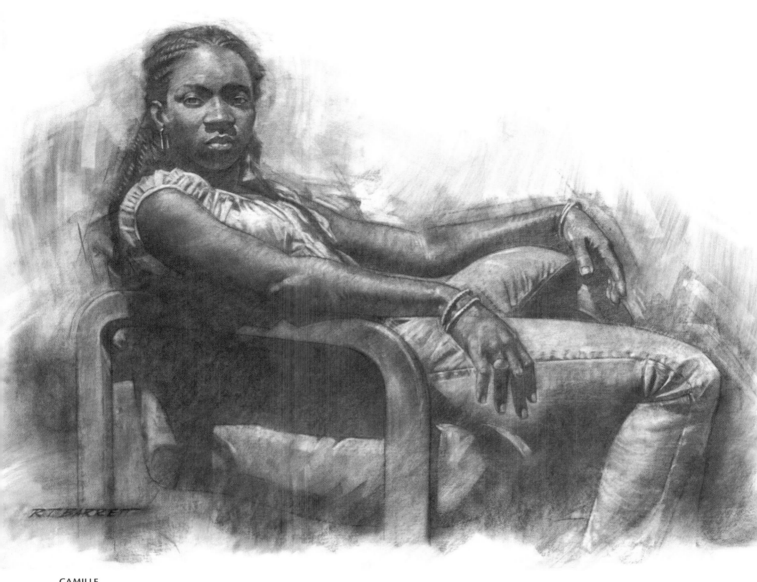

CAMILLE
Charcoal on paper
22" × 30" (56cm × 76cm)
Collection of the Springville Museum of Art

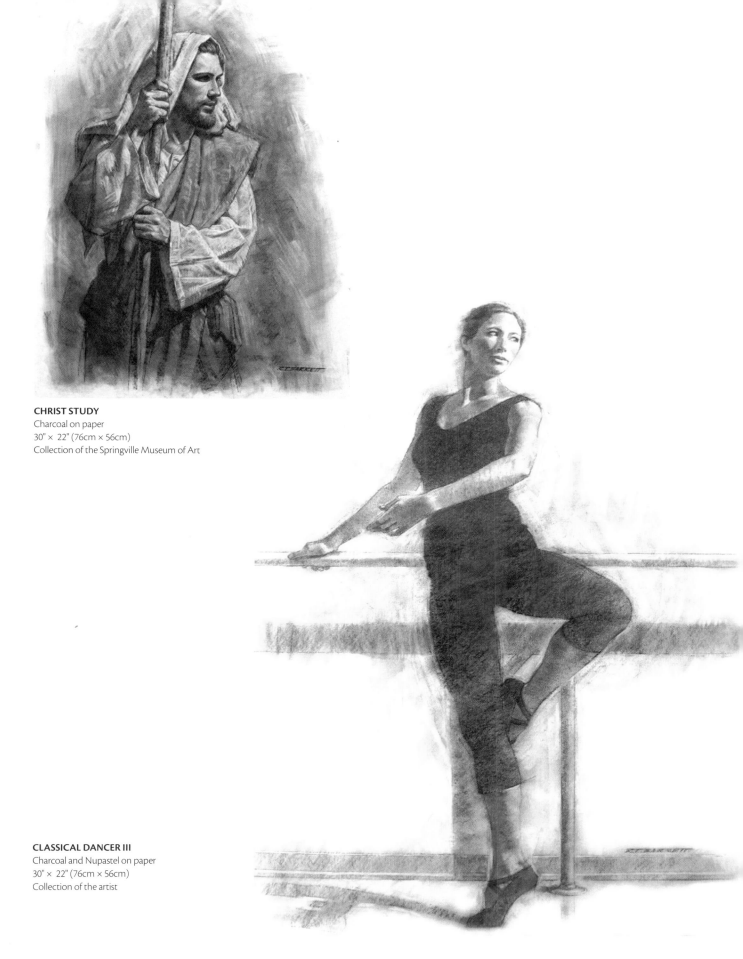

CHRIST STUDY
Charcoal on paper
30" × 22" (76cm × 56cm)
Collection of the Springville Museum of Art

CLASSICAL DANCER III
Charcoal and Nupastel on paper
30" × 22" (76cm × 56cm)
Collection of the artist

The best in fine art instruction and inspiration is from North Light Books!

The practical instruction and time-honored methods provided in The Art of Portrait Drawing will help you develop the skills necessary to draw portraits in the realist tradition. Learn how to capture not only the likeness, but also the mood and essence of your subject, through lessons gathered from generations of the world's greatest artists.

ISBN-13: 978-1-58180-712-7
ISBN-10: 1-58180-712-0
Hardcover, 144 pages, #33378

Before you can draw like an artist, you need to see like one. Drawing With Your Artist's Brain offers an unusual, interesting and proven approach to maximize your powers of seeing. Use the exercises, checklists, technique summaries and step-by-step drawing demonstrations within, and unveil the secrets to creating better art!

ISBN-13: 978-1-58180-811-7
ISBN-10: 1-58180-811-9
Hardcover, 128 pages, #33494

To draw the human body with accuracy and confidence, you have to know how its anatomy functions beneath the skin. Anatomy for Artists bridges the gap between observation and creative expression by showing you how to use your own body as a reference tool for better work. Whether your goal is to achieve tight realism or stylized illustration, you'll discover how to blend what you see with what you learn and feel to be true about human anatomy, enabling you to capture the human form with greater richness and clarity.

ISBN-13: 978-1-58180-931-2
ISBN-10: 1-58180-931-X
Paperback, 128 pages, #Z0669

These books and other fine North Light titles are available at your local fine art retailer, bookstore, or online suppliers. Also visit our website at www.artistsnetwork.com.